LENSES

FOR DIGITAL SLRS

LENSES

FOR DIGITAL SLRS

AMMONITE
PRESS

ROSS HODDINOTT

First published 2010 by
Ammonite Press, an imprint of AE Publications Ltd,
166 High Street, Lewes,
East Sussex BN7 1XU
United Kingdom

Text © Ross Hoddinott, 2010
All photographs © Ross Hoddinott, except page 89, 96
and 97, Thomas Collier (www.thomascollier.com), page
76, Ollie Blayney (www.burntvisionphotography.com) and
page 117, Daniel Lezano (www.digitalslrphoto.com)

Copyright in the Work © AE Publications Ltd, 2010

ISBN 978-1-90667-276-8

Editor Ailsa McWhinnie
Designer Ali Walper

Colour origination by GMC Reprographics
Printed and bound by KNP, Thailand

CONTENTS

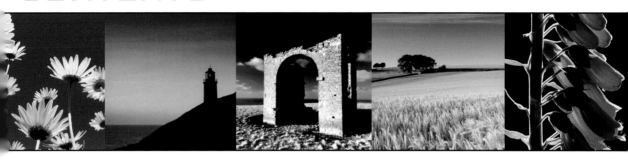

INTRODUCTION

LENS/NOUN: 'A PIECE OF GLASS, CURVED ON ONE OR BOTH SIDES, USED IN AN OPTICAL DEVICE – LIKE CONTACT LENSES OR A CAMERA LENS – TO CHANGE THE CONVERGENCE OF LIGHT RAYS FOR MAGNIFICATION OR TO CORRECT DEFECTS IN VISION.'

When you buy a digital SLR, you are not simply purchasing a camera, but investing in a whole 'system'. One of the biggest advantages of a single lens reflex (SLR) camera, compared with a digital compact, is the ability to change lenses. This allows photographers to select the lens and focal length best suited to the subject or situation – this unrivalled flexibility makes an SLR the perfect choice for beginners, enthusiasts and professionals alike.

With the exception of the four-thirds system (see page 24), camera lenses can't be swapped from one make to another, due to the different mounts employed by camera manufacturers. However, regardless of the camera you own, each brand offers a wide range of optics designed to fit its dedicated lens mount. In addition to this, popular third-party lens makers, like Sigma, Tamron and Tokina, produce their lens range in different mounts to fit all the popular brands. As a result – whether you own a Canon, Nikon, Olympus, Pentax, Samsung, Sigma or Sony DSLR – you will not be short of options when creating or adding to your system.

However, with so much choice, buying a new lens can prove daunting. It is a big decision and a substantial investment. Despite this, many photographers still deliberate far longer over which camera to buy than they do when choosing a lens. This guide is aimed at redressing this. Before parting with your cash, it is important you understand how lenses work, the benefits and drawbacks of different focal lengths and which subjects they suit best. For instance, do you opt for a prime or zoom lens; one with image stabilizing (page 54) technology or not; and how do you best clean and look after your optics? These are the type of questions that this guide is intended to answer, helping you to make the right choices.

This book isn't simply designed as a buyers' guide, though. Its main purpose is to help you realize the full, creative potential of your optics – regardless of whether they may

Evening light at Trebarwith. Selecting the most appropriate lens is an intuitive skill. At first, new photographers might need to make a conscious decision regarding focal length. However, with just a little time and experience, you instinctively grow to know which focal length will suit which subject. When I photographed the warm, evening light at this Cornish beach, I immediately knew that an extreme wideangle lens would best capture the scene before me.

Nikon D300 with Nikkor 12-24mm lens (at 12mm), 20 seconds at f/22, ISO 100, polarizing, 0.9ND and graduated 0.9ND filters, tripod

be new or part of an existing system. A good understanding of a DSLR's interchangeable lenses will help you to be more creative, and enable you to take more control over your photography. Having the ability to choose the most suitable lens for the task ahead is a skill – otherwise you risk missing or ruining good photographic opportunities. Your choice of lens will, of course, be influenced by a number of factors – for example, the available light, its maximum aperture (speed) and, of course, the subject matter itself. It will also be dictated by practical considerations, like, the lens's weight, size and the focal length's effect on depth of field and perspective (page 26).

Focal length is a key compositional and creative tool. By switching from a short focal length to a longer one, or vice versa, you can completely alter the way your subject is recorded. For example, a powerful telephoto lens can be used to photograph a portrait of a wild bird or mammal, while a shorter lens will show the creature in context with its environment. Extreme focal lengths, like a dedicated fisheye lens (see page 108), distort perspective, and so are capable of creating surreal, eye-catching effects.

The majority of optics are designed for general-purpose photography, but some have a more specific use. For instance, macro lenses (see pages 110–113) are optimized for close focusing, allowing photographers to capture the miniature world beneath their feet – something they would be unable to do with a standard lens. Each lens has a use and role, but every photographer has different needs. As a result, the lenses you personally require, and should employ in your system, depend on the subjects you most enjoy photographing.

Basically, what I am saying to you is that an interchangeable lens isn't simply something you attach to a camera to vary the level of subject magnification. In reality, a lens has more influence over the look of the final image than the camera itself. After all, a camera is effectively just a light-tight box – it is the focal length, speed and quality of the lens which is of greater importance.

I hope this title proves an exhaustive guide on lenses for DSLRs, answering your questions and helping to illustrate how the most popular focal lengths can be utilized in a number of different ways in order to achieve different

⋀ Marbled white butterfly. Interchangeable digital SLR lenses are available in a wide variety of focal lengths, from extreme wideangle circular fisheyes, to long, powerful telephotos of 1000mm or more. There are hundreds of lenses currently available to buy, made by various camera and third-party manufacturers. There are many more – both existing and discontinued models – available second-hand, which are perfect for photographers on a budget. Your lens choice will have a huge influence on the look of the final image. In this instance, I attached a macro lens in order to be able to photograph this butterfly in close-up.

Nikon D300 with Sigma 150mm lens, 1/13sec at f/16, ISO 100, tripod

results. In addition to this, I also cover how some lens flaws, like aberrations and vignetting, can be corrected post capture, as well as lens care. So, whether you presently own just one lens, or a large system of different focal lengths, this book is aimed to ensure you realize their full creative potential… and your own.

1 THE BASICS

Lens choice has a huge impact on the way we capture a scene or subject. For example, focal length not only dictates how the subject will be recorded, but also perspective. Being the 'eye' of the camera, a lens's optical quality is also hugely significant, which is why you should take care when choosing a lens, utilizing MTF charts to ensure you buy the best lens that falls within your budget. Lens care and craft is also important in order to maximize image quality.

CHOOSING YOUR DIGITAL LENS

IF YOU HAVE RECENTLY BOUGHT YOUR FIRST DSLR (DIGITAL SINGLE LENS REFLEX) CAMERA, CHOOSING, BUYING AND USING INTERCHANGEABLE LENSES WILL BE A NEW EXPERIENCE. ALTERNATIVELY, YOU MAY BE RETURNING TO PHOTOGRAPHY AFTER A BREAK – WITH DIGITAL CAPTURE HAVING REIGNITED YOUR LOVE FOR PHOTOGRAPHY. REGARDLESS OF WHETHER YOU ARE A BEGINNER, AMATEUR OR KEEN ENTHUSIAST, A GOOD UNDERSTANDING OF LENSES IS IMPORTANT IF YOU WISH TO REALIZE THEIR FULL POTENTIAL. THIS CHAPTER IS DESIGNED TO HELP YOU GET TO GRIPS WITH THE BASICS.

⊼ **Reflection.** Only by having an understanding of lenses, can you expect to make good decisions when buying and using them. Focal length has a huge impact on composition and the look of the final image. This guide will help you to make the most of your system – both your existing lenses and those you intend to buy in the future.

Nikon D300 with 12–24mm lens (at 19mm), ISO 100, one minute at f/14, polarizer and 0.9ND grad, tripod

Lens functions

Most photographers, when they buy a DSLR, are keen to learn more about digital capture and the significance and role of such matters as resolution, white balance, ISO sensitivity, dynamic range and signal noise. However, the camera alone isn't responsible for image quality – the lens attached to the body is just as significant. Therefore, it is as important to be familiar with lens design, functions, technology and types. This chapter will introduce you to lens basics. It is written in easy-to-understand language, designed to be as jargon-free as possible.

We begin by looking at commonly used lens terminology – brief descriptions that will help you get to grips with their meaning, before they are explained in greater detail later in this chapter, or in other chapters. For example, we will look at the merits of zoom and prime lenses, focal length and angle of view, as well as the significance of sensor size. Pages are also dedicated to depth of field and focus types, before help is given on choosing a lens and comparing lens quality with the aid of MTF charts. Before the chapter ends, we will consider lens care and also lens craft, including how best to shoot handheld and types of support you can invest in to keep your set-up stable.

WHAT IS A SINGLE LENS REFLEX CAMERA?

A digital single lens reflex camera – or digital SLR/DSLR – is a camera type in which the photographer looks through the actual taking lens when they peer through the viewfinder. It employs a mechanical mirror system and pentaprism to direct light from the lens to an optical viewfinder at the back of the camera. When you take a picture, the mirror assembly swings upward, the aperture narrows – if set smaller than wide open – and a shutter opens to allow the lens to project light onto the digital sensor positioned behind. All of this occurs so quickly that some DSLRs are able to capture up to a staggeringly quick ten frames per second. SLR cameras are popular with all types of photographer, of any ability. They allow photographers to accurately preview framing immediately before the moment of exposure and, being compatible with a vast range of different, interchangeable lenses, their capabilities are endless.

∧ **Digital SLR.** Light entering the lens of a DSLR hits a mirror installed in the body at a 45-degree angle, deflecting the light up into the viewfinder pentaprism. When the photograph is taken, the mirror flips up, the shutter opens and light strikes the sensor for the duration of the shutter speed.

Basic lens terminology

If you are relatively new to DSLR photography – perhaps you have recently upgraded from using a digital compact, for example – using interchangeable lenses may prove a new experience. DSLR photography is littered with terms and jargon, which can seem daunting or confusing at first. Therefore, to help, listed over the next few pages are brief descriptions of some of the most relevant and frequently employed lens terms. Being familiar with this terminology will also help you use this guide effectively.

Angle of view

This is a measurement of the amount of a scene that can be recorded by any given lens – stated in degrees – and is directly related to the lens's focal length. It is usually provided as a diagonal measurement across the image area. The size of the digital sensor has an effect on the angle of view. For more on angle of view, turn to page 20.

Aperture

The lens aperture is the adjustable opening through which light passes to expose the digital sensor. The lens diaphragm governs the aperture stop, controlling the effective diameter of the lens opening – functioning like the iris of an eye. The lens aperture dictates depth of field. For more on apertures, turn to page 30.

Elements

An element is an individual piece of glass that makes up one component of a lens. Camera lenses are constructed from multiple individual elements assembled together inside a cylindrical barrel. Elements are often assembled closely together to form a 'group'.

Field of view

The term field of view is often used interchangeably with angle of view. However – technically speaking – it shouldn't be, as the field of view is a linear measurement that is also dependent on the subject distance.

> **The front element.** A lens is constructed from multiple pieces of optical glass – which are known as elements. The complexity of a lens – the number of elements and their degree of asphericity – depends upon its angle of view and maximum aperture (speed). Because the front element is exposed, it is important to care for it – avoid touching the glass and try to keep it protected from dirt, dust or moisture.

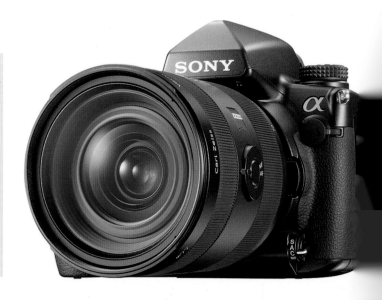

Focal length

In basic terms, the focal length of a lens is the numerical value in millimetres that indicates its power and angle of view. The smaller the number, the wider the field of view; the larger the number, the narrower the angle of view. For example, a 28mm lens has an angle of view of 74 degrees, while a 300mm lens has one of eight degrees. Quite simply, focal length indicates the lens's power. A zoom lens has an adjustable focal range.

For the more technically minded, the focal length is given as the distance between the focal plane and the rear nodal point of the lens, given infinity focus. For more on focal length, turn to page 20.

Focal plane

This plane is perpendicular to the axis of the lens and results in the sharpest point of focus. Basically, the focal plane represents the area in a camera where the light is focused. The digital sensor is positioned on the focal plane.

⋀ Focusing. A lens needs to be accurately focused on your subject for it to be properly defined and detail recorded sharply. Focus can be achieved by either turning the lens's focusing ring manually, or using the camera's automatic focusing system.

Nikon D3X with 150mm lens, ISO 100, 1/10sec at f/18, manual focus, tripod

Focus

This is the point at which an image, projected onto the sensor by the attached lens, is properly defined and details appear clearly. When an image is sharply defined then it is said to be in focus; if it is not, then it is out of focus. A lens needs to be focused, either automatically or manually, to obtain focus. For more on manual and automatic focus, turn to page 32.

Lens mount

This is the attachment system used to couple the lens to a DSLR camera. DSLRs employ a bayonet mount system, enabling interchangeable lenses to be attached and removed quickly and easily. Typically, lens mounts are incompatible between camera systems – for example, a Nikon lens will not fit a Canon body. The four-thirds system is the main exception to this rule.

∧ **Minimum focusing distance.** Every lens has a minimum focusing distance. This indicates how close the lens can be placed from the subject and still achieve sharp focus. By shooting at a lens's minimum focusing distance, you also effectively magnify the subject more.

···

Nikon D300, 80–400mm (at 400mm), ISO 200, 1/30sec at f/7.1, polarizer, tripod

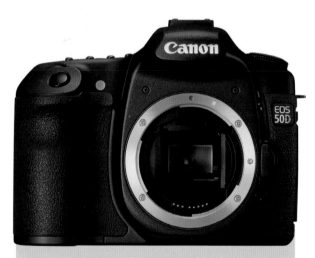

∧ **Lens mount.** With a single half-turn of the lens, a bayonet mount allows photographers to attach and detach optics quickly and easily. Each camera brand employs its own mount, so lenses are not generally interchangeable or compatible with other systems.

Minimum focusing distance

This indicates how close the lens can be placed from the object while still being able to achieve sharp focus. The distance is measured from the vertex of the front glass of the lens. A lens's minimum focusing distance varies from one lens to the next and can range from just a few centimetres to several metres. Shorter focal lengths generally have a smaller minimum focusing distance than longer telephotos.

Prime

A prime lens has a fixed focal length – for example a 28mm, 50mm or 135mm lens. The term 'prime' has come to be used as the opposite of zoom. For more on prime lenses, turn to page 16.

Standard lens

A standard – or normal – lens is said to be one with a focal length and angle of view roughly equivalent to our own eyesight. This equates to a focal length of 50mm. A short zoom lens, which includes 50mm within its range, is normally considered to be a standard zoom. Chapter 4 (page 78) is dedicated to using standard lenses.

Telephoto lens

A telephoto is a lens with a narrower angle of view than the human eye so, technically speaking, any lens upwards of 50mm in length is telephoto. However, we typically think of telephotos as being longer and more powerful – for example, 200mm, 300mm and 400mm are all popular telephoto lengths. Chapter 5 (page 90) is dedicated to using telephotos.

Wideangle lens

The human eye has an angle of view of approximately 46 degrees; a wideangle is a lens with a larger angle of view than this. Typically they have a focal length of 35mm or less and an angle of view of between 60 to 108 degrees. Chapter 3 (page 66) is dedicated to using wideangles.

Zoom

Zoom refers to a type of lens with a mechanical assembly of lens elements that have the ability to vary focal length – and therefore the angle of view – as opposed to being a fixed focal length (prime) lens. For more on zooms, turn to page 18.

LENS HISTORY

Although the first permanent images were produced by Louis Daguerre and William Henry Fox Talbot early in the 19th century – probably using a single convex lens – the camera lens evolved from optical lenses developed centuries before. In 1568, Daniel Barbaro, a Venetian nobleman, placed a lens over a hole in a camera box and studied sharpness of image and focus. This lens was formed using an elderly gentleman's convex spectacles. Astronomer Johann Kepler later elaborated on Barbaro's experiments and, in 1611, described single and compound lenses – explaining image reversal and enlarging images by grouping together convex and concave lenses.

The first box cameras had a lens mounted in the opening in the box. The lens inverted the image on a light-sensitive plate at the rear of the camera. At this point, there wasn't a shutter to open the lens; instead, a lens cap had to be removed – for several seconds or longer – to expose the plate. Later, the iris diaphragm was developed to enable photographers to control

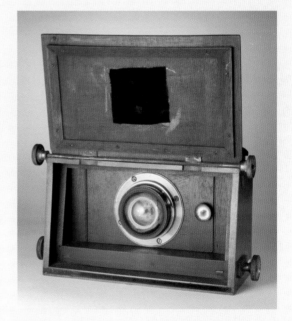

exposure – its metal leaves being able open and close together to form a circular opening, allowing the aperture's diameter to be varied.

Zoom or prime?

There are two types of lens, prime and zoom. Prime – or fixed – lenses have a specific focal length which cannot be altered, while a zoom lens has an adjustable focal length, allowing photographers to choose from a range of lengths without having to physically change lens. Both have advantages and drawbacks, which are outlined here to help you decide which type is best suited to your photography.

Prime

When zooms were first introduced, their optical quality was undeniably poor. This meant prime focal lengths remained the only practical choice for serious photography. However, today's zooms offer such high image quality that many amateurs overlook fixed optics altogether, citing their lack of flexibility as the reason. While at first glance, having a fixed range – 28mm, 50mm, 100mm, 135mm, 200mm and 300mm are all popular fixed focal lengths – might seem limiting, prime optics continue to offer much to today's digital SLR photographers.

Most significantly, prime lenses still just have the edge over zooms in terms of optical quality – particularly at wide apertures, giving them an advantage in low light. This is because fewer compromises have to be made in their optical design. Fixed lenses also tend to have a faster – and fixed – maximum aperture, creating a brighter viewfinder image, and are generally more compact, too. However, on the downside, photographers need to carry more lenses in order to cover a wide range of focal lengths. This can prove expensive and – if walking far – impractical due to the added weight and bulk of lugging around so much equipment.

It is often presumed that a fixed lens's biggest drawback is its lack of flexibility and convenience. While, to an extent, this is true, oddly this can also be one of its greatest benefits. Using a fixed focal length makes you a more creative photographer, forcing you to physically adjust your shooting position in order to frame the image precisely – rather than simply standing in one position and zooming in and out. As a result, it could be argued that using prime lenses helps ensure photographers don't grow lazy or complacent.

∧ **Prime lens.** Fixed focal lengths might seem outdated, but they still have much to offer digital SLR photographers. Their high optical quality and fast, fixed aperture, make them appealing to enthusiasts. They are available in short focal lengths – like this prime 35mm lens – up to long telephotos exceeding 1000mm.

> **Swanage Bay.** Both prime and zoom lenses have their advantages and disadvantages. There are times when the versatility of a zoom is preferable; whilst the speed and simplicity of a prime lens is better suited to other situations. Like many photographers, I employ a hybrid system to ensure I have a focal length to suit practically any subject.

Nikon D300 with 20mm lens, ISO 100, three minutes at f/22, polarizer, 10-stop ND, 0.9ND grad, tripod

LENS TIP

Both prime and zoom lenses have a place in your kit bag and, like many photographers, I employ a hybrid system of both – designed to suit different subjects. Whatever you opt for, though, always buy the best you can afford.

Zooms

A zoom lens is a mechanical assembly of lens elements with the ability to vary its focal length – and thus the angle of view (see page 20). Most designs consist of a number of individual elements that may be either fixed, or slide axially along the body of the lens. As the magnification of a zoom lens is altered, it is necessary to compensate for any movement of the focal plane to keep the focused image sharp. This may be done mechanically or optically. For example, the assembly of a zoom lens may be divided into two parts; a focusing lens – similar in principle to a standard, fixed-focal-length lens – preceded by an afocal zoom system. This is an arrangement of fixed and movable lens elements that, instead of focusing the light, alters the size of the beam of light travelling through it and, therefore, the overall magnification of the lens system.

The biggest advantage of using zooms is their unrivalled flexibility and convenience. By having an adjustable focal range – covering many focal lengths – a zoom can theoretically replace several prime optics; meaning you don't have to pay for, or carry, extra lenses. Neither do you incur so many delays caused from having to change lens – which in turn minimizes the amount of dust and dirt entering the camera body and settling on the sensor or low-pass filter.

By simply twisting or sliding the zoom collar, you can precisely select any focal length within the lens's range. Zooms are hugely popular today and available in a wide

variety of lengths, from super-wideangle 10–20mm zooms, to hugely powerful 300–800mm tele-zooms. Some of the most popular ranges are 17–50mm, 18–70mm, 55–200mm and 70–300mm, but every brand offers a wide variety of zooms within its lens range to cater for the needs of different photographers.

Zooms are often described using the ratio of their shortest-to-longest focal lengths. For example, a lens with a range from 100mm to 300mm will often be retailed as a '3x' zoom. The term superzoom or hyperzoom can be used to describe zooms boasting very large focal length factors – typically ranging up to 10x or even greater. For example, an 18–200mm zoom has a large 11.1x zoom range.

While it's true that early zooms were optically poor, the gap in terms of image quality is now quite small. This is thanks to developments in construction which have made the production of higher-quality zooms easier and at lower costs. The kit lens bundled with most new digital SLRs is now normally a standard zoom and many modern photographers rely heavily on using zooms – amateurs and professionals alike. They are not without drawbacks, though. Cheaper zooms can be prone to aberrations and flare. They tend to have a slower maximum aperture too, and this may not be fixed – growing progressively slower as the focal range is increased. For example, a lens advertised with an aperture

ZOOM CREEP

This is a problem often suffered by push-pull zoom lenses. This type of zoom has its focal length settings held in place by friction, and sometimes this isn't enough to counteract the weight of the lens. If you your lens slowly slides, changing focal length, when it's pointing up or down then you have a lens which exhibits zoom creep. Two-touch zoom lenses usually do not suffer from this problem to the same extent. Some lenses have locking friction rings to help deal with the problem.

LENS TIP

If opting for zooms, buy two or three lenses covering shorter ranges, instead of just one all-purpose superzoom, which covers them all. This is because, generally speaking, more compromises have to be made in the construction of a zoom boasting a large range of 10x or more.

> **⌃ Zoom lens.** Today, zooms are available in almost every imaginable length. This is a 300–800mm tele-zoom made by Sigma. While large and pricey, it maintains high image quality throughout its range. Despite its long focal length, it boasts a relatively fast fixed aperture of f/5.6, making it well suited to wildlife, sports and action photography.

of f/3.5–5.6, indicates that, at its short end the fastest available f/stop is f/3.5, while at its long end this increases to f/5.6. Also, the front element of some zooms rotates as the lens is zoomed, which can prove a nuisance if you have a filter, like a polarizer or grad, attached.

However, a prime lens cannot match a zoom for convenience and versatility, potentially allowing a photographer to switch from a wideangle shot to a telephoto length in an instant.

> **⌄ Zoom range.** Zooms are wonderfully versatile and useful in a wide variety of shooting situations. You can create very differing results by simply adjusting the focal range. These two images help illustrate the contrasting results possible using a zoom – in this instance I took images using both the short and long end of an 18–270mm telephoto zoom.
>
> **Nikon D300 with 18–270mm lens, ISO 200, 1/200sec at f/8, handheld**

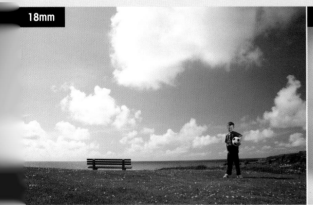

18mm

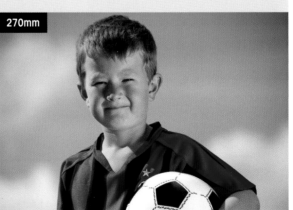

270mm

FOCAL LENGTH

THE FOCAL LENGTH OF A LENS DETERMINES NOT ONLY ITS ANGLE OF VIEW, BUT ALSO HOW MUCH THE SUBJECT WILL BE MAGNIFIED. THIS IS REPRESENTED IN MILLIMETRES, WITH A LOW NUMBER INDICATING A SHORT FOCAL LENGTH (LARGE ANGLE OF VIEW) AND A HIGH NUMBER REPRESENTING A LONG FOCAL LENGTH (SMALL ANGLE OF VIEW). THE LENS'S FOCAL LENGTH ALSO HELPS TO DETERMINE PERSPECTIVE (PAGE 26).

The focal length of an optical system is a measurement of how strongly it converges (focuses) light. When parallel rays of light strike a lens focused at infinity, they converge to a point – referred to the focal point. The focal length of the lens is defined as the distance from the middle of the lens to its focal point. Put simply, a lens's focal length is the distance in millimetres from the optical centre of the lens to the sensor when focused on a subject at infinity. In order to focus on an object closer than infinity, the lens is moved farther away from the sensor plane. This is why some lenses (physically) increase in length when you turn the focusing ring.

Photographic lenses are available in very many strengths, ranging from circular fisheyes (page 108) to hugely powerful telephotos upwards of 1000mm. We often categorize lenses as having either a wide angle (page 66–77), standard (page 78–89) or telephoto (page 90–103) focal length. Our eyesight is roughly equivalent to around 50mm, so a focal length in the range of 35–50mm is considered to be standard – anything smaller than this is referred to as wideangle, while longer lenses are thought of as telephoto.

Using a longer focal length will cause the subject to appear larger in the frame than using a shorter lens from the same distance. In fact, the relationship is geometric; assuming the

LENS TIP

The focal length of a lens can also have an impact on how easy it is to achieve a sharp, handheld photograph. Longer focal lengths require faster shutter speeds in order to minimize blurring caused by the photographer's natural movement (camera shake – page 55).

ANGLE OF VIEW

The term angle of view is a measurement of the amount of a scene that can be recorded by a given lens – or in other words, the lens's field of view – stated in degrees. This is usually provided as a diagonal measurement across the image area.

Basically, the amount of a scene or subject that is visible in the frame depends on the lens's angle of view and also the focal plane-to-subject distance. Lenses with a short focal length – for example 28mm – have a wide angle of view, while long focal lengths have a much narrower angle of view. At any given distance, the amount of the scene included (field of view) will grow larger as the lens's angle of view increases (focal length is shortened). Conversely, if the focal length is increased, the subsequent angle of view decreases and the amount of the scene included in the frame is reduced.

same subject-to-camera distance, a doubling of the focal length will cause the size of the subject within the frame to also double. Alternatively, keeping the focal length the same but halving the subject-to-camera distance will also cause the subject's magnification within the frame to double. Many digital SLR cameras have a smaller (cropped-type) image sensor than the 35mm standard, which effectively increases the focal length of the lens attached. As a result, a shorter focal length is required to achieve an equivalent angle of view. It is for this reason that digital SLR/lens combinations are often referred to in terms of their 35mm equivalent focal length.

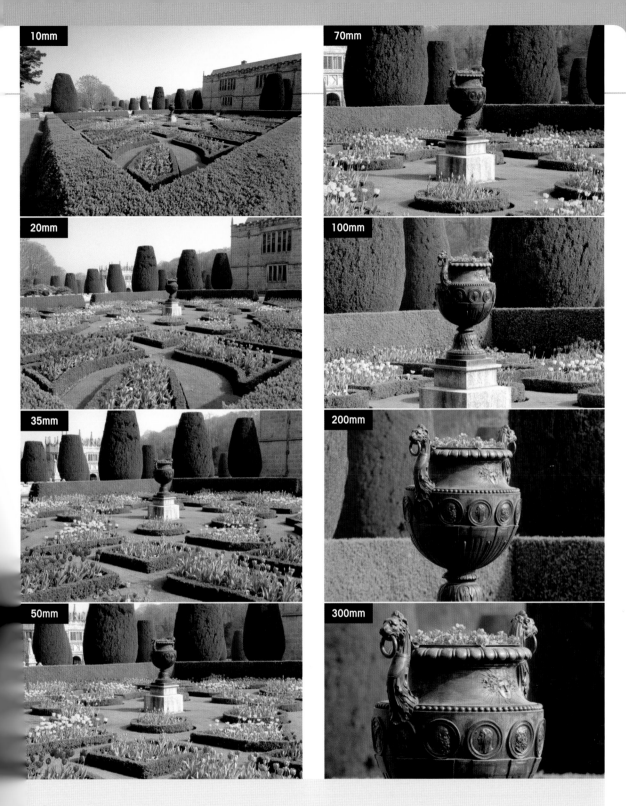

∧ **Focal length.** This simple focal length comparison sequence helps illustrate the impact focal length can have on a scene or subject. The images were all taken from the same shooting position – only the focal length changed.

LENSES AND SENSORS

AT THE HUB OF A DSLR IS ITS IMAGE SENSOR. SENSORS ARE SILICON CHIPS, WITH MILLIONS OF PHOTOSENSITIVE DIODES ON THEIR SURFACE – CALLED PHOTOSITES – EACH OF WHICH CAPTURES A SINGLE PIXEL. EACH DIODE READS THE QUANTITY OF LIGHT STRIKING IT DURING EXPOSURE. THIS IS THEN COUNTED AND CONVERTED INTO A DIGITAL NUMBER, REPRESENTING THE PIXEL'S BRIGHTNESS AND COLOUR. THIS DATA IS THEN CONVERTED INTO AN ELECTRICAL SIGNAL AND THE CHARGES ARE PROCESSED TO RECONSTRUCT THE IMAGE.

Sensors

The most common types of sensor design found in DSLRs are Charge Coupled Device (CCD) and Complementary Metal Oxide Semiconductor (CMOS). Both sensor types accomplish the same task of capturing light and converting it into electrical signals. While neither technology has a clear advantage in terms of image quality, a CMOS design can be implemented with fewer components, employs less power and provides data faster than a CCD. Not only does a camera's image sensor dictate resolution, but the size of the sensor format also alters the magnification of the lens attached. Therefore, the sensor type employed in your camera has a significant effect on your lens's effective focal length.

It is incredible to think that, each time you take a digital photo, your camera quite literally makes millions of calculations in order to capture, filter, interpolate, compress,

∧ **Image sensor.**
At the heart of a digital camera is its sensor. It is this technology that dictates the image's resolution and whether or not there is a focal length multiplication factor. This is the 24.6 megapixel, full-frame CMOS sensor found in the Sony Alpha 900. Full frame DSLRs do not have a 'crop factor', so the focal length of the lens attached is unaltered.

store, transfer and display the image. All these calculations are performed in-camera by a processor – similar to the one employed in your desktop computer, but dedicated to the task. However, it is the sensor itself that dictates the camera's resolution and image quality. The vast majority of DSLRs boast a resolution in excess of 10 million pixels – with one million pixels being equivalent to a megapixel. They are produced in a variety of sizes and, generally speaking, the bigger the sensor, the higher quality the resulting image will be. So-called point and shoot compacts employ the smallest chips, while medium format digital cameras boast the largest. There are three different types of sensor commonly employed in DSLRs: full-frame, cropped-type and four-thirds.

Full-frame sensors

The 35mm film format has remained popular and relatively unchanged since its inception in the late 19th century – it remains the standard we refer to in this digital age. A full-frame camera is one that incorporates an image sensor the same size as a traditional 35mm negative – 36x24mm. Because it is cheaper to manufacturer smaller sensor sizes, full-frame chips are normally only found in high-specification models – like the Nikon range of FX format DSLRs. However, full-frame cameras are steadily growing more affordable.

Full-frame DSLRs have no 'crop factor', so the attached lens will produce exactly the same field of view and degree of magnification as if it would on a 35mm film camera. Not only do full-frame sensors offer higher image quality – larger photosites capture more light with less noise, so images are smoother, more detailed and sharper – but they don't alter the original characteristics of the lens. For example, the wide field of view of a 28mm wideangle lens is maintained. As a result, full-frame cameras are particularly popular among landscape photographers.

Comparative sizes of sensors

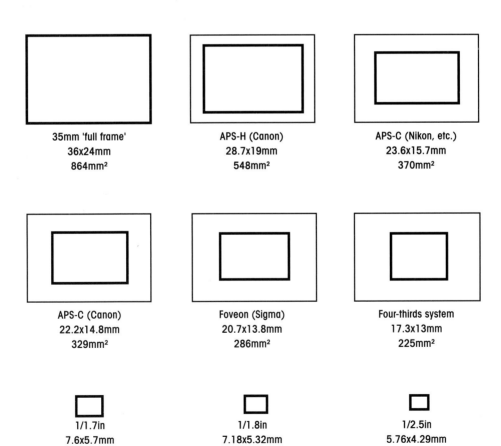

Medium format (Kodak KAF 3900 sensor)

35mm 'full frame'
36x24mm
864mm²

APS-H (Canon)
28.7x19mm
548mm²

APS-C (Nikon, etc.)
23.6x15.7mm
370mm²

APS-C (Canon)
22.2x14.8mm
329mm²

Foveon (Sigma)
20.7x13.8mm
286mm²

Four-thirds system
17.3x13mm
225mm²

1/1.7in
7.6x5.7mm
43mm²

1/1.8in
7.18x5.32mm
38mm²

1/2.5in
5.76x4.29mm
25mm²

CROPPED-TYPE SENSORS

The vast majority of entry-level and consumer DSLRs employ an APS-C size sensor – smaller than the 35mm standard. This is equivalent in size to 'Advanced Photo System' images, which are 25.1x16.7mm. However, in practice, sensor size tends to range from 20.7x13.8mm to 28.7x19.1mm, depending on the make and model. This format is commonly regarded as a cropped-type image sensor as it creates the impression of multiplying the focal length of the lens attached due to its smaller size – known as its multiplication factor or focal length multiplier (FLM). This factor has to be applied to any attached lens in order to calculate its correct, equivalent focal length. The degree of multiplication depends on the exact size of the sensor, but typically it is a 1.5x. Therefore, a 200mm lens will effectively be 200x1.5 = 300mm, when attached to a camera with this type of cropped-type design. Depending on the subject you are photographing, this can prove either advantageous or disadvantageous. For example, traditional

> **Multiplication factor.** Cropped type sensors have a significant impact on focal length, effectively increasing the power of your interchangeable lenses. This is advantageous when photographing timid wildlife and distant subjects. The effect of using an APS-C size sensor, compared with a full-frame model, is obvious from the images opposite.

wideangle lenses lose their characteristic effect, meaning an even shorter focal length has to be employed to retain the same field of view. However, when photographing distant subjects, like sport, wildlife and action, the multiplication factor can be hugely beneficial and desirable.

FOUR-THIRDS SYSTEM

The four-thirds system gets its name from the CCD image sensor it employs. The size of the sensor is 18x13½mm (22½mm diagonal). Therefore, its area is 30–40 per cent less than the APS-C size image sensors found in the majority of other consumer DSLRs and its aspect ratio is 4:3 – squarer than a conventional frame, which has an aspect ratio of 3:2. It was devised by Olympus and Kodak with the intention to free manufacturers from the onus of providing compatibility with traditional camera and lens formats. The system has subsequently, been supported by Panasonic and Sigma. The diameter of its lens mount is approximately twice as big as the image circle, allowing more light to strike the sensor from straight ahead, thus ensuring sharp detail and accurate colour even at the periphery of the frame. The small sensor effectively multiplies the focal length by a factor of 2x, enabling manufacturers to produce more compact, lighter lenses. The four-thirds system is providing a growing challenge to more conventional systems.

> **Four-thirds.** Olympus was one of the pioneers of the four-thirds system. The aim of the system is to provide a standard that allows for the interchange of lenses and bodies from different manufactuers.

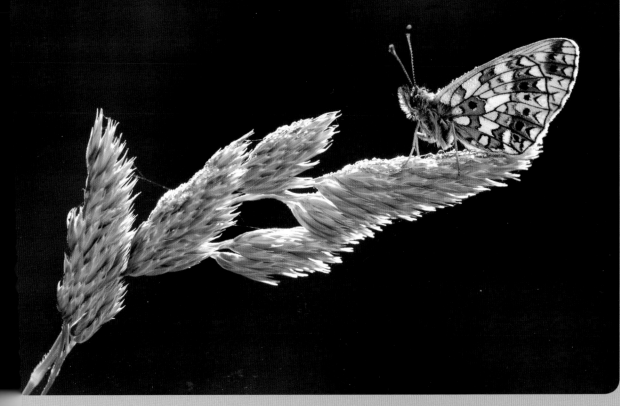

PERSPECTIVE

THE WORLD IS THREE DIMENSIONAL, YET PHOTOGRAPHS ONLY REPRESENT TWO DIMENSIONS. DESPITE THIS, OUR BRAIN RECOGNIZES THE ELEMENTS WITHIN AN IMAGE TO DETERMINE SCALE, DISTANCE AND DEPTH – OR, IN OTHER WORDS, PERSPECTIVE. THE APPEARANCE OF PERSPECTIVE IS DICTATED BY THE CAMERA-TO-SUBJECT DISTANCE AND, TO SOME EXTENT, FOCAL LENGTH (PAGE 20). AN UNDERSTANDING OF PERSPECTIVE IS IMPORTANT, ENABLING YOU TO CREATE, CONTROL AND MANIPULATE IT IN ORDER TO PRODUCE STRIKING COMPOSITIONS.

Perspective refers to the appearance of depth or spatial relationships between objects within an image. The human eye judges distance through the way elements within a scene diminish in size, and the angle at which lines and planes converge – for example, if you look down a railway line, our eyes perceive the tracks to meet at a distant point on the horizon. Perspective is a powerful compositional and visual tool, which photographers can utilize to create the impression of volume, space, depth and distance.

The more a photographer is able to control the transition from 3D to 2D, the more control they have over the look of the final image. Strictly speaking, perspective is controlled solely by the camera-to-subject distance. Moving further away will compress the appearance of foreground-to-background space (between given points), making subjects that are apart look closer together. Moving closer will exaggerate the foreground-to-background distance between certain elements; stretching the appearance of perspective and making foreground subjects look far larger and more dominant than those behind.

The reason why many photographers falsely believe that perspective is altered simply through focal length – for example, wideangles are generally thought to exaggerate perspective, whilst telephotos flatten it – is simple to explain. It is due to the fact that, in order to render a given subject exactly the same size in the frame using both short and long focal lengths, the photographer would be forced to move closer or further away from the subject, resulting in a shift in perspective.

However, lens choice clearly has a huge impact on the way perspective is recorded. For example, when using a short focal length to photograph a nearby subject, background objects appear further away from the main subject. This is because, when we focus closer, the distance between the lens and foreground and background objects changes proportionally. The closer object will appear bigger and more dominant in the frame, while the object further away will seem smaller – thus creating the effect of exaggerated perspective. In fact, using a short focal length, together with a close approach, is a popular technique – drawing attention to the main subject or creating a 'distorted' view of the scene. Similarly, using a telephoto lens doesn't actually compress perspective; it just creates that impression.

By using the right combination of camera-to-subject distance and lens focal length, a photographer can create a picture that looks deep or shallow. While the feeling of depth or shallowness may only be an illusion, it is an important visual tool.

LENS TIP

Shoot your own comparison sequence – maintaining the subject's size in the frame, but varying the camera-to-subject distance and, therefore focal length, with each subsequent frame. Doing so will help you to appreciate the affect of perspective... and its role.

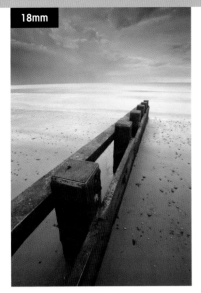

18mm

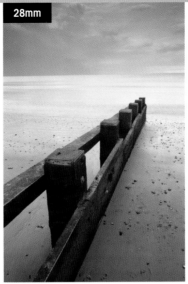

28mm

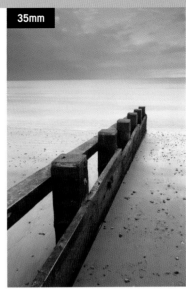

35mm

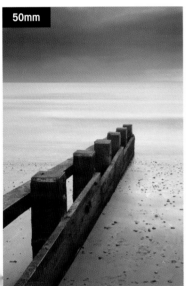

50mm

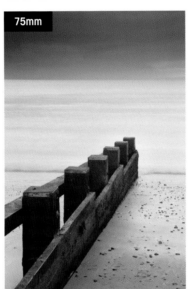

75mm

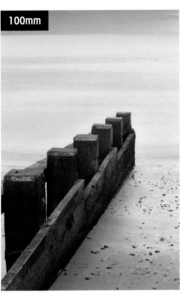

100mm

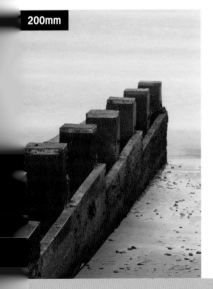

200mm

⋀ **Perspective and focal length.** Perspective is determined by the camera-to-subject distance and relates to the size and depth of subjects within the image space. Look at this sequence of images and you will notice that, although the size of the principal subject remains greatly unchanged, its appearance and relationship to the surroundings alters considerably.

THE HYPERFOCAL POINT

ALTHOUGH A LENS CAN ONLY PRECISELY FOCUS AT ONE DISTANCE, SHARPNESS DECREASES GRADUALLY ON EITHER SIDE OF THE POINT OF FOCUS. AS A RESULT, ANY REDUCTION IN SHARPNESS WITHIN THE AVAILABLE DEPTH OF FIELD IS IMPERCEPTIBLE UNDER NORMAL VIEWING CONDITIONS. DEPTH OF FIELD EXTENDS APPROXIMATELY ONE THIRD IN FRONT OF THE POINT OF FOCUS AND TWO THIRDS BEYOND IT. THE HYPERFOCAL DISTANCE IS THE POINT WHERE YOU CAN ACHIEVE MAXIMUM DEPTH OF FIELD FOR ANY GIVEN APERTURE. IDENTIFYING AND FOCUSING ON THIS POINT IS IMPORTANT WHEN YOU REQUIRE EXTENSIVE DEPTH OF FIELD – WHEN PHOTOGRAPHING LANDSCAPES, FOR EXAMPLE. WHEN A LENS IS FOCUSED ON THE HYPERFOCAL POINT, DEPTH OF FIELD EXTENDS FROM HALF THIS POINT TO INFINITY.

The hyperfocal distance depends on the focal length and lens aperture. Calculating this point is made far easier if your lens has a depth of field scale – simply align the infinity mark against the selected aperture. Unfortunately, manufacturers of many modern optics have disposed of this useful scale, meaning photographers have to calculate or estimate the distance.

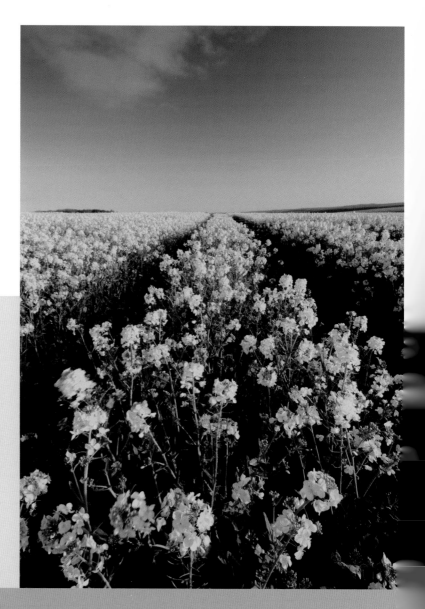

> **Hyperfocal focusing.** I took this image using a 12mm lens on a cropped-type camera with an aperture of f/16. Using the opposite chart, I knew the hyperfocal distance was approximately 1.7ft (52cm). I manually focused the lens at this distance and took the picture in the knowledge that everything from half this distance to infinity would be rendered acceptably sharp.

Nikon D300 with 12–24mm lens (at 12mm), ISO 100, 1/15sec at f/16, polarizer, tripod

There are a variety of depth of field calculators and hyperfocal charts, tables and equations available to download from the internet to help. However, when in the field, photographers often require a faster method. One way is to focus on infinity and then depress your camera's preview button. The closest point remaining in focus is the hyperfocal length. Adjust your focus to this point to maximize depth of field. However, for greater accuracy, here are two charts you can copy with the hyperfocal distance for a range of popular wideangle focal lengths – at various apertures, for both full-frame and cropped-type DSLRs.

Frustratingly, it can prove difficult focusing your lens to a specific distance, as many lenses have rather perfunctory distance scales – for example, a lens may only have 0.3m, 0.5m, one metre and infinity marked on their scale. As a result, a degree of guesswork may be required. However, it is not essential that hyperfocal focusing is exact – it just needs to be close to it. Therefore, if necessary, just make your best estimate of where the hyperfocal distance is from the camera position.

Allow margin for error, by focusing a little beyond the hyperfocal distance, and everything from at least half the focal point to infinity will be acceptably sharp in the final image. Many photographers don't bother calculating the distance at all, and simply focus approximately a third into the image – a rough, but quick method that, although far from exact, is still better than simply focusing on infinity.

> ⓥ These charts will help you to identify the hyperfocal distance, depending on sensor type, focal length and aperture. Once you have focused on the hyperfocal distance, do not adjust focal length or aperture – otherwise you will need to recalculate.

HYPERFOCAL DISTANCE: CROP SENSORS

Focal length

Aperture	12	15	17	20	24	28	35
f/8	3.2ft (98cm)	5ft (1.5m)	6.4ft (1.95m)	8.9ft (2.71m)	12.6ft (3.8m)	17ft (5.18m)	27ft (8.2m)
f/11	2.3ft (70cm)	3.5ft (1.07m)	4.5ft (1.37m)	6.2ft (1.88m)	9ft (2.74m)	12ft (3.65m)	19ft (5.79m)
f/16	1.7ft (51cm)	2.5ft (76cm)	3.3ft (1.05m)	4.4ft (1.34m)	6.4ft (1.95m)	8.6ft (2.62m)	14.5ft (4.42m)
f/22	1.2ft (37cm)	1.9ft (58cm)	2.3ft (70cm)	3.2ft (98cm)	4.5ft (1.37m)	6ft (1.82m)	9.5ft (2.9m)

HYPERFOCAL DISTANCE: FULL-FRAME SENSORS

Focal length

Aperture	16	20	24	28	35
f/8	3.8ft (1.16m)	5.6ft (1.7m)	8ft (2.43m)	11ft (3.35m)	17ft (5.18m)
f/11	2.6ft (79cm)	3.9ft (1.19m)	5.8ft (1.77m)	7.8ft (2.38m)	12ft (3.65m)
f/16	1.9ft (58cm)	2.9ft (88cm)	4ft (1.22m)	5.5ft (1.67m)	8.5ft (2.6m)
f/22	0.4ft (12cm)	2ft (61cm)	2.9ft (88cm)	3.9ft (1.18m)	6ft (1.82m)

APERTURES AND DEPTH OF FIELD

INTERCHANGEABLE DSLR LENSES ARE DESIGNED WITH AN APERTURE; A TERM RELATING TO THE IRIS DIAPHRAGM. THE IRIS CONSISTS OF A NUMBER OF THIN BLADES THAT CAN BE ADJUSTED INWARD OR OUTWARD TO VARY THE SIZE OF THE NEAR-CIRCULAR HOLE – THE APERTURE OR F-STOP – THROUGH WHICH LIGHT PASSES TO FORM AN IMAGE ON THE SENSOR. SIMILARLY TO THE WAY THE PUPIL OF AN EYE WILL CONTRACT OR ENLARGE DEPENDING ON THE LEVEL OF LIGHT, BY ALTERING THE APERTURE PHOTOGRAPHERS CAN VARY THE AMOUNT OF LIGHT ENTERING AND PASSING THROUGH THE LENS.

The aperture is one of the major controlling variables of exposure – along with shutter speed and ISO sensitivity. Depth of field is dictated by the lens aperture, so a good understanding of how the selected f-stop will affect the final image is essential.

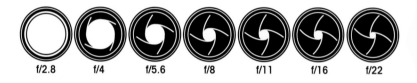

f/2.8 f/4 f/5.6 f/8 f/11 f/16 f/22

∧ **Lens aperture.** This graphic helps illustrate how the size of the aperture varies at different f/stops.

Understanding f-numbers

Lens apertures are stated in numbers – or f-stops. Typically, this scale ranges from f/2 to f/32. However, this range will depend on the lens itself, with some having more or fewer settings. The standards for aperture are f/2.8, f/4, f/5.6, f/8, f/11, f/16, f/22 and f/32.

The f-numbers stated above refer to whole-stop adjustments. However, modern DSLRs also allow photographers to alter aperture size in ½ and ⅓-stop increments, allowing for more precision over exposure.

The f-number relates to a fraction of the focal length. For example, f/2 indicates that the diameter of the aperture is half the focal length; f/4 is a quarter; f/8 is an eighth and so on. With a 50mm lens, the diameter at f/2 would be 25mm; at f/4 it is 12.5mm and so forth.

A lens's aperture range is often referred to by its maximum and minimum settings. The maximum – or fastest – aperture relates to the widest setting of the lens iris; while closing it down to its smallest setting – allowing the least amount of light through – is the minimum aperture. Many zooms have two maximum apertures listed, for example 55–200mm f/4–5.6. This indicates that the lens's maximum aperture changes as you alter focal length.

F-numbers can cause confusion. This is due to the way in which a large (wide) aperture is represented by a low number, for example f/2.8 or f/4; and a small f-stop – when the aperture is closed down – is indicated by a large figure, like f/22 or f/32. This may appear to be the opposite way round to what you would imagine. Therefore – to help you remember which value is bigger or

smaller – it can be helpful to think of f-numbers in terms of fractions – for example, ⅛ (f/8) is smaller than ¼ (f/4).

Lens aperture has a reciprocal relationship with shutter speed, as adjusting the size of the aperture alters the speed at which sufficient light can pass through the lens to expose the sensor. In other words, select a large

LENS TIP

'Stopping down' is a common term in photography, referring to reducing the light entering the lens by decreasing the size of the aperture. For example, by altering the f-stop from f/8 to f/11, you are effectively 'stopping down' the lens by one stop.

DEPTH OF FIELD

Depth of field is an important creative tool. A large aperture, like f/2.8 or f/4, will create a narrow depth of field. This can be helpful to throw background and foreground detail quickly out of focus, reducing the impact of any distracting elements within the frame and placing emphasis on your subject or point of focus – ideal for action, portraits and close-ups. However, if the aperture is too large, it may not provide sufficient back-to-front sharpness to keep your subject in acceptable focus.

By selecting a small aperture, like f/16 or f/22, depth of field will be extensive. This helps photographers capture good detail throughout the shot, so is particularly well suited to scenic photography, where you normally require everything – from the foreground to infinity – to be in focus.

Lens aperture is the overriding control dictating the level of depth of field achieved. However, it is also affected by the focal length of the lens; the subject-to-camera distance and the point of focus. This is useful to know in situations where you want to maximize the zone of sharpness without altering the f-number. For example, longer focal lengths produce a more restricted depth of field than a shorter lens. The distance between the camera and the object being photographed also has a bearing on depth of field – the closer you are to the subject, the less depth of field you will obtain in the final image. This is one of the reasons why it can prove so challenging to achieve sufficient depth of field when shooting close-ups. Finally, the exact point at which you focus the lens will affect where depth of field falls in the final image. Depth of field extends from approximately one third in front of the point of focus to roughly two thirds behind it, so if you focus on – or near to – infinity, the part of the zone falling beyond the point of focus will be wasted.

< **Depth of field.** This comparison sequence helps illustrate how different f-stops affect depth of field and also the way in which a subject is recorded.

aperture (small number) and light can pass quickly, so the corresponding shutter speed is faster; select a small aperture (large number) and the exposure will take longer, resulting in a slower shutter speed. This has a significant visual effect, with the shutter speed affecting how motion is recorded and the aperture determining the area in your image which is recorded in sharp focus. This zone is known as depth of field.

AUTO AND MANUAL FOCUSING

IN ORDER TO CAPTURE SHARP IMAGES, A CAMERA LENS HAS TO BE PRECISELY FOCUSED. THIS IS THE POINT AT WHICH THE IMAGE OF AN OBJECT, CAST ONTO THE SENSOR BY AN OPTICAL SYSTEM, IS PROPERLY DEFINED AND SUBJECT DETAIL APPEARS CLEARLY. AN OUT-OF-FOCUS SUBJECT WILL LOOK SOFT OR BLURRED, RUINING THE IMAGE. ACHIEVING FOCUS CAN BE OBTAINED IN TWO WAYS; EITHER MANUALLY, BY THE PHOTOGRAPHER TURNING THE LENS-FOCUSING RING TO FOCUS THE LENS FOR A SPECIFIC DISTANCE; OR VIA AUTOFOCUS, WHICH RELIES ON SENSORS TO DETERMINE THE CORRECT FOCUS. BOTH FORMS OF FOCUSING ARE USEFUL, BEING SUITED TO DIFFERENT SITUATIONS. THEREFORE, MY ADVICE IS NOT TO RELY SOLELY ON EITHER, BUT INSTEAD SELECT THE TYPE OF FOCUSING BEST SUITED TO THE SUBJECT OR SITUATION.

Manual focus (MF)

Manual focus overrides the camera's built-in automatic system, enabling photographers to focus the lens by physically rotating the focusing ring – moving the lens elements in order to obtain a sharp image. Normally, it can be selected via a small lever near the lens barrel, via one of the camera's menus and/or via a MF/AF switch on the side of the lens itself.

If you are still new to digital SLR photography, you may be wondering why you would ever utilize manual focusing when your camera boasts a sophisticated autofocus system to do the hard work for you. While the latest AF systems are often reliable and fast, they are not infallible. For example, in low light or when the subject is very close or far away, your camera may struggle to focus accurately – searching back and forth for the subject and wasting valuable time. Also, if you are taking pictures through glass – from an aeroplane window, for instance – or shooting captive animals through fencing, you camera may get confused where to focus. In instances like this, manual focusing is a better option.

LENS TIP

AF systems work within a particular illumination range, so in low light, they can struggle to focus accurately. The camera's AF-assist beam should still enable accurate autofocusing, but if the camera is struggling switch to manual.

Your camera cannot predict your desired point of focus, either. For example, to utilize the full extent of the depth of field (page 31) available – for a given aperture – you may need to focus slightly in front or behind you subject. This is best done manually.

Manual gives you far greater control and pinpoint accuracy over focusing and, for certain subjects – like landscape and macro – it is preferable to focus manually if your eyesight will allow you to do so. With practice, it is possible to focus by hand with remarkable speed and precision and some photographers prefer to work manually at all times, even if the subject is moving. However, with the latest automatic systems boasting increased speed, versatility and accuracy, AF is normally the preferred focusing method when tracking fast movement, like sports, moving animals and flight.

Autofocus (AF)

Autofocus systems rely on electronics, sensors and motors to determine the correct focus. Most modern DSLRs utilize through-the-lens optical AF sensors, which also perform as lightmeters. Autofocusing is generally fast, accurate and quiet and achieved by simply depressing the shutter release button halfway. It is hardly surprising then, that it's the preferred type of focusing for the majority of photographers.

Most DSLR cameras utilize a 'passive' – or phase-detection – system (page 56). This determines the distance to the subject through passive analysis of the image entering the optical system – analyzing the scene and driving the lens

back and forth searching for the best focus. Passive autofocusing requires light and contrast in order to do its job efficiently. Therefore, if you try to take a picture of a large object of uniform colour – like a blank wall – the camera can struggle to achieve focus as it is unable to compare adjacent pixels. However, the majority of DSLRs have an AF-assist beam, which fires a patterned beam onto the subject to allow the AF system to still operate effectively. Unlike 'active' autofocusing – the system commonly utilized in compact cameras which employs an infrared beam to achieve focus – there is no distance-to-subject restriction with passive autofocus.

Autofocusing is an essential aid for photographers who have less than perfect eyesight. Also, many press, sports and wildlife photographers rely heavily on the accuracy of modern AF to help them achieve sharp images of moving subjects. AF is an integral part of modern lens design and autofocusing is growing increasingly more sophisticated. Many systems employ a multipoint system, with a number of selectable AF sensors. The increased area of coverage makes it easier for AF to lock onto the main subject and also enables photographers to focus on off-centre subjects. Many AF systems allow you to choose between leaving all the sensors active or selecting just individual points. There are also different AF-area modes and AF-focus modes – for example single-shot AF, which focuses just once, and Continuous AF, which continues to track moving subjects.

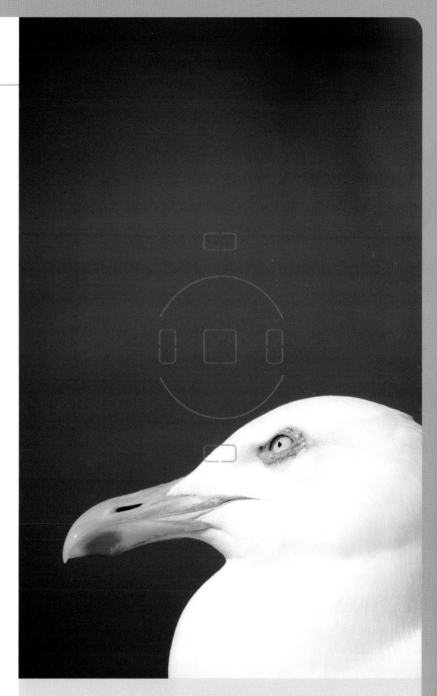

⋀ **Focus points.** Modern DSLRs have multipoint autofocusing systems – boasting a number of AF sensors – giving them extended coverage across the frame. Most multipoint systems allow the photographer to choose between leaving all the AF sensors active or selecting individual points. This enables sharp autofocusing even when the subject is off-centre.

Pentax K10D with 55–200mm lens (at 200mm), ISO 200, 1/800sec at f/5.6, handheld

CHOOSING A LENS

IT IS DIFFICULT OFFERING ADVICE ON CHOOSING A LENS. MUCH WILL DEPEND ON YOUR OWN PERSONAL BUDGET, DEMANDS, AND THE TYPE OF SUBJECTS YOU WANT TO PHOTOGRAPH. THE BEST GENERAL ADVICE I CAN GIVE YOU, IS TO BUY THE BEST OPTICS YOU CAN AFFORD. THIS MIGHT SEEM OBVIOUS, BUT IT IS SURPRISING JUST HOW MANY PEOPLE WILL BLOW THEIR BUDGET ON A CAMERA, AND THEN HAVE TO SCRIMP ON WHAT THEY SPEND ON ACCOMPANYING LENSES. DOING SO IS FALSE ECONOMY — WITHOUT GOOD-QUALITY GLASS, HOW CAN YOU REALIZE THE CAMERA'S FULL POTENTIAL?

WITH SO MANY DIFFERENT LENS TYPES AND BRANDS AVAILABLE, BUYING A LENS CAN FEEL LIKE A MINEFIELD. HOPEFULLY THIS GUIDE WILL ARM YOU WITH THE KNOWLEDGE TO HELP YOU MAKE THE RIGHT DECISIONS.

Which focal lengths do I need?

Only you can properly answer this. It will greatly depend on your requirements and the subjects you intend shooting. One of the great advantages of DSLR photography is that you are not restricted to just one focal range — you can add different focal lengths and expand your system whenever you wish to. Ultimately, most photographers will build a system of several different lenses, covering a wide range of focal lengths. For example, I have optics ranging from 12mm (super wide) to 400mm (long telephoto). Unfortunately, the majority of us can't afford, or justify, buying three or four lenses at once — instead, build your system over several years, prioritizing in the first instance.

If you are new to DSLR photography, it is best to begin with a standard lens (pages 78–89). Most new cameras are sold with a short, standard zoom anyway. This is perfectly suited to day-to-day photography and the ideal lens type to build your system around. However, these kit lenses, as they are known, tend to be fairly basic, with a relatively slow maximum aperture and of average build and image quality. Therefore, in the long term, you may wish to replace your kit lens with a higher-quality version.

Unless you intend to photograph sports or action, there is no need to invest in a long, fast telephoto, which can prove very costly. However, most photographers will want to shoot distant subjects or capture frame-filling images. Therefore, some sort of telephoto (page 90–103) is a good lens to invest in next. An excellent option is a tele-zoom, covering a range of around 70–300mm. This is a versatile focal range that will prove useful to photograph all number of subjects. If you can only justify buying two lenses, a standard zoom, and tele-zoom are the most practical, useful options. Together they cover a broad range from 35mm (short) to 300mm (long) – thus enabling you to capture most subjects.

V Which lens? Buying a lens can be a big investment, so you don't want to make the wrong choice. This lens guide should help you to decide which focal lengths are personally suited to you, and whether a zoom or prime lens would be best. Ultimately, which lens – or lenses – you buy will depend on your budget and requirements. For example, if you enjoy shooting wildlife, a telephoto or tele-zoom will probably be your priority.

Nikon D300 with 70–300mm lens (at 200mm), ISO 200, 1/125sec at f/4, handheld

Lens choice. A huge variety of focal lengths is available. However, for the majority of DSLR photographers, two or three different focal lengths are all they ever require. Base your purchases on your personal requirements and the subjects you enjoy shooting.

LENS TIP

When you are looking to add a lens to your system, don't overlook buying second-hand. Doing so can either save you money, or allow you to buy a better lens for the same outlay. As long as the optics are perfect, a little wear on the barrel or focusing ring is just aesthetic. Most camera shops will offer a three- or six-month warranty on used equipment.

However, a wideangle lens (pages 66–77) is a great addition to any photographer's kit bag – particularly if you like shooting landscapes – so make this your next priority.

Once you own these core focal lengths, you might want to expand your camera's capabilities further, by buying a specialist lens (page 104–117).

Should I buy prime or zoom lenses?

Again, there is no simple, categorical answer – your decision needs to be based on your budget and needs. On pages 16 to 19 we looked at the merits of prime and zoom lenses. Zooms offer greater versatility, but prime focal lengths typically have the edge in terms of speed and image quality. Like many photographers, I have a hybrid system of zoom and prime lenses. Due to their flexible, adjustable range, zooms are more popular and will help make your budget go further. A zoom is certainly the best choice if you can only afford, or carry, one lens. They are well suited to travel photographers, or when you are walking long distances and need to travel light. In situations like this, the portability of a 'one lens does all' zoom – like an 18–200mm lens – can prove a good, practical choice.

However, prime lenses are usually optically superior and often boast a faster maximum aperture. Their fixed focal length may seem restrictive, but in practice this will make you work harder and think more about composition and viewpoint – rather than lazily zoom in and out from one position. Therefore, prime lenses still have a place in your camera bag and enthusiast photographers, building a larger system of lenses, will want to invest in at least one or two

high-quality fixed focal lengths. Before you buy, carefully consider what you expect from the lens and what your priorities are – let the answers help dictate your decisions.

Independent lens brands

Each camera manufacturer produces a wide range of dedicated lenses to fit its DSLR bodies. Manufacturers will naturally recommend you invest in their lens range, but they can prove more costly than third-party brands. Therefore, if budget is an issue, don't overlook independent makers, like Sigma, Tamron and Tokina. Today, the build and optical quality of their lenses can often rival that of the camera manufacturer, yet they typically cost less. The majority of independently made lenses boast full compatibility with the camera's automatic functions (although it is always wise to check before buying) and all the leading brands produce them in the most popular camera mounts fits – including the four-thirds system.

Buying lenses made by a third-party brand shouldn't be considered a compromise and it is an excellent way of maximizing your budget.

Independent brands. The optics of independent lens brands, like Sigma, Tamron and Tokina, are excellent and often comparable to that of the camera's manufacturer. Therefore, they shouldn't be overlooked, particularly if you are trying to maximize your budget.

OPTICAL QUALITY AND MTF CHARTS

BUYING A LENS IS AN IMPORTANT DECISION AND YOU WILL ALWAYS WANT TO BUY THE LENS BOASTING THE BEST OPTICAL QUALITY WITHIN YOUR BUDGET. EVERY PHOTOGRAPHER AT ONE TIME OR ANOTHER WILL FIND THEMSELVES DEBATING OVER WHICH LENS TO BUY. SO HOW DO YOU COMPARE ONE LENS WITH THE NEXT? READING EXPERT REVIEWS IN PHOTO MAGAZINES AND ONLINE IS USEFUL, BUT ONE OF THE BEST WAYS IS TO VIEW A LENS'S MODULATION TRANSFER FUNCTION, OR MTF CHART. THIS IS A GRAPH WHICH ANALYZES A LENS'S ABILITY TO RESOLVE SHARP DETAILS IN VERY FINE SETS OF PARALLEL LINES, AND A LENS'S CONTRAST OR ABILITY TO PROVIDE A SHARP TRANSFER BETWEEN LIGHT AND DARK.

Modulation Transfer Function

The quality of a lens is known by its resolving power and the resolving power of the lens is dependent on its ability to transmit contrast. Although the title might seem daunting and technical, Modulation Transfer Function charts are relatively easy to understand and give photographers an insight into a lens's optical capabilities. 'Modulation' refers to the process of modifying the signal. Ideally a lens should transmit all the light it receives, but no lens is perfect and the light passing through the optics is affected by the lens. Therefore, the lens is said to modulate the light. Modulation Transfer Function is a measure of the modulation by the lens and the MTF chart is the pictorial representation of this.

A lens is evaluated by looking at how well it transmits evenly spaced lines of black and white; this is measured in 'line pairs per millimetre' (lp/mm). As these lines grow more tightly spaced, the 'noise' between them blurs the edges, making black lines appear dark grey and white lines light grey to the lens. As the lines get closer together, the lens may not distinguish them tonally, and the lens 'sees' one undifferentiated tone of grey. This ability on the part of the lens, charted graphically, is what MTF charts represent.

To explain this more simply, think of a 1mm-wide strip of white paper with 50 parallel black lines drawn on it. The space between the black lines automatically appear like white lines, so effectively there are 50 black and 50 white lines on the paper, making a total of 100 lines. The thickness of each line is 1/100 of a millimetre or 0.01mm. The lens is now tested on how well it captures these lines – will they be rendered as distinct lines, or will they be a hazy mix? In order for a lens to resolve these into distinct black and white lines, it needs to transmit the contrast. So the quality of the lens depends on the amount of contrast the lens modulates. The less the modulation, the better the contrast is transmitted and, as a result, the better the picture quality will be.

Interpreting MTF charts

Being able to understand MTF charts will help you to make the right decision when buying a lens. Opposite is an example of a typical chart.

The vertical axis is from 0 to 1 – or 0 to 100% – and represents the contrast transmitting capability. For example, a value of 0.95 on the vertical axis would mean the lens is able to transmit 95 per cent of the contrast.

The horizontal axis is in millimetres and represents the distance from the centre. With a 35mm frame, the maximum distance from centre is approximately 21mm. A value of 10mm on the horizontal axis refers to points which are 10mm away from the image centre. By knowing this, and looking at the example graph opposite, you can tell that the corresponding lens is better at the centre than it is towards the edges of the frame.

Different manufacturers present their MTF charts slightly differently, but typically they consist of two sets of paired lines. A pair consists of one solid and one dotted line – one representing the Meridonial line and the other the Sagittal line. One pair of lines represents the results for tests done at high resolution (for example, 100 lines per mm) and the other pair for tests done at low resolution (30 lines per mm, for instance). The high-resolution results relate to the resolving power of the lens; while the low-resolution test results signify its contrast transmitting ability.

With this understanding, interpretation of MTF charts is relatively simple. Basically, the higher on the chart the pair of lines for low resolution are, the better the lens is at reproducing contrast. The higher up the chart the pair of lines for high resolution are, the better the lens's resolution.

Ⓥ **Reading MTF charts.** This is the corresponding MTF chart for Sigma's 24mm wideangle lens. Reading the graph, you learn that both the lens's resolving power and contrast-transmitting ability is excellent at the centre of the frame. However, they begin to steeply fall away towards the edges.

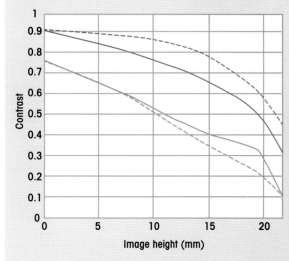

The less the lines fall with distance from centre, the better the image quality is towards the frame's edges. The closer together the solid and the dotted lines are the more pleasing the out of focus areas – or bokeh – will be. Zooms have two MTP charts, representing either end of their focal range.

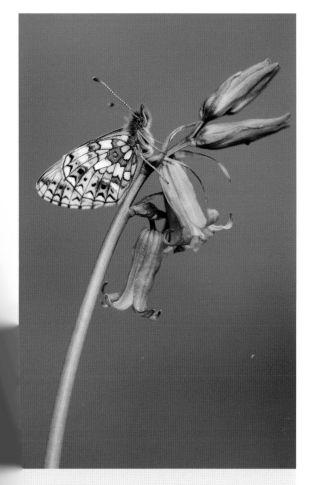

Ⓐ **Image quality.** Having invested money in a high-quality DSLR, you require lenses that are going to ensure your images are crisp and bitingly sharp. MTF charts are a useful resource that will help ensure you buy the best optics within your budget.

Nikon D300 with 150mm lens, ISO 200, 1/80sec at f/4, tripod

LENS TIP

You can view a lens's MTF chart in the manufacturer's publicity brochures and on the brand's website. By comparing optical performance, you will be able to decide which lens, from your shortlist, is the best buy.

LENS CARE

BUYING A LENS REPRESENTS A SIGNIFICANT INVESTMENT, NOT JUST FINANCIALLY, BUT IN THE IMAGE QUALITY OF YOUR PHOTOGRAPHS. THEREFORE, IT'S LOGICAL THAT YOU SHOULD WANT TO PROTECT YOUR INVESTMENT BY HANDLING AND TREATING YOUR OPTICS WITH CARE. BY MOUNTING, CARRYING, CLEANING AND STORING YOUR LENSES WELL, YOU WILL HELP ENSURE OPTIMUM PERFORMANCE AND LONG LIFE.

Mounting

In order to alter focal length and lens type, DSLR users are regularly required to change lenses. Doing so is simple and straightforward. Even if you are new to using a DSLR, it won't be long before you can change lens quickly and instinctively. However, it is worth remembering that the contacts on the lens, and bayonet mount of the camera, are delicate components and that careful alignment is important to ensure they are not damaged. Whenever you attach a lens, check that the camera is switched off first and keep the mounting mark on the lens aligned with the mounting mark on the camera body. Position the lens in the camera's bayonet mount and rotate until it clicks securely into place. Whether you need to rotate the lens clockwise or counter-clockwise to attach, will depend on the make of the camera – if you are unsure, check your user's manual first.

By mounting your lenses with care, you will minimize wear and eliminate the risk of damage. However, it is inevitable that both camera and lens mounts will grow dirty over time. If the contacts are dirty, automatic features like auto-focusing may be affected. To clean, gently wipe the mount using a soft, dry lens cloth.

Cleaning

The lens is the 'eye' of your camera, so if it is dirty, marked or scratched, image quality will be degraded. Dust and dirt settling on the front element of the lens is an ongoing challenge for photographers. While you shouldn't clean optics more than is necessary, it is important to keep them clean. Otherwise, image quality will be affected and the risk of lens flare enhanced. In the first instance, use a 'blower', or soft photographic brush to remove any loose particles of dust and dirt – using a cloth, you can unwittingly rub grit or tiny, hard particles across the lens. To remove smears or fingerprints, use a dedicated micro-fibre lens cloth, using gentle, circular motions to clean the lens. Photographic wipes and lint-free tissues are also available. For stubborn marks, you might require a cleaning fluid. Only buy solutions intended for photographic lenses and – unless the instructions say otherwise – apply it to the cleaning cloth, not the lens itself. Never attempt to clean using ammonia or other household cleaning solutions – permanent damage may result. When cleaning, don't overlook brushing the rear of the lens – dust on the rear element can fall into the camera body and settle on the sensor, causing marks on the final image.

One of the best ways to protect your delicate optics is to keep a clear filter, like a UV or skylight, attached to the front element at all times (page 129). After all, a scratched or damaged lens is irreparable and costly, while a filter is comparatively cheap to replace. Finally, remember to keep the rear and front caps on whenever the lens isn't in use, to protect the optics from dust, dirt and damage.

LENS TIP

Invest in a dedicated camera bag or backpack – designed to protect your equipment while you are carrying it, or during transportation. The compartments are padded to help protect optics from shocks or impact and it will also help keep them clean and moisture-free. Billingham, Lowepro and Tamrac are among the leading brands.

 Lenspen. Dedicated accessories, such as the Lenspen by Hama, are intended to help you care for your optics. It boasts a retractable soft bristle brush, designed to remove dust and dirt. Then, using its unique tip, which flexes in order to follow the contours of the lens, you apply the cleaning compound. By applying gentle pressure on the lens and using smooth circular motions, smudges are safely removed.

 Lens storage. Most lenses are supplied with a fitted, protective case – ideal for safely storing the lens should it not be required for a prolonged period. Alternatively, there is a wide range of lens pouches available to buy, which range in size to suit the focal length.

Storage

If you do not intend using a lens – or lenses – for an extended period of time, it is important to store them well. If the lens was supplied together with a fitted, protective carry case, this will prove one of the safest places. Store the lens along with a sachet of silica gel, to keep moisture at bay. Alternatively, store optics in airtight, plastic or aluminium containers, protected in a lens wrap, pouch or sleeve (page 120). Again, silica is a cheap way to ensure your lenses stay free of moisture. Keep optics in a dry, cool environment – humidity can prove damaging, enhancing the risk of fungus and mould. Lastly, keep equipment stored above ground level – this will prevent the risk of water damage should there be a leak or flooding.

 Lens pouch. Many lenses are supplied with some type of lens pouch or soft case, designed to protect the lens whilst being transported or stored. Being lightweight, pouches can also be used to offer lenses extra protection within your camera bag.

LENS TIP

A sudden change in temperature can lead to condensation – for example, if you take a lens from a cool, air-conditioned room into humidity. Condensation can prove problematic and encourage mould or fungus. To prevent this, place the lens in a plastic bag along with a sachet of silica gel and seal. The condensation will form on the bag and not the lens. Allow the bag to reach the ambient temperature before removing and using the lens.

LENS CRAFT

REGARDLESS OF THE FOCAL LENGTH YOU ARE USING, IT IS IMPORTANT TO HOLD OR SUPPORT YOUR SET-UP WELL. FAIL TO DO SO AND YOUR PICTURES ARE LIKELY TO SUFFER FROM INCORRECT OR POOR FRAMING, OR CAMERA SHAKE. BOTH PROBLEMS GROW MORE LIKELY THE NARROWER THE LENS'S ANGLE OF VIEW. THANKFULLY SUCH PROBLEMS NEEDN'T BE A WORRY IF YOU LEARN TO HOLD YOUR CAMERA WELL, OR UTILIZE ONE OF THE DIFFERENT TYPES OF CAMERA SUPPORT AVAILABLE TO PHOTOGRAPHERS.

Handholding

Using a support isn't always practical or convenient. Also, some photographers simply prefer the freedom and manoeuvrability of shooting handheld. However, when doing so, its important to hold the camera well to maximize stability and reduce the risk of shaky images at slow shutter speeds.

When taking pictures from a normal standing position, photographers should place their feet shoulder-width apart with one slightly in front of the other. Keep your elbows in to your chest and hold the camera firmly to your face. Hold the set-up with both hands, supporting the lens from underneath, and gently squeeze the shutter release button. When possible, brace yourself against something sturdy – a tree, fence or the side of a building, for instance.

When appropriate, kneeling is more stable than standing. Press your elbows against your body and your camera firmly against your face to minimize movement.

For some subjects, like mammals, flora, amphibians and reptiles, a prone position will create the most natural-looking results. A prone position can also be good for producing images with an unusual, low perspective. Lying flat on the ground limits body movement, so it is a stable position when working without a support – using a beanbag will limit movement even further.

Monopod

A monopod is a simple camera support with a single leg. You attach the camera either via a head or directly to a screw thread. They normally have two or three sections and, once it is adjusted to the height you require, you are ready to begin taking pictures – without any of the fuss associated with positioning the legs of a tripod. Although they are unable to offer the same level of stability as a tripod, they are an excellent compromise. They offer far more freedom

Monopod. A monopod is preferable to shooting handheld and offers good support, but it can't match the stability of three legs.

LENS TIP

Live View is a useful camera function, but its best not to use this facility to compose images when handholding your DSLR. Doing so involves holding the camera at arm's length, which exaggerates your natural movement. As a result, the likelihood of shake, or poor composition, is greatly increased.

and manoeuvrability than a tripod, making them a popular choice for sports and nature photographers using long telephotos. They are relatively lightweight and can be strapped to the side of a camera backpack. Some are even designed to work as a walking stick, for hill walkers who also enjoy taking pictures.

Tripods

Without doubt, the most stable and reliable form of support is a tripod. However, it is also the least convenient, being large and often relatively heavy. Not only will a good tripod eliminate the risk of shake at slow shutter speeds and when using long focal lengths, but it also assists with precise framing and focusing.

There are a vast number of different models and designs on the market and the leading brands – like Benbo, Giottos, Gitzo, Manfrotto, Slik and Velbon – produce supports to cater for all types of photographer, from the casual to professional user. If you wish to improve your images, than buy a good tripod – that is how important they are.

When buying a tripod, your choice will be partly dictated by budget and the types of subject you will be using it for. For example, if you enjoy close-up photography, you will need a support that can be adjusted to almost any position – Benbo tripods are renowned for their flexibility. However, for general photography a more traditional design is best.

Next consider weight. This needs to be considered from two perspectives. If it is too lightweight, its usefulness will be limited. It won't be able to support a heavy set-up, or long lenses, and will be more susceptible to movement or being knocked over. A heavier tripod is preferable. It will offer excellent stability and support and is essential for users of heavier and longer lenses. Unfortunately, sturdy also equates to heavy, which can be a problem if you need to carry the tripod long distances. An alternative is to buy a tripod made of carbon-fibre, which offers good stability despite being lighter. They are pricier than aluminium legs, but a good long-term investment.

Before buying, also consider height. Tripods are normally designed with either three or four adjustable leg sections. Buy a support that will extend to a height you are comfortable using – you don't want to be forever bending over to peer through the viewfinder. Due to the choice of different designs, weights, heights and the material, if possible, test the tripod in the shop before buying.

Tripod legs. A tripod will improve your photographs – it is a simple fact. They not only provide stability, but also allow photographers to precisely compose their images. Buy the heaviest, most stable legs that you can still carry comfortably.

Tripod heads

Although budget models are typically an 'all-in-one' design, with tripod head and legs fixed together, good tripods have a detachable head, making them compatible with an array of different heads. Although tripods are available in kit form, it is best to buy legs and head separately in order to select the type of head you prefer using. While the choice and range of designs can seem daunting, most are simply a variation on either a traditional pan-and-tilt head or a ball-and-socket design. A ball-and-socket head allows you to smoothly rotate the camera around a sphere and then lock it into the position of your choosing. A pan-and-tilt design offers three separate axes of movement: left–right tilt, forward–back tilt and horizontal panning. Again, try before you buy to ensure you purchase the type of head you are most comfortable using and that best suits your needs.

LENS TIP

Always extend the legs fully, before raising the centre column – extending the column can compromise the tripod's stability, particularly if it is breezy. If your tripod has a hook from which to hang a weight, like your camera bag, use it to maximize stability.

The best tripod heads are designed with a quick release plate. This plate secures directly to the camera – via its screw thread/tripod bush – and snaps on and off the tripod head to allow photographers to attach and detach their set-up quickly and easily.

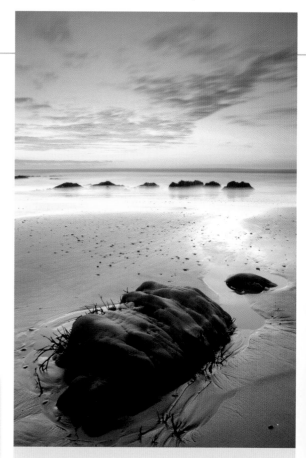

△ **Long exposure.** Using a long exposure – of several seconds or more – is a popular technique used in order to create the impression of movement. Such images are impossible to achieve without the help of a sturdy tripod.

Nikon D3X with 24–85mm lens (at 24mm), ISO 50, 10 seconds at f/20, ND grad, tripod

▷ **Tripod heads.** The type of tripod head you opt for is a matter of personal preference. Many photographers like a three-way pan-and-tilt design, but the ball-and-socket head is also popular.

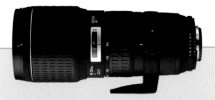

^ Tripod collar. Many longer, heavier telephoto lenses are designed with a dedicated tripod collar, aimed at balancing the weight of your set-up more evenly. This increases stability and reduces the pressure on the lens mount.

Tripod collars

A tripod collar is a ring attachment that fits around the base of, typically, large (telephoto) lenses and which is designed with a 'foot' with a tripod mounting screw socket. This type of attachment is only necessary when using long, heavy optics that – when attached to your DSLR – will have a centre of gravity beyond that of the camera body. By attaching the camera directly to the tripod, the weight and length of the lens puts strain on the lens mount and also increases the risk of movement. The solution is to put the tripod-mounting socket on the lens itself, to create a better balance. This is achieved via a dedicated tripod collar. This is held in place via friction and an adjustable screw, permitting the photographer to conveniently rotate the ring for shooting in either portrait or landscape format. Lenses that require a tripod collar are normally supplied with one by the manufacturer.

Beanbag

Beanbags, designed specifically for photography, offer excellent support for your camera set-up. Rested on a stable surface – like a wall, car roof or placed on the ground – a beanbag gives good, overall stability. The bag's filling naturally shapes around the camera and lens and absorbs the majority of movement. They are particularly well suited to nature photographers using long telephotos. They are cheap, simple to use and, in the right situation, the most practical type of lens support.

There are a couple of different designs on the market, including the 'Grippa bag'. The 'H' shape of is design allows it to grip a door – with window down – without sagging or losing its shape and usefulness. This is perfect for wildlife photographers using their car as a hide while photographing birds and mammals from a vehicle – for example, during a safari.

GORILLAPODS

Carrying a weighty tripod around might not be fun, but a camera support is often essential for stability. However, what do you do when it is not practical or convenient to carry one – for example, when walking a long distance – but you still need to support your camera. One alternative is a Joby Gorillapod.

Gorillapods are different to any other camera support. They have short bendable, gripping legs that can either be stood up or – for elevation – be wrapped around a post or fence. They are available in a range of sizes. The 'Focus' is the strongest member of the family and best suited to supporting a DSLR set-up. This version boasts aluminium sockets with an anodized gunmetal finish, designed to offer excellent flexibility while ensuring a solid, safe hold that you will be able to trust with your valuable camera. Rubberized ring and foot grips provide extra gripping ability and it can support a weight of up to 5kg – despite only being 11½in (29cm) in height and weighing just 500g.

While a Gorillapod couldn't be considered a replacement for a tripod, it is a good compromise in situations when carrying a traditional support isn't possible. Due to its small size, the viewpoints from which you can take photographs are somewhat limited, but being so compact a Gorillapod can be slipped into a camera bag or rucksack and carried around without fuss and without adding significant extra weight to your load.

< Gorillapod. The trademark bendable, grippy legs of the Gorillapod can be positioned in an infinite number of ways, or wrapped around something. While they might lack the elevation of a normal tripod, they are lightweight, adaptable and extremely convenient.

2 MODERN LENS TECHNOLOGY

Digital SLR photographers need to be familiar with lens anatomy and design in order to realize their optics' full potential. Doing so will help you use your lenses intuitively – important in situations when you need to be able to react quickly to changes in light or subject movement. Practically every lens suffers from some type of aberration – being aware of common lens flaws, and how to minimize their effect, is also important. This chapter is designed to arm you with the knowledge you need.

INTRODUCTION

A CAMERA LENS WORKS VERY MUCH LIKE THE HUMAN EYE. IT 'SEES' AN IMAGE, FOCUSES IT AND THAN TRANSMITS ITS BRIGHTNESS, COLOURS AND SHARPNESS TO THE DIGITAL SENSOR WHICH – LIKE THE HUMAN BRAIN – RECORDS IT TO MEMORY. THE PRINCIPLE OF A LENS'S OPERATION REMAINS THE SAME AS WHEN THE VERY FIRST IMAGES WERE CAPTURED IN THE EARLY 19TH CENTURY. HOWEVER, THE TECHNOLOGY EMPLOYED IN THE CONSTRUCTION OF MODERN OPTICS IS FAR REMOVED FROM WHEN IT WAS FIRST CONCEIVED. THEN, LENSES DIDN'T EVEN BOAST AN APERTURE. TODAY, THEY ARE HIGHLY SOPHISTICATED, WITH RESPONSIVE FOCUSING TECHNOLOGY AND HIGHLY CORRECTED OPTICS.

Modern lens technology

This chapter begins by looking at the typical anatomy of a camera lens – both inside and out – before looking in more detail at lens construction, technology, optical quality and compatibility. Being familiar with their workings and capabilities will help you to select the best lens for the subject. It should also assist you when purchasing a new lens.

While the chapter is designed to take a closer look at modern lens technology and optical quality, I have resisted the temptation to get too technical about a lens's actual mechanics. I have tried to keep the contents informative enough to satisfy the more technically minded, without getting so in-depth that it is daunting or difficult to understand.

The technology employed within modern DSLR lenses – which enable fast, quiet and accurate automatic focusing and image stabilization – is highly sophisticated. It is easy to forget just how fortunate we are to have such remarkable technology at our fingertips. However, of far greater importance is a lens's actual optical quality. A camera lens is constructed from optical glass and is the 'eye' of the camera. Lenses work by focusing rays of light – refracting or bending them so that they meet or converge at a common point. Their optical performance will greatly define the quality of the end image. However, no lens is perfect – every optic suffers from one or more aberration and this naturally affects image quality to some degree. Thankfully, modern optics are highly corrected and aberrations are kept to a minimum. The very highest specification lens's are near

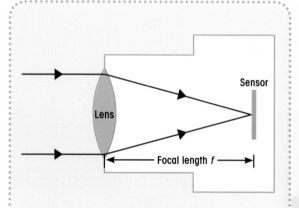

BASIC THEORY OF LENS OPERATION

Light strikes the front surface of the lens and passes through the glass element. Since light rays bend when they enter glass at any angle other than 90 degrees, they change direction. This effect is known as refraction. By employing various glass shapes in their design, lenses are able to channel the light in a specific direction. Focusing occurs because the lens's adjustable elements are able to precisely control the light's direction so that the rays converge at one point – on the camera's light-sensitive array.

LENS TIP

Don't underestimate a lens's influence on image quality. The most basic DSLR, fitted with a good lens, will still capture a good image. However, the best camera in the world cannot produce a good image if the attached lens is of poor quality.

faultless and even so-called budget optics remain excellent. While it is important to be aware of common lens deficiencies, in reality, image quality will rarely be affected to a point that is a significant problem. The affect of some lens flaws can actually be reduced post capture (page 142).

⌃ **Folly**. It is easy to take for granted the technology and optical quality of modern optics. Their sophistication enables us to concentrate fully on being creative with our cameras.

Nikon D90 with 12–24mm lens (at 12mm), ISO 100, eight seconds at f/20, ND, tripod

LENS ANATOMY: EXTERIOR

DESPITE THE SOPHISTICATION OF MODERN OPTICS — AND THE TECHNOLOGY INCORPORATED WITHIN THEM — CAMERA LENSES REMAIN RELATIVELY BASIC ON THE OUTSIDE, WITH FEW CONTROLS. HOWEVER, IT IS STILL IMPORTANT TO BE FAMILIAR WITH A LENS'S FEATURES IN ORDER TO GET THE MOST OUT OF YOUR SYSTEM. HERE WE LOOK AT THE TYPICAL ANATOMY OF THE OUTSIDE OF A LENS — ALTHOUGH IT IS IMPORTANT TO BEAR IN MIND THAT DESIGN AND FEATURES VARY FROM ONE LENS TO THE NEXT. FOR EXAMPLE, SOME DSLR LENSES ALSO BOAST IMAGE STABILIZING (PAGE 54) AS AN OPTION, OR ARE DESIGNED WITH A TRIPOD COLLAR (PAGE 43).

Focus ring

This is the manual focus ring. While many photographers prefer using automatic focusing, this ring allows the photographer to override AF and focus manually (page 32).

Filter thread

The vast majority of optics are designed with a thread, of a certain diameter, at the end of the lens barrel. This allows the attachment of screw-in filters or a filter holder.

AF/MF switch

This switch allows the photographer to select either autofocusing (AF) or manual focusing (MF) mode. Some lenses have the additional feature of allowing manual focusing override while in autofocusing mode.

Zoom ring

Naturally, this is a function only found on zooms, and not prime optics. This ring allows the focal length of the lens to be altered. Rotating the ring on the lens barrel causes the optical elements within the lens to move accordingly.

Aperture ring

The aperture ring is linked mechanically to the lens diaphragm to allow the aperture to be set manually. However, few lenses today still boast an aperture ring, as aperture selection is typically made via the camera itself.

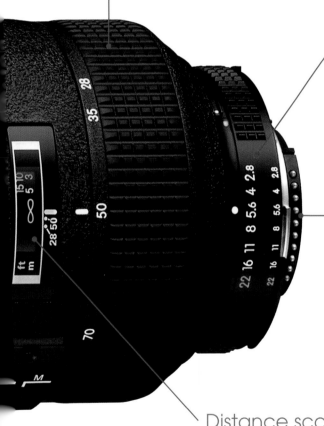

Lens mount/contacts

This enables the lens to be mounted to a compatible camera body with fully automatic coupling. A lens mount index – normally a red or white dot – is included on both the camera and lens to indicate how the lens should be fitted.

Distance scale

This is a scale on the lens barrel – in units of metres and feet – that indicates the distance between the subject and the camera. On some models, the depth of field at a given aperture is also marked.

LENS ANATOMY: INTERIOR

LENS TECHNOLOGY HAS IMPROVED SIGNIFICANTLY OVER THE PAST 20 YEARS – WE ARE A VERY FORTUNATE GENERATION OF SLR PHOTOGRAPHERS. INNOVATIONS INCLUDE IMPROVEMENTS TO OPTICAL ELEMENTS, THE DEVELOPMENT OF FAST AND PRECISE AF SYSTEMS AND THE INTRODUCTION OF OPTICAL STABILIZATION (PAGE 54). QUITE SIMPLY, LENSES TODAY ARE GENERALLY FASTER, MORE RESPONSIVE AND EXHIBIT FEWER ABERRATIONS. HOWEVER, HAVE YOU EVER WONDERED HOW THIS IS POSSIBLE, OR HOW A LENS IS CONSTRUCTED? HERE WE LOOK AT THE BASIC ANATOMY OF THE INSIDE OF A CAMERA LENS.

Diaphragm

This is the mechanical or electromechanical light-blocking device used to control the lens's aperture (page 30). Typically it is iris-shaped and consists of a number of thin metal leaves. It can be adjusted to alter the size of the hole – or lens aperture – through which light passes. The aperture expands or contracts much like the pupil of a human eye. Many lenses have mechanical diaphragms operated by levers. The levers are either adjusted manually – by the photographer rotating the aperture ring – or by the camera physically moving the levers. Modern lenses often have an electromechanical diaphragm operated by small electric motors or actuators.

Lens elements

A photographic lens is constructed from optical elements – the exact number varying depending on the lens type and design. Elements are also cemented together to form 'groups'. Each element is individually ground and polished to perform a specific role – such as focusing the light passing through it in a specific way, or helping to correct an aberration introduced by another element. Elements are curved pieces of glass much like the lenses commonly found in ordinary magnifying glasses or in eyeglasses. Modern lenses are normally a complex design and manufacturers often employ a large number of elements within their construction.

AF module

Most autofocus systems rely on an array of sensors to determine correct focus. Most multi-sensor AF cameras allow manual selection of the active sensor, and many offer automatic selection of the sensor using algorithms, which attempt to discern the location of the subject. Some AF cameras are able to detect if the subject is moving towards or away from the camera, including speed and acceleration data, and keep focus on the subject. Typically, the data collected from AF sensors is utilized to control an electromechanical system that adjusts the focus of the optical system.

Zoom lens mechanics (not applicable to prime lenses)

Zooms feature a complex internal construction. Not only must its mechanics move the various optical groups with the correct rates of movement, but also do so while maintaining optical alignment of the optical elements. This movement is performed by a complex arrangement of gears and cams in the lens housing, or computer-controlled servos are employed to perform positioning.

Lens barrel

Digital SLRs are more prone to image degrading reflections than their film counterparts. For example, image sensors tend to reflect a certain amount of light. Internal reflections bounce off the elements and inside of the lens barrel before finding their way back to the sensor, creating a reduction in contrast and sharpness, as well as introducing flare and ghosting. Lens coatings (page 52) greatly help reduce the problem, but the inside of the lens barrel is also coated to help absorb reflected light. Also, the barrel's overall construction plays a role in preventing internal reflections. Flare-cutting diaphragms block stray light from entering the rear of the lens. Baffles, and other construction elements, also help to keep non-image-forming light from reaching the sensor. The length and size of the lens housing varies depending on the lens type and focal length.

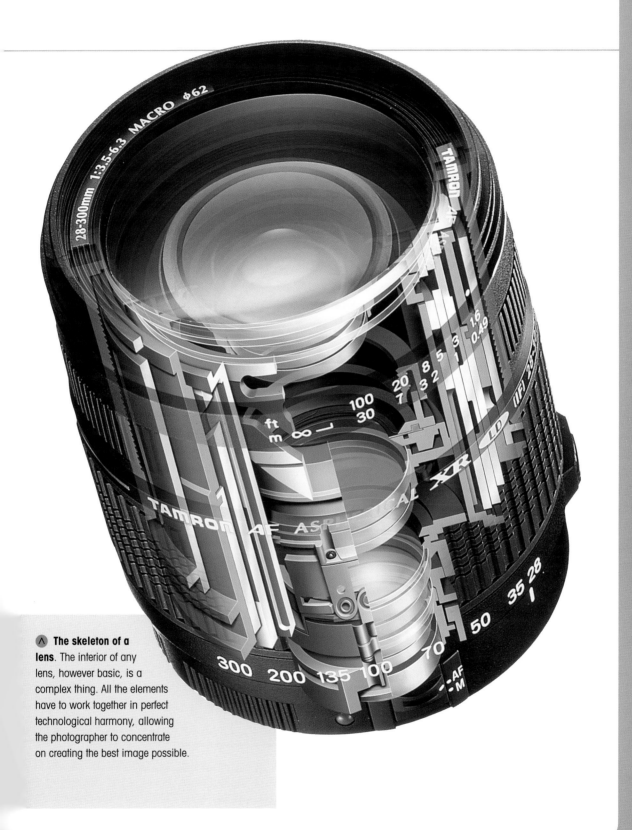

The skeleton of a lens. The interior of any lens, however basic, is a complex thing. All the elements have to work together in perfect technological harmony, allowing the photographer to concentrate on creating the best image possible.

LENS CONSTRUCTION AND THE MANUFACTURING PROCESS

HOW A LENS IS CONSTRUCTED VARIES DEPENDING ON THE LENS TYPE – FOR EXAMPLE, WHETHER IT IS PRIME OR ZOOM, WIDEANGLE OR TELEPHOTO. HOWEVER, WHILE THERE ARE CONVENTIONS OR PATTERNS FOR THE DIFFERENT LENS CATEGORIES, SOME DESIGN ASPECTS ARE STANDARDIZED. HERE WE TAKE A GENERIC LOOK AT THE RAW MATERIALS EMPLOYED IN A LENS AND EXPLAIN, IN VERY SIMPLE TERMS, THE MANUFACTURING PROCESS.

Lens elements

Lens elements are constructed from optical glass supplied to the manufacturer by specialized vendors. Often it is provided as a 'pressed plate' or sliced glass plate from which the elements are cut. The elements are shaped to concave or convex forms by a curve generator machine that is a first-step grinder. However, to reach the exact specifications for its shape, a lens undergoes a sequence of processes where it is ground by polishing particles in water. The polishing particles grow smaller in each step as the lens is further refined. After grinding and polishing, the elements are centred so that the outer edge of the lens is perfect in circumference relative to the lens's centreline or optical axis. Lenses made of plastic or bonded glass and resin are produced using the same process. Bonded materials are used to make lenses with non-spherical surfaces – often referred to as 'hybrid aspherics'.

Lens coatings

An optical coating is a treatment applied to the outer surfaces of lens elements. They are designed to alter the way in which the optic reflects and transmits light. Coatings are a layer (single-coating) or layers (multi-coating) that are a fraction of a wavelength of light thick. Without coating most glass reflects a degree of the light – often around seven per cent – and this degrades image quality. Therefore, coatings are an important part of lens design, helping to eliminate ghosting, low contrast and other flaws caused by light reflecting inside the lens. Coatings also protect the material from oxidation, and increase transmission. Before coatings are applied to formed lenses, the lens surfaces are carefully cleaned. Techniques for applying coatings and the coatings themselves are major selling points among manufacturers and are often carefully guarded

secrets. Some types of coatings include metal oxides, light-alloy fluorides, and layers of quartz that are applied to lenses and mirrors by a vacuum process. Several layers of coating may be applied for the best colour and light transmission.

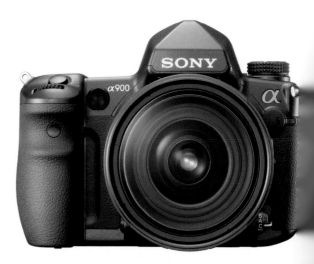

Lens coatings. The type and purpose of a lens's coatings will be listed among its specification. However, you can normally tell if it is coated by simply looking at it. Today, practically all camera lenses benefit from multiple coatings, but an uncoated lens would have a white reflection, similar to a window or drinking glass. A single-coated lens typically has a blue and amber reflection from its glass. However, the reflection from a modern, multi-coated lens will typically be green and magenta.

The lens barrel

The lens barrel is a metal or plastic tube in which the lens elements and mechanical components are housed. The barrel includes the chassis that supports the various lens elements and the cosmetic exterior. Metal mounts, grooves and moving portions of the lens are critical to the performance of the lens, and are machined to very specific tolerances. Lens mounts may be made of brass, aluminium, or plastic. Most metal barrel components are die-cast and machined. Metal mounts are more durable, maintain their dimensions and can be machined more precisely. Plastic mounts are less expensive and lighter weight. If the barrel is made of engineering plastic, it is produced by a highly efficient and precise method of injection moulding. The interior surfaces of the barrel are also coated – called electrostatic flocking – to protect them and to prevent internal reflection and flare.

Lens assembly

Other parts of the lens, such as the diaphragm (page 50), autofocus module (page 48–49) and image-stabilizing module – applicable to image stabilizing lenses – are produced as subassemblies. Typically, the diaphragm assembly is fastened into place when the lens mount is attached to the end of the barrel. The autofocus is also added, the optical elements are positioned, and the lens is sealed. After final assembly, the lens is adjusted and inspected rigorously. It must meet the design standards for optical resolution, mechanical function, and autofocus response. Quality control and stress tests are incorporated in each manufacturing step, and elements and components are measured with precise instruments. Some measuring devices can detect deviations of less than 0.0001mm in a lens surface or in lens centring.

ABOUT ELEMENTS

SPHERICAL
Most optics are spherical – their two surfaces are parts of the surfaces of spheres, with the lens axis perpendicular to both surfaces. Each surface can be convex (bulging outwards), concave (depressed into the lens), or planar (flat). The line joining the centres of the spheres – forming the lens surfaces – is called the axis of the lens. Typically the lens axis passes through the physical centre. However, they may be cut or ground after manufacturing to give them a different shape or size. The lens axis may then not pass through its physical centre. Spherical aberration – a lens flaw causing softness of focus, particularly away from the centre of the lens – is a common problem with this type of element.

ASPHERICAL
An aspherical lens is one which is not a portion of a sphere in cross section. This type of element optimizes the focus of light coming through both the edges and the centre of the lens. Therefore they reduce distortion and improve sharpness along the edges (spherical aberration). There are essentially three types of aspherical elements: ground, moulded and hybrid. Ground aspherical elements are made from glass. The grinding and polishing process of an aspherical lens is precise and expensive, but optical quality is maximized. Moulded aspherical elements are produced by directly moulding glass in a machine. Typically, moulded aspherical elements are found in lenses designed for the enthusiast market. Hybrid aspherical lenses are cheaper to produce and widely incorporated in consumer-grade optics. Hybrids consist of an aspherical glass lens, together with a plastic surface, to form the aspherical shape.

IMAGE STABILIZING TECHNOLOGY

OPTICAL IMAGE STABILIZATION (OIS) IS DESIGNED TO INCREASE THE STABILITY OF THE IMAGE AND, THEREFORE, MINIMIZE OR ELIMINATE THE DEGRADING EFFECT OF CAMERA SHAKE. THE TECHNOLOGY IS AIMED TO COUNTERACT VIBRATIONS AND MOVEMENT THAT CAN, POTENTIALLY, ROB A PHOTOGRAPH OF ITS SHARPNESS. NOT ALL LENSES ARE DESIGNED WITH OIS AND THEY ARE MORE COSTLY. HOWEVER, IF YOU REGULARLY SHOOT HANDHELD, BUYING OPTICS BOASTING THIS TECHNOLOGY WILL PROVE A GOOD INVESTMENT — ALLOWING YOU TO SHOOT AT UP TO THREE OR FOUR STOPS SLOWER THAN WOULD OTHERWISE BE POSSIBLE.

'Shake' creates lens movement during exposure, shifting the angle of incoming light relative to the optical axis and resulting in image blur. Optics boasting OIS correct camera shake by shifting certain optical components in inverse relation to the lens's movement. Doing so maintains the position of the incoming light rays on the sensor, eliminating or reducing the effect of shake. The technology works thanks to tiny, internal motion sensors, or gyroscopes. Basically speaking, these measure the motion of the lens and then feed the data to a high-speed microcomputer which converts the detection signals into drive signals. Small motors, or actuators, then move the optical elements accordingly, in order to redirect the optical path to provide higher sharpness than would otherwise be possible.

Lens brands have different names for OIS technology, for example, Image Stabilization (Canon); Vibration Reduction (Nikon); Optical Stabilization (Sigma) and Vibration Compensation (Tamron). While the OIS technology employed in optics might differ from one manufacturer to the next – and each will claim that theirs is the most effective system – the principle of the design remains the same.

Alternatively, some manufacturers employ shake reduction technology in the camera itself, rather than the lens. This works in a similar way, but the sensor itself moves in order to maintain the projection of the image onto the image plane. The advantage of in-camera stabilization is that all attached lenses benefit – rather than just those boasting OIS technology – and it negates the extra cost of buying this type of optic. Pentax, Olympus, Samsung and Sony are among the brands that prefer this method of reducing shake. While OIS technology will never replace the stability and precision of using a tripod, it is a huge advantage to have lenses boasting stabilization within their design. It is

⌃ **Vibration reduction.** In many situations, OIS technology can prove the difference between success and failure. In this instance, I couldn't physically keep my 80–400mm lens still enough in the overcast conditions to completely eliminate shake. With the lens's VR switched on, I could achieve a sharp result.

Nikon D200 with 80–400mm lens (at 400mm), ISO 200, 1/100sec at f/5.6, handheld

CAMERA SHAKE

Camera shake is a common problem, occurring when the selected shutter speed isn't fast enough to eliminate the photographer's natural movement. The result is a soft or blurred image, effectively ruining the shot. The problem is further exaggerated when using a long focal length lens or employing a high degree of magnification. The most effective way to eliminate shake is to use a support – like a monopod, beanbag or, best of all, a tripod. However, it is not always practical to use a support.

If the situation dictates that you have to shoot handheld, a good basic rule is to always employ a shutter speed equivalent to the focal length of the lens you are using. For example, if you are using the long end of a 70–300mm zoom, select a minimum shutter speed of 1/300sec. To help generate a faster shutter speed, employ a larger aperture, or increase the camera's ISO sensitivity. However, this will reduce depth of field, or increase noise levels, respectively. If your lens is designed with image stabilizing technology, use it; sharp images can be produced at speeds up to four stops slower than normal.

It is also possible to limit the effects of shake through the way you support your camera. For example, kneeling is more stable than standing. Hold your elbows in towards your chest and hold the camera firmly to your face. Hold it with both hands and squeeze the shutter release button smoothly.

particularly useful in situations where using a tripod is impractical – when stalking wildlife, for instance. It is also beneficial when using longer focal lengths or shooting in low or limited light – for example, indoors, at dusk, or on a cloudy day. OIS can prove essential in situations where the use of a tripod or flash is prohibited – like museums and concert halls.

Without doubt, OIS is a highly useful option to have on a lens, proving beneficial in a wide variety of shooting situations. In the future, it is likely to become a standard feature, but in the meantime it is well worth considering spending the extra money on buying OIS lenses, particularly for longer focal lengths. Thanks to OIS, it can be possible to take sharp images in situations where it would otherwise be impossible. However, it is important to reiterate that OIS doesn't signify the demise of the tripod – continue to use one for stability, and to aid composition, whenever practical.

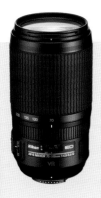

Image stabilizing lenses. Image stabilizing has a variety of names, dependent on the brand. However, all work using a similar principle and design. Nikon calls its version Vibration Reduction (VR). This technology, which can allow photographers to shoot at speeds of up to three or four stops slower than normal, is particularly useful when shooting in low or limited light and with longer focal lengths.

FOCUSING TECHNOLOGY

For anyone new to photography – or who hasn't been taking pictures for longer than 15 years – autofocusing (page 32) is something you will take for granted. Practically all modern lenses are of an autofocus design and – unlike when they were first introduced in the early 1980s – automatic focusing is fast, quiet, accurate and reliable. The sensors employed to achieve autofocusing can even track subject movement. The autofocusing sensor(s) and electronics are in the camera body itself, but this circuitry provides electrical power and signals to the lens's integral motor which then adjusts focus. There are different forms of autofocusing – here we look at some of the technology.

A DSLR's AF system relies on one or more sensors to determine correct focus – most cameras today boast an array of sensors arranged in a pattern across the frame. The speed and accuracy of through-the-lens optical autofocusing is truly impressive and when photographing action of a moving subject, this technology can prove the difference between success and failure. Most DSLRs have a choice of AF modes – optimized for particular shooting situations. Typically, a camera is designed with some sort of servo mode, which is able to detect if the subject is moving towards or away from the camera – including speed and acceleration data – and maintain focus on the subject. The data collected from the AF sensors is employed to control an electromechanical system that adjusts the focus of the optical system. The most sophisticated cameras employ a passive system.

Passive AF systems achieve correct focus by performing analysis of the image entering the optical system. Unlike active AF, they do not work by directing ultrasonic sound or infrared light waves towards the subject, although they do often employ an infrared AF-assist beam in low light to take passive measurements. Passive autofocusing is commonly achieved via a phase-detecting system or through contrast measurement.

Phase detection

Phase-detection AF is the most common system in digital SLRs. It is achieved by dividing incoming light into pairs of images and then comparing them. Secondary image registration (SIR) TTL passive phase detection is a common technology in DSLRs. This system utilizes a beam splitter – implemented as a small semi-transparent area of the main reflex mirror, coupled with a small secondary mirror that directs light to an autofocus sensor. Optical prisms capture the light rays and divert it to the AF sensor. The two images are then analyzed for similar light intensity patterns and the phase difference is calculated in order to find if the object is in front- or back-focus position. This provides the exact direction of focusing and amount the focus ring needs moving. Although AF sensors are typically one-dimensional photosensitive strips – only a few pixels high and a few dozen wide – some modern cameras feature area SIR sensors that are rectangular – providing two-dimensional intensity patterns. Cross-type focus points have a pair of sensors oriented at 90 degrees to one another. Some cameras also boast 'high-precision' focus points with an additional set of prisms and sensors.

Contrast measurement

Contrast measurement is achieved by measuring contrast within a sensor field through the lens. In simple terms, the AF sensors provide input to algorithms that calculate the contrast of the actual picture elements. The microprocessor in the camera then looks at the difference in intensity among adjacent pixels. If the scene is out of focus, adjacent pixels have similar intensities. The microprocessor moves the lens, repeating the process again to see if the difference in intensity between adjacent pixels improves or worsens. The difference in intensity naturally increases with correct image focus. The optical system can thereby be adjusted until the maximum contrast is detected. This is the point of best focus.

In this form of passive focusing, AF does not involve actual distance measurement and is generally slower than phase detection systems – particularly when operating in low light. However, being implemented in software (it doesn't employ a dedicated sensor), contrast-detect autofocus can be more flexible and potentially more accurate. Some DSLRs employ this type of system in their Live View modes.

∧ Focusing technology. Typically, DSLRs employ a passive autofocus system in order to achieve focus. This is an AF mechanism that achieves focus by analyzing the camera's view of the scene. Many passive autofocus mechanisms rely on some sort of contrast detection system for measuring focus.

Nikon D200 with 200mm lens, ISO 100, 1/1000sec at f/5, tripod

∨ Action. Achieving pin-sharp images of moving subjects can prove difficult when focusing manually. The speed and reliability of autofocusing can prove the difference between success and failure when shooting fast action.

Nikon D200 with 100–300mm lens (at 300mm), ISO 400, 1/400sec at f/5.6, handheld

AUTOFOCUS LOCK

By default, a camera presumes the subject you wish to focus on will be central in the frame. Therefore, when you wish to take pictures of subjects which are off centre you will either need to adjust your active focus point accordingly or lock focus. Locking focus can often prove the fastest method. This is simple to do. In some AF modes, you can lock focus by simply keeping the shutter release button semi-depressed after focusing on your subject. However, many DSLRs have a dedicated autofocus lock (AF-L) button. Simply focus on your subject and, by pressing the AF-L button, focus remains locked whilst it remains depressed. This allows you to adjust composition without the camera refocusing. However, do not alter the distance between camera and subject while focus lock is in effect. If you or the subject moves during focus lock, remember to focus again at the new distance.

OPTICAL QUALITY AND ABERRATIONS

WHEN PHOTOGRAPHERS REFER TO A LENS AS BEING OF A HIGHER OR LOWER OPTICAL QUALITY THAN ANOTHER, WHAT EXACTLY DO THEY MEAN? JUST LIKE ANY PRODUCT, CAMERA LENSES VARY IN QUALITY DEPENDING ON THEIR CONSTRUCTION AND THE MATERIALS EMPLOYED TO MAKE THEM. WHILE IT MIGHT BE A CLICHÉ, 'YOU GET WHAT YOU PAY FOR'. THE CHEAPER THE LENS, THE MORE THE MANUFACTURER WILL HAVE TO COMPROMISE WITH ITS CONSTRUCTION. AS A RESULT, IT WILL BE MORE PRONE TO COMMON LENS FLAWS.

While even the most basic kit lens is capable of good results, scrutinize image quality more closely and aberrations – like softness, blurring, reduced contrast, colour fringing and distortions – grow increasingly obvious. Here, we look at some of the most common types of lens deficiencies and aberrations. Depending on the subject matter, some lens artefacts are not be as objectionable as others, while others can be corrected during post processing (page 138-139).

What is aberration?

Despite their high quality, lenses do not form perfect images. There is always some degree of distortion – or aberration – introduced by the lens, which causes the image to be an imperfect replica of the object. Aberrations occur when light from one point of an object does not converge into – or does not diverge from – a single point after transmission through the optical system. Careful design and correction of the lens system, for a particular application, ensures that aberrations are minimized. There are several different types of aberration which can affect image quality.

Barrel distortion

Barrel distortion – or curvilinear distortion – is a common lens flaw or aberration in which parallel lines towards the edge of the image area appear to bow outwards, like the shape of a traditional wooden barrel. Also known as negative distortion, it is a problem most commonly associated with wideangle lenses when used at their widest setting. The position of the camera lens causes images to look outwardly curved or skewed when straight edges are near the side of the frame – lines that you would expect to appear perpendicular are not. Some lenses are more susceptible to this effect than others, depending on their focal length and construction.

> **Barrel distortion.** This illustration simulates the effect barrel distortion will have on your photographs.

Whilst not all barrel distortion is undesirable, the effect can be eliminated by simply moving further away from the subject and zooming in.

Pincushion distortion

Pincushion distortion is the opposite effect to barrel distortion. It is an aberration which makes images appear 'pinched' at their centre. Lines which do not go through the centre of the image seem to bow inward. This type of distortion is most closely associated with older and low-end telephotos, and also the long end of tele-zooms. Zooms with large focal ranges – varying from wideangle to telephoto – can suffer from barrel distortion at its widest setting, which gradually shifts to pincushion distortion when you zoom to its telephoto setting. Unlike some other lens aberrations, closing the aperture will not reduce the effect. In practice, this type of distortion may hardly be noticeable and will not significantly degrade image quality. However, when capturing buildings, horizons or other subjects with straight lines, pincushion – and barrel – distortion can be clearly visible. Images suffering from the effect are relatively easy to correct using photo-editing software.

> **Pincushion distortion.** This graphic is a simulation of the type of effect pincushion distortion will have on your images.

Chromatic aberrations

Chromatic aberration – also referred to as 'colour fringing' is a common lens flaw. It is caused by the camera lens not focusing different wavelengths of light onto the exact same focal plane – the focal length for different wavelengths is different – and/or by the lens magnifying different wavelengths differently. The result is brightly coloured halos – typically green or purple – forming along boundaries that separate dark and light parts of the image. Chromatic aberration is most common in budget optics and, while it won't normally be immediately obvious, colour fringing grows more noticeable the larger the image is reproduced. Effectively, there are two types of chromatic aberration – 'longitudinal' and 'lateral'. The degree of chromatic aberration depends on the dispersion of the glass. The problem can be minimized by using an achromatic lens or achromat in the lens's design, in which materials with differing dispersion are assembled together to form a compound lens.

For more information on chromatic aberration – and how it can be corrected post capture – turn to page 142.

∧ **Chromatic aberration.** Chromatic aberration is a relatively common lens flaw, particularly in cheaper lenses. Normally, colour fringing isn't immediately obvious, but the larger the image is reproduced, the more noticeable it becomes – as you can see from the enlarged section of this photograph of an old granite cross on Dartmoor. Turn to page 142 to see how the problem of colour fringing can be reduced.

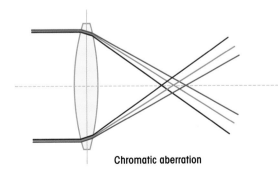

Chromatic aberration

< **Chromatic aberration.** This common lens flaw is caused by the camera lens not focusing different wavelengths of light onto the exact same focal plane.

Spherical aberrations

Spherical aberration is a lens imperfection that occurs when rays of light from a point on the optical axis of a lens with a spherical surface do not all meet at the same image point. Elements with spherical surfaces are relatively easy to manufacture, but their shape is not perfect for the formation of a sharp image.

This type of lens flaw causes beams parallel to – but distant from – the lens axis to be focused in a slightly different place from beams close to the axis. This manifests itself as a softening of the image, although optics are corrected to minimize the problem. Lenses in which closer-to-ideal, non-spherical surfaces are used are called aspheric. These used to be extremely expensive, but advances in technology have greatly reduced their cost.

Coma

Comatic aberration – or coma – in an optical system refers to a lens aberration inherent to certain optical designs, or due to imperfection in the lens which results in off-axis point sources, such as stars, appearing distorted. Similar to spherical aberration, coma is caused when light rays pass through an off-axis point causing the lens to focus at different points, resulting in blur. Off-axis highlights tend to grow radial tails resembling comets – hence the name – and are due to differential magnification at the centre and edge of the image.

Lens diffraction

Although diffraction is a lens-related problem, which affects image quality, it is not related to optical quality. Diffraction softens overall image quality. As you stop down the aperture – making it smaller by selecting a larger f-number – the light passing through the hole tends to diffract or, in other words,

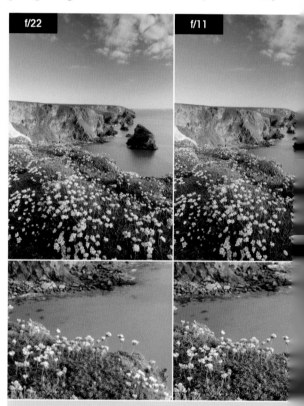

⋀ **Diffraction.** Have a look at the above two photographs – together with an enlarged section of each image. The first was taken at f/22 the second at f/11. While you might presume that the one taken using the smaller aperture (f/22) would be sharpest (due to the extended depth of field), in practice the shot taken at the larger aperture (f/11) is sharper. This is because – on a DLSR with a crop factor – this f/number is 'diffraction limited'.

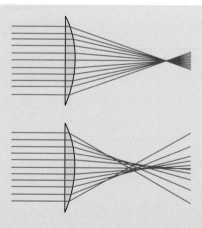

⋀ **Spherical aberration**. A perfect lens (top) would be able to focus all incoming rays of light to a point on the optic axis. However, a camera lens with spherical surfaces (bottom) suffers from spherical aberration. It focuses rays more tightly if they enter it far from the optical axis than if they enter closer to the axis. Therefore, it is not able to produce a perfect focal point.

Bokeh

The word bokeh is derived from Japanese and means blurred or fuzzy. It is a photographic term referring to the areas of an image that are out of focus – produced by a camera lens using a shallow depth of field. Defocused backgrounds are utilized by photographers to reduce distractions and to emphasize the main subject, and the quality of bokeh can produce different aesthetic qualities. The quality of bokeh is of particular significance to macro and telephoto lenses, as these lens types are more commonly used with a large aperture.

Bokeh – pronounced boke-aay or boke-uh – is difficult to quantify and is subjective. Some optics enhance overall image quality by producing more pleasing out-of-focus areas. The shape of the lens aperture has a great influence on the subsequent quality of bokeh, as – in areas which are out of focus – each point of light becomes a miniature image of the aperture. Generally speaking, the more circular the aperture is, the more pleasing bokeh will appear – hard-edged bokeh is normally considered undesirable. Therefore, some lenses have aperture blades with curved edges to make the aperture more closely resemble a circle – opposed to a polygon. Increasing the number of blades will also achieve the same effect. If you wish to assess the bokeh of a given lens, look for points of light in the background. Perfect subjects for this are distant points of light or sometimes light shining through foliage. If they all blend together nicely, that's good bokeh. If they are perfect little circles, then that's neutral bokeh. If they are irregular or doughnut-shaped, then this is generally considered bad bokeh.

A catadioptric telephoto lens – or mirror lens (page 116) – produces doughnut-shaped bokeh. This is because its secondary mirror blocks the central part of the aperture opening.

scatter. The reason for this is that the edges of the lens's diaphragm blades tend to disperse the light passing through. The smaller the hole, the greater the effect. As a result, even if depth of field is increased, image sharpness can deteriorate. This can create a conflict of interests for photographers, particularly when shooting landscapes. For example, traditionally, a small aperture is a priority when shooting scenics to ensure that everything from the foreground right up to infinity is in acceptable focus. However, while an f-stop in the region of f/22 or f/32 will maximize back-to-front sharpness, it also exaggerates the effect of diffraction. At a lens's smallest aperture, the gain in depth of field may not be sufficient to offset the increased level of diffraction. Therefore – as is so often the case in photography – a compromise has to be made. F/11 is generally considered to be the smallest aperture that remains greatly unaffected – or is 'diffraction limited' – on cropped-type cameras. If you are using a full frame DSLR, this 'guideline' tends to be f/16. While the aperture you select will be greatly dictated by the scene or subject and the effect you wish to achieve, the above settings will prove a useful guideline to help you maximize image quality.

< **Bokeh.** Bokeh describes the appearance – or 'feel' – of out-of-focus areas. It is not how far something is out of focus, but the character of the blur.

Nikon D300 with 150mm lens, ISO 100, 1/300sec at f/4, tripod

LENS COMPATIBILITY

AS PREVIOUSLY MENTIONED, A CAMERA'S BAYONET LENS MOUNT DIFFERS FROM ONE MANUFACTURER TO THE NEXT. IN OTHER WORDS, DSLR LENSES ARE NOT UNIVERSAL – THEY ARE ONLY COMPATIBLE WITH CAMERAS THAT SHARE THE SAME DEDICATED LENS FITTING. FOR EXAMPLE, ONLY OPTICS BOASTING NIKON'S F-MOUNT WILL FIT A NIKON DSLR; WHILE CANON DSLRS HAVE A UNIQUE EF (ELECTRO-FOCUS) BAYONET FITTING. THE LIKES OF PENTAX (K-MOUNT) AND SONY (α MOUNT) HAVE ALSO DEVELOPED THEIR OWN DEDICATED LENS MOUNT.

Although some manufacturers do share a mount – for example, Fuji DSLRs adopt Nikon's F-mount and Samsung and Pentax share the same mount – only four-thirds system lenses are designed to be universal (with other four-thirds system DSLRs). However, lens compatibility doesn't just refer to camera mounts. Many modern optics are digital specific – so are not fully compatible with older, film SLRs – or only work on DSLRs with a cropped-type sensor, as opposed to full frame. Here we take a generic look at compatibility.

Digital-specific lenses

The way in which a digital sensor records light is different to film. In film photography, light falling on the film is recorded accurately across the frame irrespective of the angle of incidence. However, the imaging sensor employed in a digital camera is a microchip with photodiodes laid out at regular intervals on a grid. The photodiodes sit in depressions meaning that light can only reach them effectively if it comes through the lens from straight ahead. As a result, should you attach an older – non-digital-specific – lens to your DSLR, insufficient light may reach the periphery of the sensor and degrade image quality. The wider the lens's angle of view, the worse the effect is likely to be. To combat this effect, the latest models are designed specifically for use with digital cameras. Often they are of a telecentric design. This ensures that light falls on the sensor as close to 90 degrees as possible, thereby maximizing image quality.

Lenses for cropped-type DSLRs

The majority of consumer DSLRs are designed with a sensor smaller than a traditional, standard 35mm frame. A lens always projects a round image, but the image created by any given lens will be cropped more on this type of camera than one boasting a full-frame sensor (page 22). This 'crop factor' effectively increases a lens's focal length. Such an effect is undesirable for wideangle photography, shifting the focal length's key characteristic. To compensate for this multiplication factor – typically 1.5x or 1.6x –

> ⓥ **Compatibility**. Before buying a lens, check that it is compatible. For example, some lenses are designed specifically for DSLRs with a smaller APS-C size sensor and aren't necessarily suitable for full frame models. Your camera manufacturer will market a wide range of fully compatible lenses. Don't overlook third-party makes either. They produce lenses in all the popular lens mount fits.

manufacturers have produced a new breed of optics designed specifically for cropped-type DSLRs. Typically, they are super-wideangles of 10mm upwards. They are designed so that the lens's image circle matches the smaller size of the image sensor of cameras with an APS-C-size imaging sensor. Their specialized design gives these lenses the ideal properties for consumer DSLRs. Their construction is more compact and lightweight, which is also beneficial. Manufacturers employ different initials to refer to this type of digital-specific lens for DSLRs with smaller imagers – for example, EF-S (Canon); DX (Nikon); DC (Sigma); and Di-II (Tamron). However, this type of lens isn't fully compatible with full-frame DSLRs. Such a wide focal length would create severe vignetting (page 69) on a full-frame body due to its smaller imaging circle. Nikon will still allow you to

> ∧ **Compatibility**. Today's SLR lenses are designed for use with digital bodies. This wideangle portrait was taken using a Tamron 18–270mm ultra-high-power zoom lens, which boasts a remarkable 15x zoom ratio. It is one of Tamron's Di II – Digitally Integrated – range, which are only compatible with cameras housing an APS-C-sized chip.
>
> **Nikon D300 with 18–270mm lens (at 21mm), ISO 200, 1/250sec at f/8, polarizer, handheld**

attach this type of lens to its full-frame (FX) cameras, but the camera switches to a (lower resolution) crop mode to rectify the problem. In contrast, the design of EF-S lenses – the 'S' stands for 'short back focus' and indicates that the distance from the back of the lens to the camera's sensor is less than that of a normal EF lens – prohibits it from being mounted on Canon film bodies or EF mount digital SLRs.

To summarize: while any compatible lens should still work on a cropped-type DSLR, optics (boasting a smaller imaging circle) designed specifically for use with cropped-type DSLRs are not – or are only partially – compatible with full-frame models.

LENS TIP

The Nikon F-mount and the Pentax K-mount systems are the only SLR camera systems (other then Leica's M-mount rangefinder system) that boast a mount with compatibility across camera generations. For example, their lenses will fit a mechanical SLR camera body, a fully automatic SLR camera body and a DSLR camera body.

MODERN LENS TERMS AND ABBREVIATIONS

When you view a lens's specification, you will often find that it is accompanied by a list of initials or abbreviations. But what do they mean or represent? Basically, they either refer to types of lens design, optical quality, or technology incorporated in the lens's construction — in other words, things that will aid the lens's performance. What can prove rather confusing is that different lens brands often have differing abbreviations for the same technology. Below is a selection of the most common lens abbreviations — together with a brief explanation. While this is by no means an exhaustive list — it should help ensure that, the next time you look at a lens's specification, it is less confusing.

APO

An apochromat or apochromatic lens (APO) is a lens boasting better colour correction than an achromat one. Chromatic aberration (page 59) is a common lens flaw where different colours focus at different distances from the lens. This results in colour fringing at high-contrast edges. Achromatic lenses are corrected to bring two wavelengths (typically red and blue) into focus in the same plane. However, apochromatic lenses are designed to bring three wavelengths (typically red, green and blue) into focus in the same plane. Apochromats are also corrected for spherical aberration at two wavelengths, rather than one — as with an achromat lens.

ASP, ASL or ASPH

This is an abbreviation of aspherical — a lens surface which is not a portion of a sphere in cross section. Aspherical lenses are used by lens designers to minimize certain types of aberration — namely spherical aberration (page 60). There are two basic types of aspherical lenses — replicated and ground. Replicated optics are pressed in a mould. They are less costly, but also of a lower quality. Replicated aspherical optics are commonly used in cheaper, consumer zoom lenses. Ground aspherical lenses are precisely shaped by a process of grinding and are of a higher optical quality. However, they are also more expensive.

DO

DO — or diffractive optics/optical — lenses contain a type of lens element unique to Canon's product line-up. They are multi-layer diffractive elements. The elements are nearly flat with extremely fine grooves etched into them. They exploit the principles of optical diffraction rather than optical refraction. The advantage of DO elements is that they combat colour fringing. They can also be made much lighter than regular low-dispersion or fluorite lens elements, thereby shortening the length and reducing the weight of long focal length lenses.

ED, LD and UD

This represents variants of low-dispersion glass — for example, ultra-low dispersion (UD) glass and extra-low dispersion (ED) glass. This is high-quality optical glass which reduces unwanted colour fringing — chromatic aberration — and other optical problems in lenses. Dispersion is the rainbow effect seen with prisms and the like — white light being split into a rainbow spectrum of its constituent wavelengths. Low dispersion glass does not disperse white light as much as other types. Therefore, it reduces the degree of correction required to compensate for the phenomenon.

Typically, low dispersion glass is hard and more scratch resistant, permitting its use in exposed front and rear lens elements. It delivers stunning sharpness and contrast even at large, maximum apertures.

HSM, SDM, SSM, SSM, SWD, USM and XSM

All are abbreviations describing a lens motor driven by ultrasonic waves to provide quiet, high-speed autofocusing. This motor controls the movement of the lens or focusing ring. An ultrasonic motor is much quieter – near silent – and also moves the focus lens or ring faster, when compared to a standard motor. Ultrasonic motors are able to hold the lens precisely in place at the exact instant the lens arrives at correct focus when using a DSLR's autofocus. Although Canon was the pioneer of the ultrasonic motor (USM) technology, other manufacturers have their own versions – for example, HyperSonic Motor (HSM) and Silent Wave Motor (SWM).

IF

An IF – or internal/inner focus – lens is one where focus is achieved by moving or shifting an inner lens group or groups, without any rotation or shifting of the front lens element. This makes it more convenient to use lens accessories like filters, filters holders and petal-shaped lens hoods. Also, when taking close-ups of wildlife, internal focusing helps minimize the risk of disturbing timid subjects.

S, OS, VC and VR

All these terms refer to image stabilizing technology (page 4). Different lens manufacturers have different titles for their technology – for example, Optical Stabilizer (OS), Vibration Reduction (VR) and Vibration Compensation (VC). This lens function utilizes a built-in mechanism that compensates for camera shake. It dramatically expands photographic possibilities by alleviating camera movement when shooting handheld.

RF

Essentially, rear focusing is the same as inner focusing, except only the rear element or group moves. An RF lens is equipped with a system that moves the rear lens group for high-speed, silent focusing with the rear element retracting as the lens is focused closer. One advantage of this type of system is that rear elements tend to be smaller than front elements on longer lenses. Therefore, being smaller and lighter they're easier to move quickly – important for autofocus telephotos. Sometimes identified as I/R for Internal/Rear focus, the physical length of the lens remains unaltered.

Lens abbreviations. View a lens's specification, and it will be accompanied by a list of abbreviations referring to types of optical quality or lens technology. However, unless you are familiar with such terms, this can be confusing. For example, Sigma's 150mm macro is an APO, HSM, IF lens. By referring to this accompanying list of terms, you will fully understand what such abbreviations signify.

3 LENS TYPES: WIDEANGLE

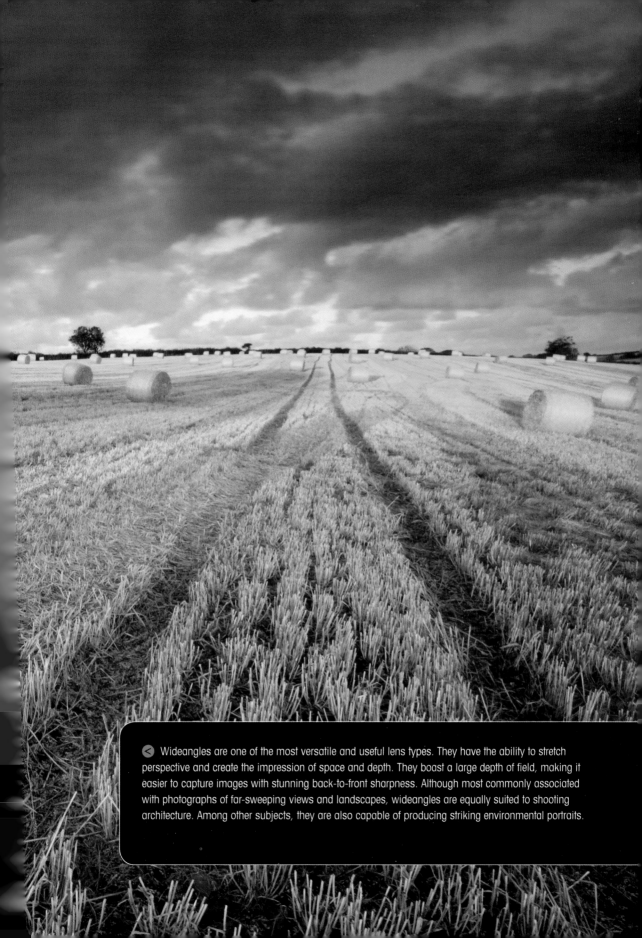

Wideangles are one of the most versatile and useful lens types. They have the ability to stretch perspective and create the impression of space and depth. They boast a large depth of field, making it easier to capture images with stunning back-to-front sharpness. Although most commonly associated with photographs of far-sweeping views and landscapes, wideangles are equally suited to shooting architecture. Among other subjects, they are also capable of producing striking environmental portraits.

WIDEANGLE LENSES: PRACTICAL CONSIDERATIONS

WIDEANGLES ARE ONE OF THE MOST POPULAR AND USEFUL LENS TYPES – NO KIT BAG SHOULD BE WITHOUT ONE. THEIR UNIQUE CHARACTERISTICS CAN SUIT PRACTICALLY ANY SUBJECT. ANY FOCAL LENGTH OF LESS THAN 35MM IS DEEMED TO BE WIDEANGLE BUT, THANKS TO MODERN LENS DESIGN, WIDEANGLES ARE GETTING WIDER. TWENTY YEARS AGO, 24MM WAS CONSIDERED TO BE EXTREMELY WIDE, BUT IN THIS DIGITAL AGE LENSES OF 18MM AND SHORTER ARE BECOMING INCREASINGLY COMMON – ALLOWING PHOTOGRAPHERS TO CREATE WIDE IMAGES WITH ENHANCED DEPTH AND DYNAMISM.

Due to the introduction of aspherical lens elements and floating-lens construction, the quality of wideangles is improving. Today, manufacturers offer a range of wideangle focal lengths – both prime and zoom – of a quality unimaginable a couple of decades ago. However, the wider the focal length, the more prone photographers are to the problems commonly associated with wideangles – distortion, flare and vignetting.

Distortion

At least some distortion is unavoidable when using short focal lengths. A wideangle distorts perspective, making near subjects appear much larger, while distant objects seem small. This type of distortion is a key characteristic of wideangles and one that can be manipulated to good effect in order to create dynamic-looking results.

Converging verticals is a form of distortion closely associated with wideangles, when parallel lines – the sides of a building, for instance – appear to lean inward to one another. This is due to the viewpoint, rather than the lens, with the effect exaggerated the more the camera is angled upward or downward. Although this may make the object look disproportionate, it can also create very eye-catching and unusual results, so there are times when you will want to emphasize the effect, rather than correct it. To minimize converging lines, the camera should be kept parallel to the subject or a perspective control lens (page 114) used. Alternatively, move further away and attach a longer focal length. However, this is not always practical, so you may be better correcting the distortion during editing (page 146). Geometric or 'corner' distortion is also common when using a wideangle, when objects at the corners of the frame

appear stretched. It arises when three-dimensional objects are projected on a plane such as a digital sensor. While objects at the centre of wideangle images will be recorded faithfully, three-dimensional objects near the periphery of a lens with a large angle of view will be elliptically elongated. The effect is most pronounced if the object in the corner of the frame is nearby.

∧ Converging verticals. By angling a wideangle lens upwards or downwards, you will exaggerate the effect of converging verticals – distortion where parallel lines appear to lean inward to one another.

Nikon D300 with 10–24mm lens (at 10mm), ISO 200, 1/300sec at f/11, polarizer, handheld

Vignetting. This image was taken using the short end of a 10–24mm lens. I used a polarizing filter to saturate the blue sky, but the thickness of the filter mount has blocked the light path at the corners of the frame – resulting in a common lens problem known as vignetting.

Nikon D300 with 10–24mm lens (at 10mm), ISO 200, 1/60sec at f/14, polarizer and tripod

Vignetting

Vignetting (pronounced vin-ye-ting) is a reduction in brightness at the image's periphery and is normally unintended and undesirable. Due to the way wideangles cover such a wide field of view, they are more likely to suffer from vignetting than other lens types. The problem is most likely to occur when you combine a short focal length with a lens hood, filter holder or screw-in filter. Such attachments begin to intrude into the imaging area, blocking the light path to the edges of the frame and causing the corners of the picture to darken. The solution is to remove such attachments – or only employ filters with

ultra-thin mounts and adaptor rings designed for use with wideangles. Even without attachments, vignetting can still occur when using ultra-wideangles. Optical vignetting is a result of rear elements being shaded by elements in front of them. This reduces the effective lens opening for off-axis incident light, resulting in a gradual decrease of the light's intensity at the periphery of the frame. This is particularly evident when the lens aperture is wide open. To correct the problem, simply stop down the lens by two or three f-stops. Many DSLRs don't have a viewfinder with 100 per cent coverage. Therefore, vignetting can easily go by unnoticed when composing your shot. If concerned, play back images on your camera's monitor, zooming into the corners to check for darkening.

The effects of vignetting can also be corrected during post capture (page 138).

Flare

Flare is the result of non-image-forming light striking the sensor and is most common when shooting in the general direction of an intense light source – like the sun. It is created when light doesn't pass directly along its intended path and instead bounces back and forth between the internal lens elements before finally striking the camera's sensor. It can appear in a variety of forms, but typically brightly fringed polygonal shapes, in addition to bright streaks and reduction in contrast. Although lens flare can be utilized creatively, it is normally undesirable and can ruin a picture. Lens hoods (page 120) are designed to prevent flare, but because of a wideangle lens's wide field of view, a hood is often impractical due to the likelihood of vignetting. Although many modern optics are designed with surface coatings to combat its effects, normally the best – or only – way to eliminate flare is to alter your shooting position.

> **LENS TIP**
>
> When using short focal lengths, camera-mounted flash may not spread widely enough to evenly illuminate the full coverage of the lens. To alleviate the problem, attach a diffuser or wideangle adapter over the flash.

WIDEANGLE LENSES: COMPOSITION

COMPOSITION IS THE ART OF ARRANGING, PLACING OR BALANCING THE ELEMENTS WITHIN A SCENE IN A WAY THAT IS VISUALLY PLEASING. LENS SELECTION PLAYS A VITAL ROLE – INCREASING OR DECREASING FOCAL LENGTH CAN WEAKEN OR STRENGTHEN THE COMPOSITION.

THOUGHTFUL COMPOSITION WILL TRANSFORM A SNAP INTO A PICTURE; BUT WHILE IT IS A SKILL THAT COMES NATURALLY TO SOME, OTHER PHOTOGRAPHERS NEED TO WORK HARDER TO ACHIEVE THE RESULTS THEY CRAVE. HOWEVER, THE MORE YOU USE YOUR CAMERA, THE MORE INTUITIVE YOUR COMPOSITIONAL SKILLS WILL BECOME.

Regardless of the lens or focal length you are using, good composition is essential. However, when using a wideangle lens, the art of composing an image grows even more important. Due to their wide field of view, you can potentially include many visual elements within your shot. Therefore, you need to select your viewpoint carefully, to ensure you arrange all the key elements in a logical, aesthetically pleasing order.

Wideangles can create the most dynamic compositions of all, boasting far greater depth than longer focal lengths. This is due to the way they appear to exaggerate perspective – making near objects seem larger and more prominent, and appearing to push distant subjects further away. This effect is a useful compositional tool for wideangle users. The effect can be exaggerated by positioning the lens close to foreground subjects, maximizing impact. Due to their wide coverage and extensive depth of field, it is possible to achieve sharpness throughout the frame; from just a few centimetres to infinity. However, in order to do this, it is normally necessary to select a small aperture and focus on the hyperfocal point (page 28).

Compositions that utilize a wideangle's ability to exaggerate the appearance of foreground subjects can suit all types of subject – for example, interiors, environmental portraits and even sports and wildlife. However, it is best suited to scenic photography, helping draw attention to key foreground interest while capturing the landscape beyond.

> **Keep composition simple.** Wideangles are well suited to shooting sweeping views and 'big landscapes'. However, the temptation can be to include too much within the frame and over-complicate the composition. Instead, it is normally best to keep images simple – arranging the key elements in a logical, visually pleasing order. In this instance, I used a wideangle lens, along with a low viewpoint, to draw emphasis to the rock in the bottom right corner. From this 'entry point', your eye naturally jumps to the next rock, then the one after, until reaching the cliffs and colourful sky in the background.

Nikon D300 with 10–20mm lens (at 11mm), ISO 100, 15 seconds at f/20, polarizer, ND grad and tripod

Rule of thirds. When employing the rule of thirds, you should place key elements of your composition on – or near to – where the lines of your imaginary grid intersect. In this instance, I have positioned the horizon so that the sky forms one third and the foreground two thirds of the image space. Then, I intentionally placed the foreground bale roughly one third into the frame. The composition appears far stronger, with a better balance, than had the closest bale been placed central in the frame.

Nikon D300 with 12–24mm (at 12mm), ISO 100, one second at f/18, 0.6ND grad and tripod

In order to create a strong composition, all the elements should work together harmoniously. When shooting 'big landscapes' – large, sweeping vistas captured with a wideangle lens – the composition can be effectively divided into three sections; the foreground, middle distance; and background. Each section should hold interest, in order to create a strong overall composition. Foreground interest can be practically anything – a rock, reflections, flowers, footbridge or path. The middle distance effectively makes the transition from foreground to background, while the background is normally a combination of the horizon and sky. By dividing an image in this way, and ensuring each section complements the others, you will capture images where the viewer's eye instinctively travels from foreground to background again and again. This type of 'near–far' wideangle composition can prove very effective and, whilst not lens-specific, a wideangle lens will normally create the most dynamic, three-dimensional results. This is because longer focal lengths appear to compress perspective, due to their narrower field of view.

COMPOSITIONAL RULE OF THIRDS

Rules are there to be broken, but when it comes to composition, the so-called 'rule of thirds' is a reliable and effective guideline. It was first developed by painters centuries ago, but remains just as relevant to visual artists today.

The idea is to imagine the image-space split into nine equal parts by two horizontal and two vertical lines. In fact, some digital SLRs can be programmed to overlay such a grid in the viewfinder to assist composition. Then, by simply placing your subject – or a key element within the scene – at or near a point where the lines intersect you will create a more balanced composition overall and effectively lead the viewer's eye through the image.

This rule is relevant to all types of subjects and, by using this approach, you will create more depth, balance, energy and interest in your photographs than had the main subject – or the horizon – been placed centrally in the frame.

While you shouldn't always conform to the rules, follow this age-old rule in the majority of situations and your images will be consistently stronger as a result.

Rule of thirds

While lens selection plays a key role in the way you depict and compose your subject, there are one or two compositional 'rules' that can be applied regardless of focal length – the most important being the 'rule of thirds' (see box).

WIDEANGLE SUBJECTS: ARCHITECTURE

NO LENS TYPE IS SUBJECT-SPECIFIC — WITHIN REASON, YOU CAN UTILIZE ANY FOCAL LENGTH FOR ANY SUBJECT IN ORDER TO CREATE DIFFERENT RESULTS. HOWEVER, DUE TO THEIR WIDE COVERAGE, SHORT FOCAL LENGTHS ARE PARTICULARLY WELL SUITED TO ARCHITECTURE AND INTERIOR PHOTOGRAPHY. NO OTHER LENS TYPE WILL ALLOW YOU TO CAPTURE SO MUCH WITHIN ONE IMAGE, OR WORK SO NEAR TO THE SUBJECT WHILE STILL BEING ABLE TO PHOTOGRAPH IT IN ITS ENTIRETY.

Large or small, old or new, industrial or residential – architecture is all around us. Houses, office blocks, skyscrapers and places of worship can all prove highly photogenic and a wideangle is a popular lens choice to capture building exteriors and interiors. If you are using a cropped-type DSLR with a multiplication factor, a wideangle in the region of 12–24mm is ideally suited. If you are using a full-frame model, employ a focal length not exceeding 35mm. In many respects; the wider the better. Super-wideangles will allow you to capture more within the image space, or work in closer proximity to the building you are photographing – useful in situations when you can't take pictures from further away due to other buildings, etc. However, the drawback of using very wide focal lengths is increased perspective distortion, such as converging verticals (opposite). This is when the sides of buildings appear to lean inward – caused when the camera is tilted upward or downward in order to take your photograph. The effect is exaggerated further at shorter focal lengths, and/or the closer you get to the building. To prevent vertical lines converging when using a wideangle, it is necessary to keep the camera parallel to the building – something which can often be impractical. Professional architectural photographers invest in perspective control – tilt and shift – lenses (page 114), designed to correct this problem. However, users of normal wideangles need to do one of two things – either minimize the effect, or intentionally exaggerate it.

The simplest way to minimize distortion is to shoot from further away. While this may not always be possible, by doing so you will effectively keep your camera more parallel with the subject, thus reducing the problem. However, by taking pictures from further away, the building will naturally be recorded smaller in the frame. If this isn't the effect you desire, simply increase focal length, but – depending on the surroundings – photographing your subject so that it is less dominant can actually strengthen composition and the look of the final image. Including a buildings environment, and placing it in context, can help convey far more about it – particularly if the building is old or decaying.

Alternatively, why not emphasize the distortion. A wideangle will allow you to photograph your subject from very close by and, by doing so you can exaggerate the 'problem'. High and low viewpoints can create dynamic-looking results in combination with short focal lengths and by angling the camera upwards or downwards, the level of distortion will increase. Thanks to a wideangle's extensive depth of field, it is possible to keep buildings sharp throughout the frame when also using a small aperture. The results can look striking, surreal or even abstract, creating the impression that the building is leaning or getting narrower.

While architectural photography is dominated by photographs of entire buildings and their interiors, don't overlook close-up photographs of detail, and wideangle shots of other structures – bridges, towers, arches, sculptures, walls and monuments, for example. Also, remember that the appearance of a structure will vary depending on the light.

LENS TIP

A degree of convergence can be corrected post capture using photo editing software like Photoshop. To do so, select the image in Photoshop and then click Edit> Transform> Perspective. Drag the top markers until the verticals are correctly aligned.

INTERIOR PHOTOGRAPHY

When photographing interiors, you often have to work within a relatively confined space. The camera can seldom be placed far enough away from the area of interest for a normal focal length lens to be used. Therefore, unless you wish to isolate specific detail, a wideangle is the obvious lens choice.

Due to their wide field of view, wideangles create a false impression of distance and space, giving the feeling that an interior is more spacious than it really is. Also, many wideangles boast a fast maximum aperture, helping produce a bright viewfinder image – useful for assisting composition and focus in poorly lit buildings, like cathedrals. Careful composition is required when shooting interiors. Converging verticals can prove problematic, and super-wideangles will exaggerate any misalignment between the sensor plane and subject plane. To help control convergence, position the camera parallel, so that it is not tilted up or down, or angled side to side. When possible, left and right edges of your viewfinder should be parallel with any vertical lines in the scene, such as doorways. However, in reality, this becomes increasingly difficult at progressively shorter focal lengths and in some situations, all a photographer can do is minimize the problem and then correct post capture (page 138).

When shooting interiors, a tripod is essential. Not only will it eliminate the risk of shake in low light, but it will help you compose your images with precision.

∧ Church. Due to the elevated position of this church, had I tried to photograph it from any closer, I would have had to angle the camera upward and the building's verticals would have converged. Therefore, I decided to take my shot from further away, but instead of increasing focal length in order to fill the frame, I continued to use my wideangle in order to capture the building in context with its surroundings. This creates a far stronger composition overall.

Nikon D300 with 12–24mm lens (at 14mm), ISO 200, 1/4sec at f/16, tripod

> **Converging verticals.** Converging angles can create striking, dynamic results. However, equally, it can be undesirable and degrade photographs of buildings. The effect is most likely, and pronounced, when using a wideangle lens near to the subject – whether you try to minimize the effect, or emphasize creatively, is down to personal taste.

Nikon D300 with 12–24mm lens (at 18mm), ISO 200, 1/100sec f/10, polarizer and handheld

WIDEANGLE SUBJECTS: LANDSCAPE

WIDEANGLES ARE MOST COMMONLY ASSOCIATED WITH LANDSCAPE PHOTOGRAPHY. THEY CREATE DEPTH AND DIMENSION AND — DEPENDING ON THE CAMERA'S ORIENTATION — A FEELING OF WIDTH OR HEIGHT. A WIDEANGLE NOT ONLY ALLOWS PHOTOGRAPHERS TO CAPTURE THE DISTANT VIEW, BUT TO INCLUDE NEARBY, FOREGROUND SUBJECTS WITHIN THE COMPOSITION. A CHARACTERISTIC, UNIQUE TO SHORT FOCAL LENGTHS, IS THE WAY THEY CAN STRETCH THE RELATIONSHIP BETWEEN NEAR AND FAR, EXAGGERATING THE SCALE OF FOREGROUND SUBJECTS. NO OTHER LENS TYPE IS BETTER SUITED TO THIS POPULAR FORM OF PHOTOGRAPHY.

A wideangle lens is an essential tool for landscape photography. While there will be situations when a longer length is better suited – for example, a short or medium telephoto to isolate specific areas of interest within the landscape – a wideangle will normally prove the best lens choice when shooting scenery. In my view, nothing can capture the awe and wonder of a landscape quite like a wideangle. A focal length of 28mm to 35mm – or its equivalent on a cropped-type sensor DSLR – is generally considered to be the 'standard' and traditional wideangle. This focal length is sufficiently wide to capture the majority of large vistas, without significantly distorting perspective. It is a focal length well suited to general use and to capturing faithful looking landscapes. However, a new breed of ultra-wideangles, covering a range of – or equivalent to – 15mm to 21mm offers scenic photographers even more creative possibilities. While you might not think that there would be a significant shift in coverage between, say, a 20mm and a 28mm lens; it is surprising just how differently they capture a scene. It is worth noting that, at this end of the focal range, even slight alterations in focal length have the ability to radically alter composition and what is, and isn't, included within the viewfinder. Super-wideangles are capable of producing far more dramatic results than a traditional 28mm lens, stretching perspective to the extreme. They work best when the photographer includes good subject matter in the foreground, as scale is accentuated by the lens's characteristics. However, the risk when using a wideangle lens is that, if you fail to include foreground interest, you will create a composition with large, empty spaces – which will weaken the shot overall. Also, try to avoid the temptation to include too much within the composition – shots that are too 'busy' can be distracting and lack a real focal point.

When photographing scenery, a large depth of field is often a priority. It is required to ensure everything from the nearest object, to the far distance, is rendered acceptably sharp in the final image. While it is important to be aware of the effects of diffraction, landscape photographers will typically select a small lens aperture in order to maximize their wideangle's already extensive depth of field. However, focusing also plays a significant role in achieving back-to-front sharpness, which is why hyperfocal focusing is particularly relevant and helpful to landscape photographers using wideangle lenses.

> **St Michael's Mount.** Wideangles are able to capture far-reaching views and exaggerate the perception of depth. As a result, they are perfectly suited to scenic photography. Normally, it is important to include subject matter in the foreground – this creates interest, depth, and helps lead the viewer's eye into the image.

Nikon D300 with 12–24mm lens (at 14mm), ISO 100, 10 seconds at f/18, polarizer, ND grad, solid ND, tripod

LENS TIP

Take care to keep the horizon level. The most popular solution is a spirit level. This attachment slots into the camera's hotshoe and, when used with a tripod, assists composition, helping ensure your horizons always remain perfectly straight.

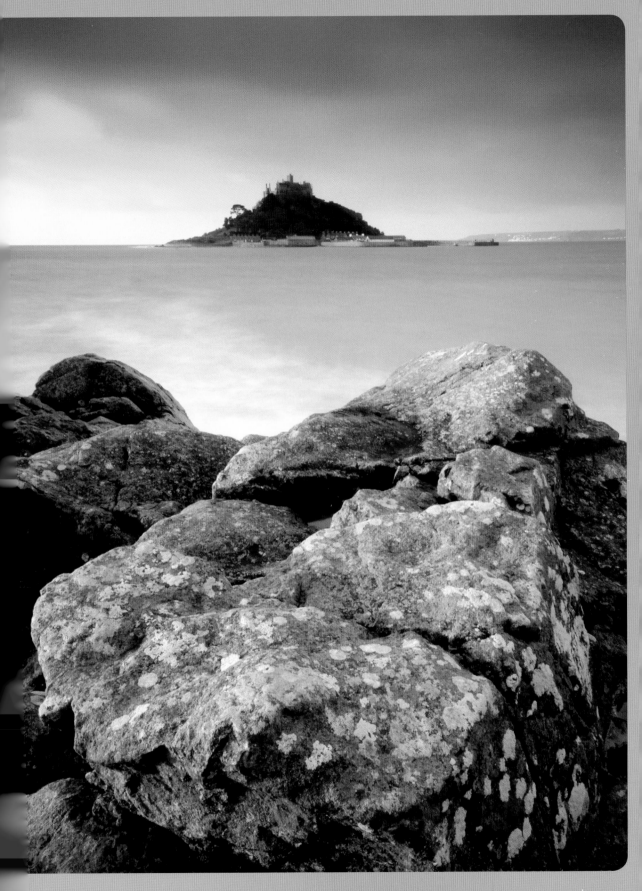

WIDEANGLE SUBJECTS: ENVIRONMENTAL PORTRAIT

THE CLASSIC RULE, WHEN PHOTOGRAPHING PEOPLE, IS TO EMPLOY A FOCAL LENGTH OF BETWEEN 50 AND 100MM. THIS TYPE OF LENGTH CREATES A FLATTERING, NATURAL PERSPECTIVE AND GENERATES A LONG ENOUGH WORKING DISTANCE FOR YOUR MODEL NOT TO FEEL TOO INTIMIDATED OR UNEASY. HOWEVER, RULES ARE THERE TO BE BROKEN AND A MUCH WIDER FOCAL LENGTH CAN PRODUCE FAR MORE DRAMATIC IMAGES — REVEALING MORE ABOUT THE SUBJECT'S CHARACTER AND PLACING THEM IN CONTEXT WITH THEIR SURROUNDINGS.

Environmental portraits

While you wouldn't immediately expect the exaggerated perspective of a wideangle lens to be suited to portraiture, the results can look modern and eye-catching. Environmental portraits are a great alternative to the classic head and shoulders image, and an opportunity for the photographer to be more imaginative. By showing your subject within a fitting environment, you immediately reveal far more of your subject's personality, or even mood. This type of portrait can be shot in a place of work, home, or out socializing. The surroundings will often be of equal importance to the person you are photographing, so creating a balanced composition is important. A wideangle lens is perfectly suited to this and will also help provide the extra depth of field required to keep both your subject, and their surroundings, in acceptable focus.

Unless you are using a professional model, few people enjoy having their photo taken. It can prove an intimidating experience, particularly when the photographer is using a wideangle and working in close proximity. Therefore, help your subject to relax by maintaining good, friendly communications. Keep talking, explaining what you are doing and why. Also, ensure they know the type of result you are striving to achieve. This should help them to relax, and your images will look more natural as a result.

The most obvious effect of using a wideangle to shoot this type of portrait is how they appear to distort perspective and depth. Due to their wide angle of view you will need to be near to your subject to keep them large in the frame.

LENS TIP

A focal length in the region of 18–24mm is well suited to this type of portrait. Presuming there is sufficient light, it can be better to work handheld as this allows more creative freedom and spontaneity. For more extreme, wacky wideangle portraits, consider using a fisheye (page 108).

The nearer you are, the more the subject's facial features will appear unnatural, particularly if combined with a high or low viewpoint. For example, an elevated angle will exaggerate the size of the subject's forehead and nose. The depth of the image will also be unnaturally increased, so your subject appears more detached from the background. While these effects may not always flatter your subject, this type of distortion is one of the fundamental effects of using a wideangle for portraits. Using a short focal length, you can make the subject's hands, feet or head appear much smaller or larger in relation to the rest of their body, or surroundings. This effect can be used for either creative or humorous effect.

Using a wideangle lens opens up a huge range of unusual portrait possibilities. The key, when shooting environmental portraits, is to treat your subject as just one element within the scene. Doing so can create unusual, original, and extremely evocative portraits: By being imaginative and utilizing context, this lens type will help you to capture memorable portraits.

4 Lens types: standard

V Sadly, standard lenses are much maligned today. Their focal length is similar to our own eyesight, so some photographers consider them rather uninteresting. However, they shouldn't be overlooked. They are capable of superb results and an excellent choice as an everyday, all purpose lens. This focal length is well suited to all types of subjects, including landscape, still-life and candid photography. This is an excellent lens type to build your lens system around.

STANDARD LENSES: PRACTICAL CONSIDERATIONS

A STANDARD – OR NORMAL – LENS HAS A SIMILAR ANGLE OF VIEW AND PERSPECTIVE TO THE HUMAN EYE, WITH A FOCAL LENGTH APPROXIMATELY EQUAL TO THE DIAGONAL MEASUREMENT OF THE SENSOR. THE TRADITIONAL STANDARD LENS IS 50MM (OR THE EQUIVALENT TO), BUT ANY FOCAL LENGTH BETWEEN 35MM AND 80MM IS GENERALLY CONSIDERED TO BE A NORMAL LENS.

Sharp, compact and lightweight

Not so long ago, almost every new camera would be sold with a fixed 50mm lens. This focal length would prove the cornerstone of a photographer's lens system. A normal lens is compact and lightweight – so suited to being used handheld – and its focal length useful on a day-to-day basis for general photography. They are also relatively inexpensive. Prime standard lenses normally boast a fast maximum aperture of f/1.4 or f/1.8, and therefore gather more light than most other optics or zooms. This not only provides a bright viewfinder image, but allows photographers to shoot in low light. Also, prime standard lenses are often superb optically, offering excellent sharpness and image quality. However, in recent years the rise of good-quality, affordable zooms have meant they have been greatly superseded, with consumers preferring the flexibility of a standard zoom. Small 'standard' zooms typically have a range of 35–70mm (2x), 28–85mm (3x) or 24–105mm (4x). These zooms are designed to replace the traditional 50mm lens. Standard zooms are certainly very useful and, today, their optical quality is almost comparable. However, a prime normal lens shouldn't be overlooked – no other lens of this quality, speed and sharpness is available for so little money.

Standard zoom. The flexibility of using a standard zoom has greatly superseded the traditional fixed 50mm lens. Most kit lenses, supplied with new DSLRs, are standard zooms. The most popular lengths are 28–70mm and 35-80mm. Their versatile range makes them useful for general day-to-day photography.

Standard lens. The traditional 50mm standard prime lens may seem outdated, but it is still a highly useful lens type. Its 'natural' looking perspective is similar to what the human eye sees, and it is ideally suited to recording subjects faithfully. Standard lenses are normally fast, compact and optically superb.

Sunset and silhouette. A standard focal length is ideally suited to photographing all number of subjects. In this instance, the natural-looking perspective created by a normal lens suited this silhouetted folly against a colourful sunset.

Olympus E30 with 14–54mm lens (at 27mm – equivalent to 54mm), ISO 100, 1/25sec at f/14, tripod

LENS TIP

Attach a standard 50mm lens to a DSLR with a cropped-type sensor and, due to the multiplication factor, its effective focal length will be approximately 75mm – ideal for shooting portraits.

Boring focal length?

While a standard lens might not have the dynamic, wide view of a wideangle, or the magnification and power of a telephoto, this focal range shouldn't be considered boring. A standard lens remains an essential lens type for practically every photographer. Thanks to the minimal distortion they display and the 'natural'-looking perspective they provide, this type of focal length is suitable for such subjects as still lifes, landscapes and street photography. Some of the world's greatest ever photographers have relied extensively on the capabilities of a standard lens. For example, Henri Cartier-Bresson – one of our most celebrated photographers – employed a standard lens for more than half the images he took. It is a focal length that will make you move around your subject, think hard about composition and strive for fresh viewpoints. It is only a boring focal length if you, the photographer, allow it to be.

STANDARD LENSES: COMPOSITION

ON A FULL FRAME CAMERA, A 50MM LENS COVERS AN ANGLE OF VIEW OF 46 DEGREES, SIMILAR TO OUR OWN EYESIGHT. THEREFORE, THE ART OF COMPOSITION IS SIMPLIFIED WHEN USING A NORMAL LENS, BEING EASIER FOR PHOTOGRAPHERS TO ENVISAGE HOW IT WILL RECORD A SCENE OR SUBJECT DUE TO ITS SIMILAR PERSPECTIVE. TO AN EXTENT, THE SAME CAN BE SAID FOR STANDARD ZOOMS. HOWEVER, HAVING AN ADJUSTABLE FOCAL RANGE ALLOWS PHOTOGRAPHERS TO ALTER THE ANGLE OF VIEW – AND THEREFORE COMPOSITION – FROM A STATIC POSITION. ALTHOUGH USERS OF A PRIME STANDARD LENS NEED TO ALTER COMPOSITION BY 'ZOOMING WITH THEIR FEET', THEIR OPTICAL SUPERIORITY IS AMPLE COMPENSATION.

∧ **Rule of space.** The 'rule of space' is particularly well suited to portraits, people and wildlife. It is a compositional guideline where the photographer intentionally leaves space for the subject to look into. Used appropriately, it will help create mood and mystery.

Nikon D300 with 50mm lens (equivalent to 75mm), ISO 400, 1/100sec at f/2.8, handheld

> **Rule of odds.** Including an odd number of objects within your composition means the central object(s) are naturally framed. Generally, the results tend to be stronger than if there is an even number. This 'rule' can be applied to any subject, big or small, and regardless of focal length.

Nikon D300 with 50mm lens, ISO 100, 1/40sec at f/14, tripod

Composition with a standard lens

A standard focal length is unique in the way it can produce images that, in certain conditions, appear to have a modest wideangle perspective, yet in different circumstances, have the feel and isolation of a short telephoto. As a result, a normal lens is a very versatile companion for many different types of photography.

While the neutral perspective of a standard lens can be advantageous and utilized to good affect, it is fair to say that it can also produce very ordinary-looking results if the photographer isn't careful or being creative. Presuming you wish to do more than simply document a scene or subject, be prepared to move around and explore different angles and viewpoints when using a standard focal length. For beginners to photography, a standard lens is a great focal length for developing your compositional skills. When using a prime lens you grow more aware of the viewfinder as a compositional frame, and develop a better understanding of how focal length affects composition.

The rules

When looking through a standard lens – or any focal length for that matter – the key to good composition is to arrange the main elements so that they form a visually interesting picture. The composition needs to be able to hold the viewer's attention. The rule of thirds (page 71) is an important tool for all types of photography, regardless of focal length. However, there are other useful tips worth remembering that also aid composition.

Like all compositional rules, the 'rule of odds' should be treated as a guideline – it won't suit every situation. This rule states that, by displaying an odd number of objects within the composition, there is always one in the middle that is framed by the surrounding objects. As a result, it creates a stronger composition with more impact – a technique regularly employed in advertising.

The 'rule of space' is designed to give your main subject room to breathe, so the image isn't cramped. It particularly appertains to photography of people. Intentionally leaving room for the direction of the subject's eyes to look into can prove highly effective, creating mood or mystery. This approach often involves using a shorter focal length in order not to compose your subject too tightly. A standard lens is often ideal when adopting this approach.

LENS TIP

Due to the simple construction of a prime 50mm lens, it is cheap to produce. They boast highly corrected optics and offer corner-to-corner sharpness, which a zoom is unable to match. They also have a fast maximum aperture. Their simplicity is suited to beginners and, as they have largely fallen out of favour with consumers, can often be bought at a bargain price.

STANDARD SUBJECTS: LANDSCAPE

WIDEANGLES ARE OFTEN THE PREFERRED LENS TYPE FOR LANDSCAPE PHOTOGRAPHY, DUE TO THEIR ABILITY TO CAPTURE SUCH A WIDE, SWEEPING EXPANSE. HOWEVER, STANDARD LENSES ARE ALSO EXCELLENT FOR CAPTURING SCENICS AND IN MANY SITUATIONS CAN ACTUALLY PROVE BETTER.

A good landscape lens

One of the drawbacks when using a wideangle lens for scenic photography is that their field of view is so wide it can be tempting to include too much within the frame, when often a simpler composition would be better. Equally, in some situations it can be difficult to fill with sufficient photographic interest the vast space a wideangle creates. As a result, the image's impact is reduced. A standard focal length can remedy such problems. Their angle of view is still wide enough to create depth and capture wide views, but their field of view is narrower – allowing you to achieve tight, striking compositions in situations when a wideangle would create too much empty space in the foreground.

⋁ River and bridge. A standard lens will capture images with a natural-looking perspective, similar to the way our eyes view the landscape. They are ideally suited to capturing tight compositions, free of distortion. They are also a good focal length when you wish to exclude a dull, uninteresting sky.

Nikon D300 with 18–70mm lens (at 40mm), ISO 100, four seconds at f/22, polarizer and ND filter, tripod

Standard lenses boast extensive depth of field and, by stopping the lens down to f/11 or smaller, you will normally generate sufficient depth of field to achieve back-to-front sharpness – often a priority for landscape photography. To ensure you maximize the depth of field available at any given f-stop, focus on the hyperfocal distance (page 28).

A normal focal length is well suited to scenes where you wish to place more emphasis on the scenery in the background, rather than the foreground. Or maybe you simply don't want your foreground to be too dominant – something that is a characteristic of wideangle shots. Standard and short telephotos are also the best lens choice when taking landscapes where you wish to exclude the sky. This can be desirable when the sky is overcast, bright or simply bland and uninteresting. Using a wide focal length, it is almost impossible to exclude the sky, but with a standard lens you can isolate the landscape from the sky and produce a stronger result.

A standard lens is also well suited to landscape photographers who don't like the type of distortion created by very wide focal lengths – they appear to 'stretch' objects towards the periphery of the frame. The natural perspective of a normal focal length will always produce faithful-looking landscapes.

LENS TIP

Due to the multiplication factor of smaller APS-C-size sensors, users will require a shorter focal length to achieve the same angle of view as a 50mm lens. There is a wide range of high-quality, inexpensive 35mm lenses on the market that will provide a similar perspective, to a traditional standard lens, when attached to a cropped-type DSLR.

SILHOUETTES

A silhouette is the most extreme form of backlight, where the subject is recorded as a black outline – without colour or detail – against a lighter background. Silhouettes within the landscape can create powerful and striking images – particularly when contrasted against a colourful sky – and a standard lens is one of the most suitable focal lengths for shooting this type of photo.

It is easiest to shoot silhouettes at either end of the day, when the sun is low in the sky. Due to the lack of detail and colour, it is important to photograph a subject with a strong, instantly recognizable outline – for example, a tree or building. My tip, when shooting silhouettes, is to keep composition tight and simple; too many competing elements within the frame will detract from the picture's impact. This is one reason why the slightly extended focal length of a standard lens can prove preferable to that of a wideangle.

When exposing for silhouettes, the most reliable method is to spotmeter from a bright area of the scene, then employ these settings to take the shot. By doing so, you will underexpose the subject itself, rendering it as a simple black outline. Utilize the image's histogram via playback to check your exposure – the majority of the pixels should be skewed toward the left-hand edge of the histogram.

∧ **Tree silhouette.** A standard focal length is well suited to capturing striking silhouettes. Thanks to their slightly narrower angle of view, they are suited to creating simpler compositions than the stretched perspective of a wideangle lens.

Nikon D700 with 24–85mm lens (at 70mm), ISO 100, 1/80 at f/11, tripod

STANDARD SUBJECTS: STILL LIFE

TYPICALLY, STANDARD LENSES – PRIME OR ZOOM – BOAST A SHORT MINIMUM FOCUSING DISTANCE OF AROUND 45CM. THIS CLOSE FOCUSING ABILITY ADDS TO THEIR VERSATILITY, AS THEY CAN BE EMPLOYED TO TAKE CLOSE-UP IMAGES, WITH A MAXIMUM REPRODUCTION RATIO OF AROUND 1:8 OR 1:10 LIFE-SIZE. WHILE THIS LEVEL OF MAGNIFICATION CAN'T RIVAL THAT OF A MACRO LENS (PAGE 110), IT IS MORE THAN SUFFICIENT TO SHOOT MANY STILL-LIFE SUBJECTS.

Still-life photography

The term still life refers to a depiction of objects – man made or natural – arranged creatively. This form of photography partly owes its popularity to its accessibility – you don't even need to set foot outside to find subjects, with a typical household being full of potential. This is a great form of photography to practise and experiment with composition, lighting and exposure, as the subject is static and the photographer has complete control over every aspect of capture. That is not to say that still-life photography is easy, though, being one of few forms of photography where you have to 'make' the picture before you can take it.

Having the ability to be able to identify suitable subjects is one of the key skills to shooting still life. Even the most mundane, everyday object can create a striking image. Look around your home with a creative eye. Cutlery, stationery, work tools, bottles, flowers, food and toys are all subjects with potential – either photographed in isolation or combined with other objects.

Despite the fact that standard lenses are compact, lightweight and easy to use handheld without a high risk of shake, it is still wise to use a camera support when shooting still-life images. A tripod will allow you to alter your arrangement knowing that the camera's position is fixed and that your composition won't change. It allows you the freedom to make as many tweaks to your set-up as you want, until you achieve just the right look and balance through the viewfinder.

Although you can buy dedicated still-life tables or coving, a simple tabletop set-up is normally more than adequate. This can be placed adjacent to a lit window, which will provide your light source, unless you prefer the added control of using flash or studio lighting. However, photographers new to still life will find it far simpler to utilize ambient light to begin with – doing so, allows you to see the light's effect on the subject.

Many still-life images are close-ups. If you need to get closer to your subject than your standard lens will allow, consider attaching a close-up filter (page 134) or extension tube (page 122). A standard lens is the perfect lens type to combine with this type of close-up attachment and together will provide the level of magnification you require without the expense of buying a dedicated macro lens (page 110).

Keyhole. Not all still-life images have to be set up. 'Found still life' refers to photographs taken of subjects that the photographer has chanced upon, rather than pre-arranged. In this instance, I was drawn to the rustic, peeling paintwork on this old door and utilized the keyhole as a point of interest.

Nikon D200 with 24–85mm lens (at 70mm), ISO 100, 1/20sec at f/14, tripod

Scissors. Everyday objects, that you wouldn't normally consider photographing, can be transformed thanks to the three key ingredients to a successful still life – lighting, composition and arrangement. To create this simple image, I positioned a pair of scissors on a lightbox to form a silhouette and then placed a sheet of plastic on top of them to diffuse the image.

Nikon D300 with 24–85mm lens (at 55mm), ISO 100, 1/40sec at f/11, tripod

Still life. One of the key skills to still-life photography is having the ability to identify suitable subjects and be able to arrange them suitably. A bowl of fruit or softly lit vase with flowers are typical of the still life subjects that normally first spring to mind. However, I'm sure you will soon think of more original concepts.

Nikon D300 with 24–85mm lens (at 70mm), ISO 100, 1/50sec at f/4, tripod

LENS TIP

Shape, form and contrast are all important ingredients of still-life photography. While colour often works best, don't overlook the possibilities of converting your digital images to mono at the post processing stage. Black and white can convey a sense of nostalgia, well suited to many still-life subjects.

STANDARD SUBJECTS: CANDID

CANDID PHOTOGRAPHY OFTEN RELIES JUST AS HEAVILY ON SPONTANEITY AS TECHNIQUE. IT CAN BE BEST DESCRIBED AS AN UNPLANNED, UN-POSED AND UNOBTRUSIVE FORM OF PEOPLE PHOTOGRAPHY, WITH THE PHOTOGRAPHER CAPTURING A BRIEF MOMENT OF EVERYDAY LIFE. ALL TYPES OF FOCAL LENGTH CAN BE USED FOR SHOOTING CANDIDS. A TELEPHOTO UPWARDS OF 200MM IS BEST IF YOU WISH TO WORK FROM DISTANCE AND REMAIN COMPLETELY UNNOTICED, BUT A STANDARD LENS OR, SHORT STANDARD ZOOM, IS ALSO A GOOD CHOICE FOR TAKING GOOD, NATURAL-LOOKING CANDIDS.

∧ **Surfer.** To ensure your images appear spontaneous and natural, your subject should be unaware of you and your camera. After I took this shot, I checked with the surfer that he didn't mind me taking his picture, but he was more than happy.

Nikon D70 with 18–70mm lens (at 35mm), ISO 100, 1/180sec at f/11 and handheld

Timing

Candid photography relies on timing – a split second too early or late and the person you are photographing may turn and look in the wrong direction, or their expression change. Therefore, you need to work quickly. Wedding receptions, bustling markets, high streets, parties and festivals are among the best places to shoot candids.

Good candid photographers keep their camera nearby, ready for any opportunity that might present itself. However, it is important to underline that some people object to having their picture taken, so seek permission when it is practical and never photograph children unless you have consent from a parent or guardian. In reality, most people are flattered when you take their photo and people like street artists and workers will happily go about their business while you position yourself ready to capture that unique moment.

A candid style of photography is growing in popularity, both in day-to-day and more formal situations – for example, many couples now favour a 'paparazzi style' of photography for their wedding pictures. A narrow depth of field often suits candid images, so select a relatively large aperture in the region of f/4. The shallow focus will help to separate your subject from its surroundings.

Images of people doing something often prove far more interesting than when your subject is passively doing nothing. Another benefit is that your subject will be concentrating on what they are doing, which takes their focus away from you and adds energy to the result.

∧ **Party time.** Parties and gigs are great places to shoot candid images. Don't overlook the possibility of converting digital images into black and white – many candid shots suit the simplicity and drama of this medium.

Canon EOS 20D with 50mm lens, ISO 200, 1/180sec at f/8 and fill-flash

Timing is everything, so wait until they are fully immersed in what they are doing before releasing the shutter. Candids of more than one person can also prove very striking. If your subjects are interacting, it can create the impression of relationship and, even if they are not, including more than one person will help add depth and interest. Creating a frame using foreground elements is also a good approach, when capturing candids. For example, by shooting over someone's shoulder, or including the frame of a doorway or window, you can give the viewer the impression that they are hiding behind something. This will only add to the voyeuristic feeling of a candid photograph.

LENS TIP

Regardless of the focal length you use to shoot candids, take lots of images. By shooting multiple images of your subject – as opposed to just one or two – you will often capture some surprising and spontaneous shots that you may have otherwise missed. By switching to a continuous shooting mode, you will increase your chances of capturing that perfect shot.

5 LENS TYPES:
TELEPHOTO

> Telephotos are designed to get us closer to our subjects. For example, using one allows photographers to shoot frame-filling shots of nearby objects, or achieve intimate portraits of distant wildlife that would otherwise be impossible with a shorter lens. They create the impression of condensing perspective, a feature photographers can utilize for creative effect. No lens type is better for shooting timid wildlife or distant action, and comes into its own in the composition of texture, detail and pattern.

TELEPHOTO LENSES: PRACTICAL CONSIDERATIONS

STRICTLY SPEAKING, ANY LENS LONGER THAN 50MM IS A TELEPHOTO. THESE LENSES HAVE A NARROWER ANGLE OF VIEW THAN THE HUMAN EYE, THEREFORE, SUBJECTS APPEAR LARGER OR MAGNIFIED THROUGH THE CAMERA'S VIEWFINDER. THEY ARE IDEALLY SUITED TO SHOOTING DISTANT SUBJECTS OR FOR WHEN YOU WISH TO FILL THE FRAME WITH YOUR SUBJECT. THEIR INHERENT SHALLOW DEPTH OF FIELD CAN PROVE RESTRICTIVE AT TIMES, BUT ADVANTAGEOUS AT OTHERS – HELPING ELIMINATE DISTRACTING FORE- AND BACKGROUND DETAIL BY THROWING THEM QUICKLY OUT OF FOCUS. ALSO, THE WAY A TELEPHOTO APPEARS TO FORESHORTEN PERSPECTIVE CAN BE UTILIZED TO CREATE STRIKING OR EVEN UNUSUAL RESULTS. A PRIME TELEPHOTO, OR TELE-ZOOM, IS A USEFUL ADDITION TO ANY PHOTOGRAPHER'S CAMERA BAG – BUT PARTICULARLY IF YOU ENJOY SHOOTING NATURE, SPORTS AND ACTION.

Focal lengths and types

Telephotos are available in a wide range of strengths up to and exceeding 1000mm – although, this type of specialist lens is not in the price range of the majority of photographers. Telephotos can be divided into three categories: short, medium and long telephotos. Short telephotos fall within a focal range of 50–135mm. While not particularly powerful, this is a useful and versatile range. They produce a flattering perspective that is well suited to portraiture and for isolating detail or interest within the landscape, or an urban environment. Even those boasting a fast maximum aperture tend to be fairly compact and lightweight, making them easy to handle and carry.

Focal lengths of 135–250mm are normally deemed to be a medium telephoto. The extra power they boast makes them suitable for shooting subjects from further away, or in situations when you can't get closer to your subject – sports events or public displays, for example. Many modern optics are designed with a relatively short minimum focusing distance, meaning they can also be utilized to shoot frame-filling close-ups of some larger subjects, like flowers. When attached to a DSLR with a cropped-type sensor, their power is increased further. However, as the focal length increases, typically, so does the physical size and weight of the lens – making it more difficult to hold your set-up steady without the aid of a support (page 40). A lens exceeding 250mm is termed a long telephoto. This is the principal tool of wildlife, sports and surveillance photographers. They allow the photographer to work from distance, yet capture images that look like they were taken nearby. Long telephotos are excellent for isolating detail, although depth of field grows progressively shallower with longer focal lengths, so careful focusing becomes more important. If the lens isn't supported, and doesn't boast image stabilizing technology, it is important to select a fast shutter speed to prevent camera shake.

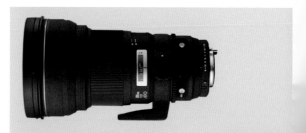

∧ > Prime 300mm telephoto and 70–300mm tele-zoom. Prime telephotos tend to offer the best image quality, and will normally boast a faster maximum aperture than the equivalent tele-zoom. However, zooms are typically cheaper, more versatile and physically smaller and lighter. Which type of telephoto you opt for will be greatly dictated by your needs and budget.

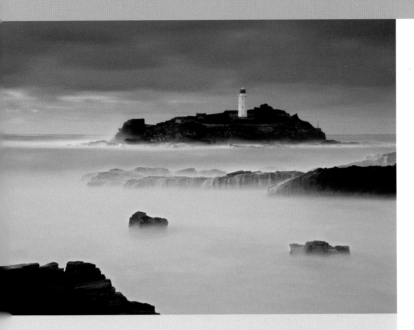

Lighthouse. Aside from subject magnification, a major characteristic of telephoto lenses is the way they compress perspective. This foreshortening, or stacking, effect results in elements of a scene appearing much closer together than they really are. It can prove a useful visual tool and is just one reason why a telephoto of some variety is a great addition to any photographer's kit bag.

...

Nikon D700 with 100mm lens, ISO 100, 20 seconds at f/18, tripod

Stability

Although advances in lens design mean telephotos are smaller than they once were, long focal lengths are physically larger, heavier and less portable than any other lens type. Telephotos with a fast maximum aperture – for example, f/2.8 or f/4 – are particularly big, large diameter lenses, that are physically long and heavy, which is often a result and indication of the lens's speed, rather than its magnification. Lens weight and length affects the photographer's ability to keep the camera still while taking pictures and, at slower shutter speeds, camera shake (page 55) is more likely to occur. Image stabilizing technology will help prevent this, but there is no substitute for a sturdy support. A tripod is best, but a monopod (page 40) is also a popular choice for supporting telephotos – nature and sports photographers, in particular, rely on the added support they offer. Long telephotos are often designed with a tripod bush at its base. As a result, the lens itself attaches to the support instead of the camera, providing a more balanced set-up and reducing the strain on the lens mount. If you have no choice, but to shoot handheld with a telephoto lens, prioritize a fast shutter speed. A good general rule is to employ a speed which is reciprocal with the focal length – for example, a minimum shutter speed of 1/400sec is required when using a 400mm lens.

Cost

Telephotos tend not to be cheap. Prime focal lengths of 300mm or greater, which also have a fast maximum aperture, will cost hundreds, if not thousands, and represent a serious investment. They are specialist optics, aimed for professional photography, hide work, the press and paparazzi. However, the majority of photographers do not generally require fast telephotos and will still be able to achieve the results they crave using a lens with a more modest maximum aperture of f/5.6 or f/8. Although slower, in good light you will be to achieve the shutter speeds required to freeze subject and camera movement. The added advantage of using a so-called, 'slower' lens is that their design is also more compact and they are not so heavy – making them more convenient to use and carry. Although prime telephotos tend to offer slightly better image quality, a tele-zoom is a better buy if you are on a budget. They are typically cheaper, more versatile, yet image quality remains high – particular at medium range f-stops of around f/8 or f/11. 70–300mm and 80–400mm zooms are good focal ranges that offer a large level of subject magnification. Most are designed with a maximum aperture of f/5.6 or f/8. In low light, this can prove restrictive, but if necessary a faster shutter speed can be generated by simply selecting a higher ISO sensitivity.

LENS TIP

If you can't justify or afford a long telephoto lens, combine a shorter focal length with an optical tele-converter (page 125). A 1.4x or 2x converter will increase your lens's range, helping you to capture frame-filling images of distant subjects.

TELEPHOTO LENSES: COMPOSITION

OUR EYES HAVE A FIXED FOCAL LENGTH — ROUGHLY EQUIVALENT TO A 50MM LENS ON A FULL-FRAME DSLR. AS A RESULT, WE ALWAYS SEE THE SAME ANGULAR DISTANCE AND FIELD OF VIEW. IN CONTRAST, THE WORLD APPEARS VERY DIFFERENT THROUGH A CAMERA LENS. WE ARE ABLE TO ALTER THE WAY WE SEE A SUBJECT, THANKS TO THE LENGTH OF THE LENS ATTACHED. MAGNIFICATION PROVIDES MANY CREATIVE AND COMPOSITIONAL OPPORTUNITIES. LONGER FOCAL LENGTHS REVEAL CLARITY AND DETAIL THAT WE CANNOT SEE NATURALLY, AND THEY ENABLE PHOTOGRAPHERS TO ISOLATE DETAIL, DISTORT SCALE AND FLATTEN PERSPECTIVE. TELEPHOTOS CAN PROVE USEFUL VISUAL TOOLS, CREATING DYNAMIC, EYE-CATCHING COMPOSITIONS.

Depth of field

Depth of field is the term used to describe the amount of a scene behind and in front of your chosen point of focus that remains sharp in the final image. Depth of field is greatly dictated by the lens aperture — a large aperture (small number) will create a shallow depth of field, while a small f-stop (large number) will maximize back-to-front sharpness. However, depth of field is also affected by focal length, with the area of sharp focus decreasing substantially as focal length increases. It is for this reason that diffused, out-of-focus backgrounds are a key characteristic associated with telephotos. This lack of depth of field can be utilized to good effect. In scenes boasting significant depth, it is possible to throw everything, but your focal point, out of focus — perfect for wildlife, action and candids. The effect can be visually striking, drawing the viewer's eye to your main subject, or intended point. This type of composition looks simple and uncluttered and is difficult to mimic using any other type of lens. To help throw back- and foreground detail quickly out of focus, also select a large aperture. However, doing so will make precise focusing essential. In order to check that the aperture you have selected will achieve sufficient depth of field to keep your main subject sharp, use your camera's depth of field preview button — which the majority of DSLRs are designed with.

∧ **Bramble leaf and frost.** Clean, diffused backdrops are a characteristic of long focal lengths. Use it to your advantage by isolating your subject from its surroundings. In this instance, I intentionally selected a focal length of 300mm in order to create a complementary out-of-focus background.

Nikon D200 with 100–300mm lens (at 300mm), ISO 200, 1/30sec at f/7.1, tripod

Perspective compression

Telephotos create the impression of bringing foreground and background objects closer together — the opposite effect to using a wideangle lens. For example, a row of pylons or trees can appear pressed up against one another in a photograph taken from distance using a telephoto lens. This is known as perspective compression — the greater the focal length, the more the effect is exaggerated. This type of compression is purely an illusion — it's not the focal length that alters perspective, but the camera's position. This form of foreshortening or 'stacking' is unique to telephotos and the effect can be utilized to create the impression that subjects at varying distances look artificially close to one another. This is particularly useful when you want an element in the background to impose itself on the foreground subject.

Filling the frame

Photographers can combine the effects of isolation and compression to capture 'full-frame' compositions. In other words, the subject fills the viewfinder for maximum impact, thanks to a telephoto's ability to magnify. This type of approach can suit practically any subject – for example, wildlife, architecture, people, texture and detail.

While, potentially, it is possible to fill the frame with your subject using any focal length, a telephoto's greater level of magnification means you can take this style of photo from further away. By doing so, photographers can also avoid the type of subject distortion associated with using a shorter focal length from close range. The technique eliminates the problem of distracting, or conflicting, fore- and background elements and creates intimate, eye-catching compositions. Full-frame images draw attention to fine detail – like texture, skin, hair, feathers or fur. A frame-filling portrait of a person or animal can look particularly effective, with good eye contact maximizing the picture's impact. However, compose your images with care and don't make your crop too abrupt. Don't fill the frame with your subject just for the sake of it – instead, be sure that this approach suits your subject.

 Beech avenue. Telephotos appear to compress perspective – making foreground and background objects seem much nearer to one another. This unusual perspective can prove a great compositional tool.

Nikon D200 with 100-300mm lens (at 100mm), ISO 200, two seconds at f/11, ND filter, tripod

LENS TIP

The unique perspective of a telephoto lens allows photographers to capture striking and unusual compositions. However, one drawback of their foreshortening effect is that the results can look quite flat – they often lack the three-dimensional feel of images taken with a wideangle.

Dartmoor pony. Long focal lengths allow photographers to photograph their subject – or specific detail – in isolation. The camera-to-subject distance and size of the subject will dictate the focal length required, but a lens in the region of 300mm is often a good choice.

Nikon D200 with 300mm lens, ISO 200, 1/400sec at f/4, tripod

TELEPHOTO SUBJECTS: SPORT

IT IS THE PHOTOGRAPHER, NOT THE EQUIPMENT, WHO MAKES THE PICTURE.
HOWEVER, WHILE THIS STATEMENT IS GENERALLY TRUE, WHEN PHOTOGRAPHING
SPORTS OR ACTION, YOU WILL STRUGGLE WITHOUT THE RIGHT EQUIPMENT. WHILE
ALL TYPES OF FOCAL LENGTH CAN BE UTILIZED FOR SPORTS, A TELEPHOTO
LENS IS THE PRINCIPAL TOOL OF SPORTS PHOTOGRAPHERS — ALLOWING THEM
TO CAPTURE FRAME-FILLING, ACTION-PACKED IMAGES FROM THE SIDELINES.

Telephoto sports

Naturally, the exact focal length you require will depend
on the sport, any restrictions that may apply, and the style
of image you wish to take. However, 200mm and 300mm
telephotos are generally the preferred choice among sports
enthusiasts. The level of magnification they provide is
sufficient to take images brimming with impact and which
make the viewer feel like they among the action. However,
when shooting sport, lens speed is also a critical factor. Lens
speed refers to the lens's maximum (largest) aperture. The
quicker the lens, the faster the shutter speed you can select.
The speed of the lens grows more important the longer the
focal length is. A fast shutter speed is often the priority when
shooting action, as the photographer will normally want to
suspend movement. Depending on the situation and speed
of the sport, this might involve using shutter speeds upwards
of 1/500sec. Unfortunately, telephoto and tele-zoom lenses
boasting a fast maximum aperture of f/4, or even f/2.8, are
pricey – often costing thousands. As a result, it's normally
only professional sports photographers who can justify
the outlay. However, great sports images are still possible,
even with a fairly basic set-up. A 70–300mm tele-zoom
will normally be powerful enough to take good images.
This type of zoom normally boasts a maximum aperture of
around f/5.6 at its long end, which will be fast enough, in
good light, in many situations. However, if your images are
suffering from subject blur and you need a faster shutter,
you can generate it by increasing the sensor's ISO sensitivity.
Although this will increase signal noise – and therefore
slightly degrade image quality – most new DSLRs boast
fantastic image quality up to and beyond ISO 800. Increasing
ISO speed is a logical compromise when you need a faster
shutter to ensure your action shots are critically sharp.

While only established sports photographers will have
access and permission to record the big sporting events,
great images are possible by photographing local sporting

∧ **Beach volleyball.** When shooting sport, don't just
photograph the obvious – look for interesting detail,
behaviour or technique. A long telephoto allows the
photographer to isolate specific detail and create
eye-catching, frame-filling images.

**Canon EOS 20D, 100–400mm lens (at 400mm), ISO 200,
1/400sec at f/6.3, handheld with image stabilization**

Serving. A telephoto allows you to get intimate action pictures at sporting events. Colour will add impact to your shots. Position yourself carefully in order to achieve a complementary backdrop which is also free of distraction.

Canon EOS 40D with 100–400mm lens (at 200mm) ISO 100, 1/640sec at f/6.3, handheld with image stabilization

events. For example, you don't typically need permission to photograph the local football or rugby teams playing, and this type of event is ideal for honing your skills. Here you can learn where best to position yourself and how to anticipate and react to the action. Always try to select a shooting position that will give you a clean or colourful backdrop. Due to the way a telephoto appears to compress perspective; the lens will quickly throw background detail out of focus, helping to separate your subject from its surroundings. Focusing is critical and achieving sharp images can prove a challenge when taking fast-moving action. Thankfully, most modern DSLRs have rapid and responsive automatic focusing systems, with the ability to 'track' movement. This will often prove the quickest, most reliable form of focusing. Also, select your camera's maximum frame rate, to enable you to capture large, continuous bursts.

While it's true that photographers will normally wish to freeze fast action, don't overlook the possibility of using a slower shutter speed to intentionally blur motion. This will help create the impression of movement. A slower shutter is also well suited to 'panning' (see box).

LENS TIP

Telephotos are long and can be bulky, making a camera support essential. A tripod will often prove too restrictive to camera movement. Instead, a monopod (page 40) is the support best suited to telephoto sports photography.

TELEPHOTO SUBJECTS: WILDLIFE

DESPITE THE CHALLENGES INVOLVED, WILDLIFE CONTINUES TO BE ONE OF THE MOST POPULAR SUBJECTS TO PHOTOGRAPH. HOWEVER, NATURE IS OFTEN ELUSIVE AND DIFFICULT TO GET WITHIN PHOTOGRAPHIC RANGE. IT IS FOR THIS REASON THAT POWERFUL TELEPHOTOS ARE THE PRIMARY TOOL OF WILDLIFE PHOTOGRAPHERS – ALLOWING THEM TO CAPTURE INTIMATE IMAGES OF NATURE FROM DISTANCE. THE USE OF LONGER FOCAL LENGTHS LESSENS THE RISK OF FRIGHTENING THE ANIMAL AWAY OR HAVING TO GET TOO NEAR TO THE CREATURE FOR YOUR OWN SAFETY. TELEPHOTOS ALLOW WILDLIFE PHOTOGRAPHERS TO TAKE PICTURES WITHOUT BEING INTRUSIVE.

Stalking

When photographing nature, there are two principal methods of getting your subject with range of your lens – by either stalking the animal, or using a hide. Stalking is a technique with a relatively low ratio of success, but often it is the only practical option. Stalking is when you approach a subject on foot – slowly getting nearer without distressing your subject, or causing it to fly or run away. While it is wise to dress in suitable clothing – camouflaged material, for instance – you are without cover, meaning the chances of being spotted by your subject are relatively high. However, when you are out with your camera and find a bird or mammal to photograph, you need to be an opportunist. With practice, it is surprising how close you can get to some animals. When stalking a mammal, always approach down-wind, so that they do not detect body odour or the smell of antiperspirant. Keep your movements small and stop if the creature looks in your direction or appears unsettled. Try to keep low so that your outline doesn't break the horizon. Use the most powerful telephoto available to you – the longer the focal length, the further away you can be from your subject.

When stalking, a tripod can prove bulky and cumbersome and the legs too difficult to position quietly and discreetly. However, unless you are using an image-stabilized lens, it is essential to support your heavy telephoto. When stalking, a monopod is the best choice, offering instant support with minimal fuss. If you don't own a monopod, or have one to hand, keep the legs of your tripod pushed together so that it acts like a makeshift monopod.

> **Robin.** Stalking is often the only practical way to get closer to wildlife. At parks and reserves, nature is much more accustomed to human activity and, therefore, tolerant of you staking them. They can prove good places to hone your stalking skills.

Nikon D70 with 400mm lens, ISO 200, 1/640sec at f/4, handheld

It is worth underlining that, when photographing nature, the wellbeing of your subject must always come first. If you suspect that young might be nearby, or that an adult bird is close to its nest, do not try to approach – if you do so, you will place the subject under great stress and risk the young or nest being abandoned.

LENS TIP

For photographers new to shooting wildlife with telephotos, consider visiting a zoo or safari park. Here, you can practise your focusing and compositional skills. If wire fencing proves a problem, select your lens's largest aperture – this will help throw wire mesh and distracting backdrop detail out of focus.

HIDE PHOTOGRAPHY

ARGUABLY, THE BEST WAY TO PHOTOGRAPH NATURE IS TO WAIT PATIENTLY IN ONE PLACE AND LET THE WILDLIFE COME TO YOU. THIS IS POSSIBLE THROUGH THE USE OF A HIDE. HIDE PHOTOGRAPHY CAN PROVE TIME CONSUMING. HOWEVER, AS THE PHOTOGRAPHER IS CONCEALED FROM THE SUBJECT, THE CHANCES OF SUCCESS ARE GREATLY ENHANCED AND THE RISK OF CAUSING DISTURBANCE REDUCED.

When working from a hide, a telephoto remains the best lens choice. However, as you are able to entice nature closer to you through baiting – placing out suitable food, or water, to help attract wildlife – a focal length in the region of 300–400mm should prove more than sufficient. The most useful types of hide available to nature photographers are small, portable hides. Either rectangular or domed in design, they are lightweight, collapsible and quick and easy to erect. Typically, they are made from camouflaged material – to help conceal their whereabouts – and have 'lens slits' designed to put your telephoto though. One-berth hides are relatively inexpensive – although you could save money by making your own or by using natural materials. The advantage of using a hide is that you can place it in a position suited to photography – where the light is good and with an attractive background. You can also introduce photogenic props. For example, when photographing songbirds, position an attractive, blossom-covered branch near your feeding station that they can use as a perch. While hide photographers need plenty of patience, they can be far more creative and have more control over the look of the final result. Hides not only conceal the photographer, but offer them and their equipment, protection from the elements.

⌃ **Dome hide.** By using a hide to conceal your presence, you can get much closer to timid wildlife. You could try making your own hide, or buying one ready-made.

▼ Blue tit. A hide is one of the best ways by which to photograph nature successfully. Portable hides allow you to take photos in the most suitable environment. Then, using food, water or nesting material, you can entice nature within range of your lens. While setting up and working from a hide can be time consuming, it offers photographers more creative control and increases their chances of success.

Nikon D200 with 100–300mm lens (at 300mm), ISO 400, 1/300sec at f/8, tripod, dome hide

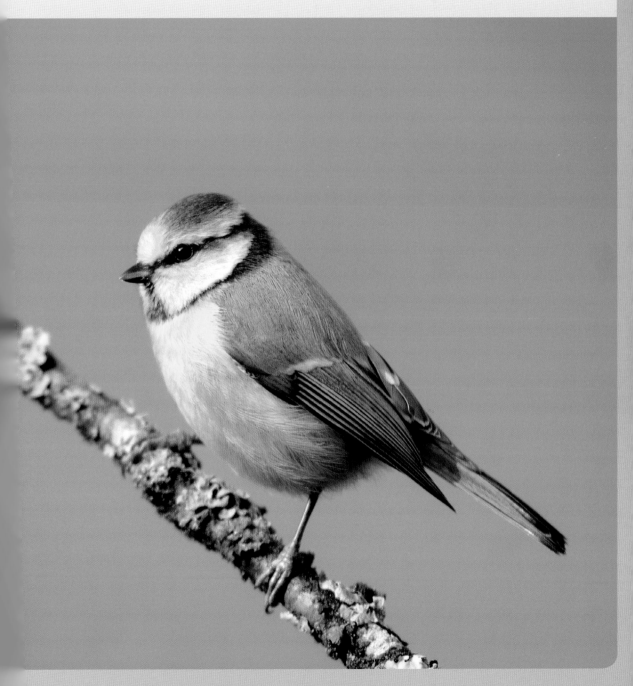

TELEPHOTO SUBJECTS: TEXTURE AND DETAIL

USING A TELEPHOTO LENS, PHOTOGRAPHERS CAN ISOLATE JUST A SMALL PART OF A SCENE OR SUBJECT. AS A RESULT, LONGER FOCAL LENGTHS ARE THE PERFECT CHOICE FOR PHOTOGRAPHERS WISHING TO TAKE FRAME-FILLING IMAGES OF TEXTURE OR INTERESTING DETAIL. NO OTHER LENS TYPE WILL ALLOW YOU TO PICK OUT AND CAPTURE KEY DETAIL WITH SUCH EASE AND PRECISION. TELE-ZOOMS ARE PARTICULARLY USEFUL FOR THIS FORM OF PHOTOGRAPHY – ALLOWING YOU TO CAREFULLY ADJUST WHAT YOU DO AND DON'T INCLUDE WITHIN THE IMAGE-SPACE WITHOUT HAVING TO CHANGE LENS OR ALTER YOUR SHOOTING POSITION.

Isolating detail

Telephotos can be utilized to highlight shape, form, repetition and detail that would otherwise go greatly unnoticed in photographs taken with a shorter focal length. However, this type of image relies on the photographer's creative eye – you need the ability to spot picture potential within a larger context.

For example, when photographing architecture, the temptation is to shoot buildings, or interiors, in their entirety using a wideangle (page 68). However, you should also look for the 'picture within the picture'.

Often, you can reveal much about the architectural style of a building just by highlighting small detail. A focal length upwards of 100mm will allow you to isolate the arrangement of windows, pillars, an archway, brickwork, stairway or even a door handle. Often the key to producing strong images is employing a tight composition – filling the frame with your subject will create impact.

The principle of using a telephoto to isolate interest can be applied to practically any subject – vintage cars,

> **Door handle.** A telephoto allows photographers to crop in tightly in order to isolate interesting form or detail. In this instance, a wider view of this beach hut wouldn't have worked. Instead, by using a telephoto to highlight the door handle and keyhole, I've managed to capture an image with impact and interest.

Nikon D200 with 70–300mm lens (at 70mm), ISO 100, 1/40sec at f/20, tripod

machinery, market stalls and signs, for instance. You just need to learn to look at the world around you in a different way.

The versatility and range of a 70–300mm tele-zoom is perfect for this style of photography and, being a compact lens type, they are well suited to using handheld if required – useful if taking pictures in an urban environment, when it may be unsafe or impractical to erect a tripod.

LENS TIP

When using long telephotos, beware of the 'pancake effect'. This is when a uniformly shaped object, which is filling the frame, appears abnormally flat due to over-compression. If an image looks too two dimensional, move closer and use a shorter focal length.

Abstract, patterns and texture

A telephoto lens is equally adept at capturing abstract-looking images. While usually we require a lens to record a subject sharply and accurately, with a high degree of realism, abstract images – by definition – are not a recognizable, accurate representation of the subject. However, the results can be artistic and striking and a long focal length lens is well suited to this style of photography. This is because the magnification of a telephoto allows photographers to isolate certain, specific elements, taking them out of context and revealing colour, texture and detail which would normally remain unseen or ignored. While focal length remains important, of greater significance is the photographer's ability to be creative in their approach – for example, by employing an unusual angle or using a creative technique. Motion can prove a useful visual tool when taking abstracts. By selecting a relatively slow shutter speed – in the region of ½sec or longer – you can intentionally blur the subject's movement. For example,

a swaying crop, flock of birds in flight or flowing water. However, when attempting this type of technique, always support your telephoto with a tripod – you do not want to add camera movement to that of the subjects. A telephoto lens allows you to take 'full-frame' compositions – something which often works well when shooting patterns and textures. Abstract photography will not appeal to everyone – and the results are often highly subjective. However, no other form of photography allows you to express your creativity more.

Lavender field. Often, to create arty, abstract images, a shallow depth of field works best. Therefore, give careful consideration to the lens aperture you select, as this will greatly dictate the level of back-to-front sharpness you achieve. In this instance, a large f/stop of f/4 created the best result.

Nikon D300 with 150mm lens, ISO 200, 1/180sec at f/4, handheld

6 SPECIALIST LENSES

When a wideangle, standard or telephoto lens is unable to fulfill our needs, a specialist lens type is the likely answer. There is a range of different types available, with the most popular being a macro – a lens optimized for close focusing and ideally suited to close-up enthusiasts. If you require an extreme wide angle of view, consider the surreal effect of a fisheye lens. If you wish to control perspective distortion in-camera, a tilt and shift lens could be for you. Learn more about these lens types in the following pages.

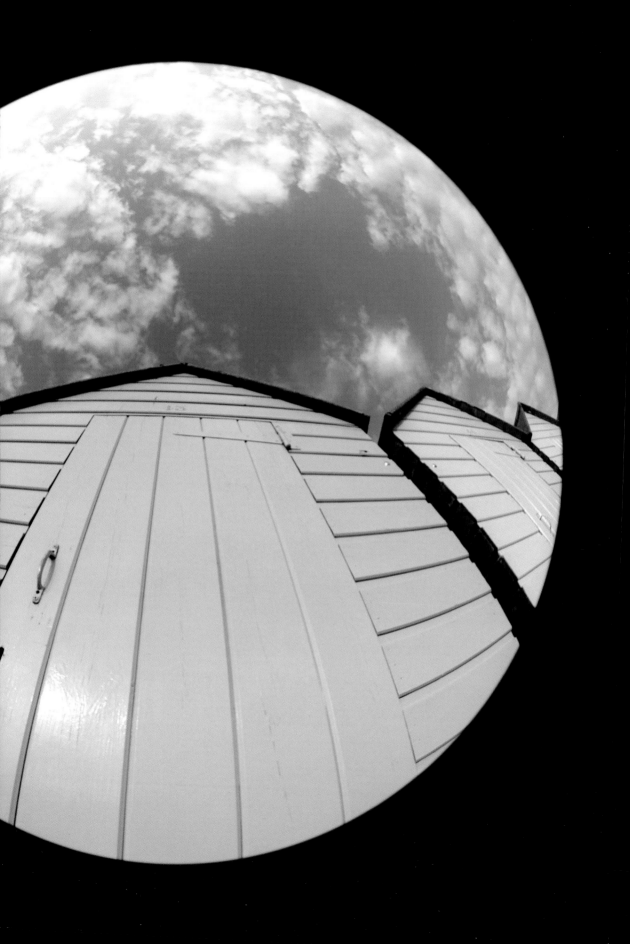

AN INTRODUCTION TO SPECIALIST LENSES

WIDEANGLE, STANDARD AND TELEPHOTO LENSES ARE THE MOST COMMON AND WIDELY USED LENS TYPES. TOGETHER, THEY PROVIDE PHOTOGRAPHERS WITH A WIDE AND VERSATILE RANGE OF FOCAL LENGTHS, SUITED TO MEET THE CHALLENGES OF DAY-TO-DAY PHOTOGRAPHY. HOWEVER, CERTAIN SUBJECTS PROVIDE AN ADDED CHALLENGE — FOR EXAMPLE, MINIATURE OBJECTS OR ARCHITECTURE — REQUIRING A SPECIALIST LENS IN ORDER FOR PHOTOGRAPHERS TO CAPTURE THEM THE WAY THEY WANT. THERE ARE A HANDFUL OF SPECIALIST LENSES AVAILABLE, DESIGNED TO COMPLEMENT THE TRADITIONAL LENS TYPES. THIS CHAPTER WILL INTRODUCE YOU TO THEM AND THE PURPOSE OF THEIR DESIGN.

Specialist optics are either designed for a specific type of photography, or have a unique quality or perspective that can be utilized creatively. They are intended to bridge the gaps of conventional lens types. The most common and useful specialist lenses are; fisheye (page 108), macro (page 110), tilt and shift (page 114) and mirror (page 116). Each type has a very specific role, with a relatively limited range of uses. Therefore, the majority of photographers will only be able to justify the investment if they are likely to use the lens on a frequent basis. For example, unless you regularly intend shooting close-ups, there is little point spending hundreds on a dedicated macro lens. However, used appropriately, specialist lenses can help you to achieve results that would be impossible with a conventional lens. For example, the extreme perspective of a fisheye is unique to this style of lens and, whilst the effect might not be to everyone's taste, there is no denying that the results are fun and eye-catching. Some specialist optics are

designed to compensate for the limitations of conventional lenses. The primary role of a tilt and shift lens, for instance, is to correct perspective distortion. They are designed with both tilt and shift movements, which can be used to correct the problem of converging verticals (page 68).

Due to their nature, specialist lenses tend to be more costly; there is less demand for them so, typically, prices are higher. Mirror lenses are an exception to this rule, though. Compromises have been made in their design in order to make them intentionally cheaper than a normal telephoto. However, their functionality is limited in comparison and, consequently, they have grown less popular in recent years.

Specialist lenses help to further expand a digital SLR's range of capabilities. The next few pages are intended to help you decide which types are suited to your photography.

THE LENSBABY

Lensbabies are not a filter, but neither are they like a conventional lens. They attach directly to your camera body – just like a normal, interchangeable lens – and work by bringing just one area of the photo into sharp focus. The rest of the frame is rendered diffused, with glowing highlights. You can quickly adjust the area in focus to any part of the frame by bending its flexible lens tubing. A Lensbaby's effect is not dissimilar to that of a soft focus filter and they are designed to promote a creative and fun approach to photography.

∧ **Oilseed rape.** The extreme wide angle of view of a fisheye lens is unique to this style of lens. There are several specialist lens types available, helping to expand photographer's capabilities beyond that of more traditional focal lengths and types.

Nikon D300 with 4.5mm fisheye lens, ISO 100, 1/40sec at f/18, tripod

FISHEYE LENSES

FISHEYE PHOTOGRAPHY IS A SUBJECTIVE EFFECT — YOU EITHER LOVE IT OR HATE IT. A TRUE FISHEYE IS A LENS BOASTING AN ANGLE OF VIEW NOT LESS THAN 180 DEGREES. OFTEN, THIS IS MEASURED DIAGONALLY, BUT THERE ARE FISHEYES AVAILABLE THAT HAVE A 180-DEGREE ANGLE OF VIEW IN ALL DIRECTIONS, CREATING A CIRCULAR IMAGE SPACE WITHIN THE CENTRE OF THE VIEWFINDER.

The name originates from the fact that fish looking upward can see a whole hemisphere above the water, due to the refraction of light at the water/air interface. The very first fisheye images were captured using a pinhole camera, with water acting as a 'lens', and originally the fisheye concept was designed for scientific use. This is because, with hemispherical coverage, it is possible to photograph the entire sky in a single frame. While this makes them ideal for astronomical and meteorological studies, due to their unique characteristics and high level of barrel distortion, today they are most popular for their huge creative potential.

There are two types of fisheye — circular and full frame. When using a circular-type lens, the 180-degree angle of view is projected onto the sensor as a circle within the rectangular image-space. However, when the popularity of fisheyes grew in general, everyday photography, manufacturers began producing them with an enlarged image circle, circumscribed around the entire frame. This type of full-frame fisheye means that less of the image-space is wasted and the majority of fisheyes are full-frame design. By their nature, fisheyes display progressive distortion towards the periphery of the image and, while there are several possible geometries for this distortion, the majority produce equidistant projection — where the radial distance from the optical centre of the image is directly proportional to the angle of view.

Being such a specialized lens type, there is not a huge choice on the market and, as a result, they don't tend to be cheap. Canon, Nikon and Sigma all have fisheyes within their range, but the Russian-made Peleng 8mm is the only genuine budget option.

If you are sceptical about the fisheye effect, reserve judgement until you have the opportunity to look at the world through such an extreme focal length. The fisheye effect is captivating. The lens's unique perspective can be combined to good effect with practically any subject — you just need to learn to look at your environment differently and with a creative eye.

∧ Oxeye daisies. You can achieve some eye-catching effects using a fisheye lens. In this instance, I lay prone on the ground and angled the camera upward to photograph these oxeye daisies from a worm's eye perspective against the blue summer sky.

Nikon D300 with Sigma 4.5mm circular fisheye lens, ISO 100, 1/400sec at f/14, handheld

LENS TIP

When using a fisheye, the darkening of the corners of the frame can fool multi-segment metering into believing the scene is darker than reality. As a result, it will automatically select a longer exposure. Opt for either centreweighted or spotmetering when using a fisheye.

The lens's 180-degree angle of view allows you to include a huge amount within the image-space. This is ideal for giving images context and perfectly suited to such subjects as environmental portraits. The characteristic barrel distortion of the lens can be exaggerated further by getting very near to your subject. At small apertures, depth of field is extensive, so you can position the front element just centimetres away from your subject and it will still remain acceptably sharp. This presents all types of creative possibilities, allowing photographers to create interesting or humorous effects and place emphasis on anything close to the lens. For example, buildings can appear to bow inward or an animal or person's head can be made to look disproportionate to its body. At first, the merits of such effects may not seem appealing, but in reality the results can appear eye-catching and striking. However, using a fisheye lens

⋀ Fisheye lens. A variety of fisheye lenses is available to buy. Sigma's 4.5mm circular fisheye is the first digitally optimized circular fisheye designed exclusively for combination with DSLRs incorporating an APS-C-sized image sensor.

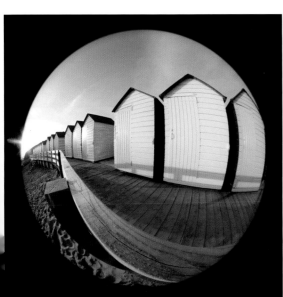

⋀ Beach huts. Be careful when using a fisheye lens to avoid including your own shadow in the picture. Also, flare can prove a problem, as it can be difficult to exclude the sun from the frame due to the wide angle of view. However, sometimes flare can be utilized as part of the image.

..

Nikon D300 with Sigma 4.5mm circular fisheye lens, ISO 100, 1/400sec at f/14, handheld

LENS TIP

It isn't possible to mount conventional filters to the front of a fisheye, but many are designed with a gelatin filter holder at the rear of the lens. Even so, fisheyes aren't compatible with such things as graduated neutral density filters, so achieving a balanced exposure in-camera isn't always possible.

can also prove quite challenging. Due to the extremely wide angle of view, excluding your own shadow from the frame can be tricky at times – particularly in morning or evening light, when shadows are long. Also, be careful not to include your own feet or leading tripod leg in your picture – this might seem like obvious advice, but is easy to do. Consideration is needed when composing shots. Fisheye photography isn't something that can be rushed and the elements you include within the frame need arranging with great care.

Before buying, you need to feel confident that you will use the lens regularly – it is too much cash to part with if you think that the novelty of its effect might wear off after just a month or two. However, while the fisheye effect won't be to everyone's taste, their creative potential is clear to see – and they are also great fun to use.

MACRO LENSES

MACRO LENSES ARE DESIGNED FOR CLOSE-UP PHOTOGRAPHY. THEY BOAST HIGHLY CORRECTED OPTICS WHICH PERFORM BEST AT A MAGNIFICATION NEAR TO 1:1 LIFE-SIZE – MAKING THEM IDEALLY SUITED FOR CAPTURING CLOSE-UPS OF THE FASCINATING MINIATURE WORLD AROUND US. HOWEVER, THEY ARE ALSO USEFUL FOR GENERAL PHOTOGRAPHY AND ARE POPULAR AMONG PEOPLE PHOTOGRAPHERS FOR SHOOTING FLATTERING PORTRAITS.

True macro photography is generally considered to be 1:1 life-size or greater – in other words, the subject is projected onto the sensor approximately the same size (or greater) as it is in reality. Today, photographers often use 'macro' as a general term to describe any close-up image. While this might not be technically correct, it really isn't of any great consequence.

Macro lenses boast optics optimized for close focusing. At their minimum focusing distance, they produce a 1:1 reproduction ratio and, while this level of magnification is possible using a standard lens combined with extension tubes, bellows or a reversing ring, none of these alternatives offers the same level of convenience and ease of use.

Macro lens. Macro lenses are available in a variety of focal lengths, but practically all boast the same maximum 1:1 reproduction ratio. Short macros, like Canon's EF-S 60mm, are compact and comparatively light – making them practical to use handheld if required.

REPRODUCTION RATIO

Reproduction ratio is a term used to describe the actual size of the subject in relation to the size it appears on the sensor – not the size to which the image is subsequently enlarged on screen or when printed. For example, if an object 40mm wide appears 10mm on the sensor, it has a reproduction ratio of 1:4 – or quarter life-size. If the same object appears 20mm in size, it has a ratio of 1:2 – or half life-size. While if it appears the same size on the sensor as it is in reality, it has a reproduction ratio of 1:1 – or life-size. This can also be expressed as a magnification factor, with 1x equating to 1:1 life-size. The vast majority of macro lenses are capable of projecting a life-size image (1:1) on the sensor without the aid of extensions or adapters.

The majority of macro lenses are prime focal lengths, ranging from 50mm to 200mm, and normally boast a fast maximum aperture – typically f/2.8. Regardless of their focal length, they all still offer the same high level of magnification. The advantages of using a short macro, in the region of 50–70mm, are that they're compact, light and can be comfortably used handheld. They are ideal if you wish to photograph static subjects – like flowers and still life – but at their minimum focusing distance (maximum magnification) the front element will be near to the subject. Their short working distance can prove a problem when photographing wildlife, as the risk of disturbing the subject is increased when shooting in such close proximity. Also, working so near to the subject can create problems with lighting – as your own shadow may obstruct the light reaching the subject.

Macro lenses, upwards of 100mm, are preferred by most close-up photographers. They provide a larger working distance, making it easier to photograph subjects from further away and allowing sufficient room to work with lighting accessories – like flash or a reflector. Also, the narrower angle of view provided by a tele-macro results in less background area being recorded in the frame. This, together with the way longer focal lengths appear to flatten perspective, means that it is easier to blur the background in order to isolate your subject.

However, the drawback of using longer macros is that they tend to be heavier and more awkward to use handheld. Before deciding which focal length to opt for, first consider the type of subjects you anticipate photographing. A good multi-purpose focal length is a 105mm, though.

Like most specialist optics, they do not tend to be cheap, but if you enjoy close-up photography, a dedicated macro lens will prove an excellent long-term investment.

LENS TIP

Although some standard zooms also feature the word 'macro' in their title, this is simply an indication that the lens has close-focusing ability. While such optics might offer a handy reproduction ratio of around 1:4 quarter life-size, they shouldn't be mistaken for a true macro.

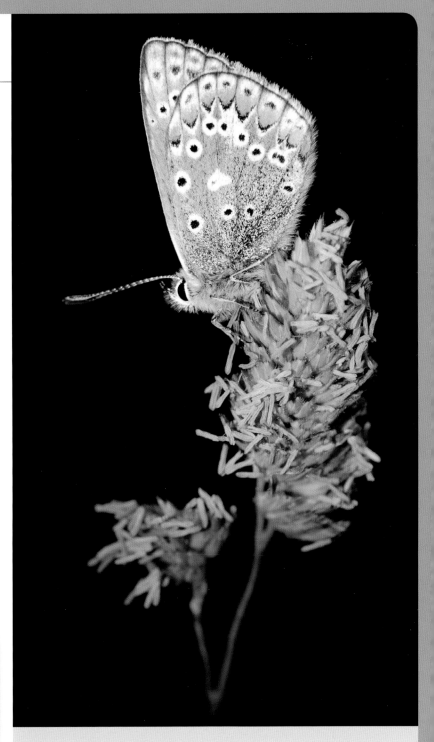

⋀ Common blue butterfly. In order to achieve frame-filling images of miniature subjects – like this small butterfly – the high image quality and ease of use of a macro lens make them an unrivalled choice for close-up enthusiasts.

Nikon D300 with Sigma 150mm macro lens, ISO 100, 1/8sec at f/20, tripod

MACRO SUBJECTS

MACRO LENSES ARE OPTIMIZED TO PROVIDE THEIR BEST PERFORMANCE AT A HIGH LEVEL OF MAGNIFICATION. A TRUE MACRO – OR 'MICRO' LENS, AS SOME MANUFACTURERS REFER TO THEM – WILL OFFER UP TO 1:1 LIFE-SIZE REPRODUCTION, MEANING THAT THE PROJECTED IMAGE ON THE SENSOR IS THE SAME SIZE AS THE OBJECT BEING PHOTOGRAPHED. THEIR CLOSE FOCUSING ABILITY MAKES THEM THE PREFERRED CHOICE AMONG FLORAL, STILL-LIFE AND MEDICAL PHOTOGRAPHERS. HOWEVER, THEIR FOCAL LENGTH MAKES THEM WELL SUITED TO A WIDE VARIETY OF SUBJECTS. THEREFORE, A MACRO WILL PROVE A USEFUL ADDITION TO ANY PHOTOGRAPHER'S LENS SYSTEM. THEY ARE MOST COMMONLY USED TO PHOTOGRAPH NATURE AND PORTRAITS.

∧ **Common frog.** If you wish to photograph small wildlife subjects – like insects, amphibians and reptiles – invest in a dedicated macro lens. They offer unrivalled convenience and image quality when shooting close-ups.

Nikon D300 with 150mm macro lens, ISO 200, 1/320sec at f/4, handheld

Wildlife close-ups

Often, when you photograph wildlife, you need to work quickly and efficiently. This is just one reason why a macro lens is popular among nature photographers. Once the lens is attached to the camera, you are ready to begin taking pictures – no other close-up accessory is required in order to achieve its maximum level of magnification. As a result, you can shoot with the minimum of fuss. Short macro lenses are compact and light enough to enable you to comfortably shoot handheld if required – useful when photographing flighty, timid subjects that prohibit the use of a support. The optical quality of a macro ensures images are bitingly sharp and crisp – they offer superior image quality to close-up filters (page 134). Also, longer macro lenses provide a good subject-to-lens working distance – helping to minimize the risk of subject disturbance and allowing photographers to keep a safe distance from venomous wildlife. Personally, I prefer using a 150mm 'telephoto macro' – the common description for longer focal length macro lenses. While its extra weight and length require the use of a support, its narrower angle of view helps throw surrounding vegetation quickly out of focus – useful when you want to isolate something like a butterfly, frog or reptile from its environment. When approaching miniature wildlife subjects, position yourself slowly, being careful not to disturb nearby vegetation that might frighten the creature away. Also – when working so close to your subject – be careful not to cast your shadow across the animal; something which will immediately alert it to your presence.

A good choice for portraits

Due to its close focusing ability and high level of magnification, a macro lens is best known for capturing close-ups. However, it is also an excellent lens for general photography and, with a typical focal length in the region of 100mm, an excellent and popular lens choice for taking portraits. This type of focal range allows the photographer to work from a comfortable distance, ensuring that the sitter doesn't feel too intimidated or self-conscious. Using a shorter focal length, you risk intruding into the model's personal space. This will make them feel less relaxed and your shot will appear less natural as a result. Another advantage of using a medium telephoto, in that a focal range of 70mm to 135mm

LENS TIP
Try to position your camera parallel to the subject, rather than at an angle – this will help you to maximize the available depth of field at any given lens aperture.

creates a flattering perspective; ensuring facial features look nicely proportionate to one another. In addition to this, a macro lens will normally boast a fast maximum aperture of f/2.8 or f/4, creating a bright viewfinder to assist focusing and aid composition. Also, as the lens isn't being used at a high level of magnification, it can be comfortably used handheld if you require the creative freedom this allows. A focal length much longer than 100mm isn't generally practical for portraits, resulting in the photographer standing too far away from the subject to communicate properly.

Evie. Although macro lenses are optimized for close-focusing, they work like any other lens and can be utilized to photograph a wide range of subjects. A medium-length macro – in the region of 70mm to 100mm – is perfectly suited to capturing flattering portraits.

Nikon D300 with Sigma 105mm lens, ISO 400, 1/180sec at f/4, fill-flash, handheld

Tilt and shift lenses

With conventional optics, the axis of the lens is mounted in a fixed position at right angles to the sensor plane. As a result, if you point your camera up or down, subject distortion will occur. This type of distortion – known as convergence – is most apparent when photographing rectilinear subjects, typically buildings, and is simply a product of the camera's sensor plane not being parallel to the plane of the subject. Tilt and shift – or perspective control – lenses are designed to correct this problem. They are an essential tool for architectural photographers, but have other uses aside.

Perspective control

Tilt and shift lenses mimic the front rise and fall movements of a view camera and many leading manufacturers boast at least one perspective control lens within their range. Due to the way they are designed and constructed, they allow photographers to alter the plane of focus, control depth of field and correct converging verticals (page 68) when shooting buildings. Typically, they boast a focal length in the region of 45mm.

While subject distortion isn't always undesirable, it is a common problem that architectural photographers, in particular, often want to correct if they are to portray a subject authentically. However, product and scenic photography can also benefit from the elimination of this type of distortion.

The tilt and shift principle involves two different types of movement – rotation of the lens (tilt) and movement of the lens parallel to the image plane (shift). Tilt controls the

THE SCHEIMPFLUG PRINCIPLE

The Scheimpflug principle is a geometric rule describing the orientation of an optical system's plane of focus when the lens plane isn't parallel to the image plane. It is commonly applied to the use of movements on a view camera or tilt and shift lens.

Normally, the lens and sensor planes of a camera are parallel and the plane of focus parallel to the lens and image planes. If a planar subject – the side of a building, for example – is also parallel to the sensor plane, it can coincide with the plane of focus and the entire subject can be recorded sharply. However, if the subject plane is not parallel to the sensor plane, it will only be in sharp focus along a line where it intersects the plane of focus. When an oblique tangent is extended from the sensor plane, and another is extended from the lens plane, they meet at a line through which the plane of focus also passes. With this condition, a planar subject – that is, not parallel

to the sensor plane – can be completely in focus. The principle is named after Captain Theodar Scheimpflug who used it when devising a systematic method for correcting perspective distortion in aerial photography.

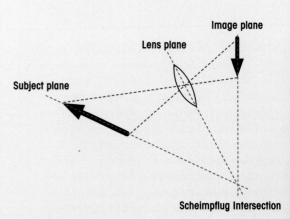

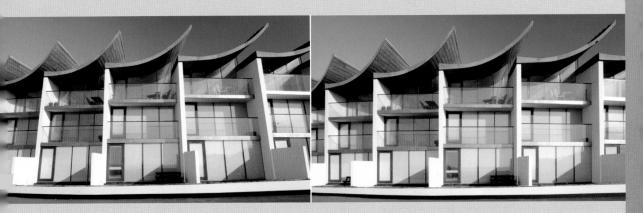

Tilt and shift lens. The image captured by your DSLR's sensor is just a central, rectangular crop of the circular image projected by the lens – known as the 'imaging circle'. In a conventional lens, this circle extends just beyond what is needed by the sensor. In contrast, a shift lens actually projects a much larger imaging circle than is ordinarily required – thereby allowing the photographer to 'shift' this imaging circle to selectively capture a given rectangular portion.

orientation of the plane of focus and, as a result, the area of the final image that appears sharp. Shift is used to control perspective, eliminating the convergence of parallel lines.

Tilt

The tilt movement on a perspective control lens enables the photographer to tilt the plane of sharpest focus in order that it no longer lies perpendicular to the lens axis. In effect, this creates a wedge-shaped depth of field – its width increases further from the camera. Therefore, the tilt movement doesn't actually increase depth of field – it simply allows photographers to customize its location to suit their subject better.

The plane of focus can also be oriented so that only a small part of it passes through the subject. This can be utilized to create a shallow zone of sharpness for creative effect – not dissimilar to that achieved by a macro lens when photographing miniature objects.

Shift

When the subject plane is parallel to the sensor plane, any parallel lines of the subject will remain parallel in the final image. However, if the sensor plane is not parallel to the subject – as is the case when pointing the camera upward to photograph a tall building, for instance – parallel lines converge and the subject appears less natural. Shift is a movement of the lens that allows the line of sight to be adjusted, while the image plane – and focus – remains parallel to the subject. Typically, this type of design is used to keep the sides of tall buildings parallel in architectural photography. The lens can also be shifted in the opposite direction, and the camera tilted up, to creatively exaggerate this type of convergence.

Optics designed for shifting have a much wider field of vision than a conventional lens of similar focal length. While the image frame fits tightly in a standard lens, a shifting lens has an imaging area many times wider. Shifting the lens allows different portions of the image circle to be cast onto the sensor plane.

LENS TIP

A tilt and shift lens is well suited to creating seamless panoramics, when stitching several images together for this purpose. The advantage of using a tilt and shift design, as opposed to a conventional lens, is not having to move the optical centre of the camera lens. As a result, photographers can avoid the problem of parallax error with foreground subjects.

MIRROR LENSES

MIRROR LENSES ARE AIMED AT PHOTOGRAPHERS WHO REQUIRE A LONG FOCAL LENGTH, BUT CANNOT JUSTIFY OR AFFORD THE HIGH PRICE TAG USUALLY ASSOCIATED WITH PRIME TELEPHOTOS. THEY ARE CONSTRUCTED USING A COMBINATION OF ELEMENTS AND MIRRORS AND WORK LIKE A REFLECTING TELESCOPE. ESSENTIALLY, THE INTERNAL MIRROR FOLDS THE LIGHT PATH IN HALF, ALLOWING THE LENS TO BE SHORTER, LIGHTER AND CHEAPER THAN A TRADITIONAL TELEPHOTO. THE MAJORITY OF MIRROR LENSES HAVE A FOCAL LENGTH OF 500MM AND BOAST A FIXED APERTURE OF EITHER F/5.6 OR F/8. DUE TO THE POPULARITY, QUALITY AND LOW PRICE TAG OF MANY TELE-ZOOMS TODAY, MIRROR LENSES ARE FAR LESS POPULAR – PRESENTLY, SONY IS THE ONLY MAJOR BRAND TO BOAST A 'REFLEX' LENS WITHIN ITS RANGE. HOWEVER, THEY CAN BE BOUGHT CHEAPLY ON AUCTION SITES LIKE EBAY AND REMAIN AN ECONOMICAL WAY TO GET CLOSE TO DISTANT SUBJECTS.

Mirror – or 'reflex' – lenses employ both glass elements and mirrors in their design. This type of construction is known as a catadioptric optical system and the technology utilized in photographic lenses is similar to that used for astronomy. Incoming light is reflected by a main mirror – located at the rear of the lens – towards a small secondary mirror at the front. This then reflects the light back towards the sensor via a corrective glass element. The lack of glass elements within its design has certain advantages over refractive lenses. For example, chromatic aberrations (see page 59) are virtually nonexistent. Also, due to the way the light path is 'folded' by the mirrors, reflex lenses are much more compact – a refractive lens of equivalent power might have as many as 20 optical elements in a housing of almost equal length to that of the lens's focal length.

While they are physically shorter in size and comparatively lightweight – making them easier to store or transport – the main mirror at the rear of the lens is quite large, so their width is increased. This also precludes the use of an adjustable diaphragm, meaning the aperture is fixed – normally at f/8. As you can imagine, this severely impedes exposure control. It is only possible to adjust the incoming light levels using shutter speed or neutral density filters. Also, with the fixed aperture being relatively slow, it is difficult to capture moving subjects – wildlife or sports, for example – unless the conditions are bright and sunny.

One of the main characteristics of catadioptric lenses is the 'doughnut' shaped bokeh – the quality of the out of focus areas of a picture – that they create. This is due to the position of the secondary mirror mounted at the front of the lens, which blocks part of the light path and transforms out-of-focus areas – particularly highlights – into little rings. Although this type of background blur can prove quite attractive, more often it is distracting and undesirable. Optically, image sharpness is normally no better than average and contrast is also quite flat. So, while 'reflex' lenses are a cheap introduction to telephoto photography, and fun to play with, the lack of control over depth of field and poor image quality severely limits their usefulness and appeal.

▼ **Mirror lens.** Only 10 or 15 years ago, practically all lens manufacturers had at least one reflex lens within their range, but today they are far less popular. However, they are still available from some independent brands, like Korean manufacturer Samyang. You can also find them second-hand and through auction sites.

MIRROR LENS DESIGN

Rather than using only glass elements to generate the focal length of the lens, a catadioptric optical design works by 'folding' the optical path in on itself. As a result, the size and weight of the lens is reduced, making longer focal lengths, such as 500mm and 1000mm more accessible to photographers on a budget. This graphic helps to illustrate just how a mirror lens works.

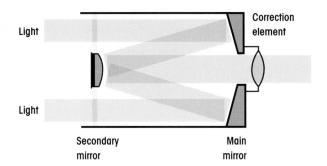

Light

Light

Correction element

Secondary mirror

Main mirror

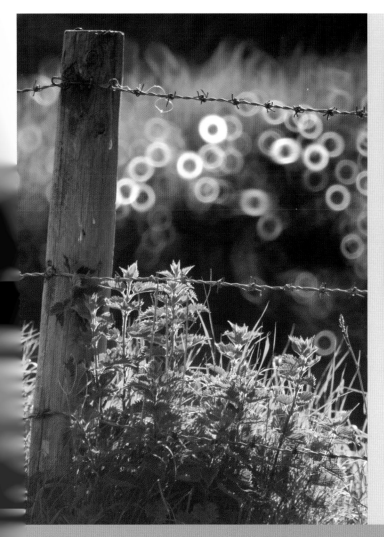

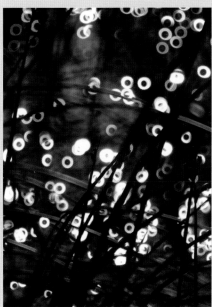

Mirror lens. One of the main characteristics of a mirror lens is the way it renders out of focus highlights as 'halos'. This type of background blur betrays the use of a catadioptric design.

Canon EOS 5D MkII with 500mm mirror lens, ISO 200, 1/250sec at f/8 and tripod

7 ACCESSORIES

A lens's capabilities can be further enhanced by using one of a number of lens accessories available. Arguably, the most popular and useful of these is a tele-converter – designed to magnify the lens's focal length. Extension tubes, reversing rings and bellows all share a similar aim – to allow a lens to focus closer in order to increase its level of magnification. Lens hoods, rain sleeves and wraps are also available – useful accessories that help you protect your valuable optics.

ACCESSORIES

WHILE A LENS HOOD — A SHADE DESIGNED TO HELP PREVENT LENS FLARE — IS THE MOST WIDELY KNOWN AND USED LENS ACCESSORY, THERE IS A VARIETY OF OTHER HANDY ACCESSORIES AVAILABLE. THERE ARE VARIOUS LENS WRAPS, POUCHES, BAGS AND SLEEVES ON THE MARKET, INTENDED TO HELP YOU PROTECT AND CARE FOR YOUR VALUABLE OPTICS. HERE WE LOOK AT SOME OF THE MOST PRACTICAL.

Lens hood

A lens hood is a plastic, metal or rubber ring which attaches to the end of the lens via a bayonet fitting. Its role is to block non-image-forming light from striking the lens from the sides – reducing contrast and causing unwanted lens flare. They are particularly useful when working outdoors and taking pictures in the general direction of the light and for backlit subjects. The majority of new lenses are supplied with a dedicated hood, designed to fit that specific model. They are made in a variety of shapes and sizes, depending on the lens and focal length. The most common are slightly flared, conical shaped hoods (much like a lampshade) of medium length – 8–20cm long. Lens hoods for telephoto lenses tend to be longer as, due to their limited field of view, the hood can extend further from the end of the lens. However, short focal lengths – prime or zoom – require a smaller and more complex hood design. A standard cylindrical hood would block the lens's wide field of view and create vignetting (page 69). Instead, a 'flower' or 'petal' shaped hood is more commonly used – basically a short hood with notches cut out to ensure that, when fitted correctly, it offers the lens optimum protection from stray light, without causing darkening at the corners of the frame. Hoods are often designed so that they can fit onto the compatible lens facing either forward – when in use – or backwards, so that the hood can be stored with the lens without occupying additional space. A lens hood also offers a certain degree of physical protection to the front of the lens from rain, snow and accidental damage.

< **Lens hood.** Hoods are highly useful lens accessories, helping to reduce the effects of flare and also offering some physical protection to the front of the lens. Most new lenses are supplied with a dedicated hood. They can be purchased separately.

Rain sleeves

Rain sleeves are simple accessories that can prove highly useful for outdoor photographers when the weather is poor or changeable. They are ideal in situations when you don't wish to pack away your camera, despite showery conditions. There are several different versions available, but all are designed to do the same job – protect the lens and camera from the elements. Despite being inexpensive, the version by OP-TECH features an eyepiece opening that will adapt to most camera viewfinders, allowing the photographer to compose images through the camera, not through the plastic covering. All camera and lens controls can be easily seen and operated through the transparent sleeve and the drawstring enclosure will fit lenses up to 17.8cm in diameter and 45.7cm in length. Kata produces a range of sophisticated, hardwearing protective coverings that slip over camera and lens quickly and which can be secured using the adjusters and pull cords. Two spacious side sleeves allow access to camera and lens controls, and an adjustable stiff hood fits a variety of lens diameters. A full-length double zipper ensures complete closure, whether shooting handheld or on a tripod. Kata's Elements covers are available in different sizes, to fit and protect different focal lengths. If you are an outdoor photographer, and are likely to be shooting in changeable conditions, a rain sleeve is a good investment – ensuring your equipment is safely protected from potentially damaging wet weather.

Pouches

Although camera bags and backpacks are generally well padded and give your optics ample protection from everyday knocks and bumps, some photographers like to keep their valuable lenses in additional pouches, stored within the bag. Although this takes up more room, it keeps optics safer and at a more constant temperature – good for avoiding condensation when not in use. The majority of lens pouches have a belt loop, or shoulder strap, to allow easy access – helpful when you need to change focal length quickly. Some

Rain sleeve. Some rain sleeves are cheap and disposable, while others are more sophisticated and hardwearing. While more costly, the versions by Kata offer both camera and lens excellent protection from the elements.

Lens hoods. Although a hood also offers protection, it is primarily designed to reduce the effects of flare. In this instance, I was taking a photograph of two backlit orchids. By shooting in the direction of the light, flare was a problem. In the image taken without a hood, you can see how non-image-forming light has reduced overall contrast. With the hood attached, I was able to capture colours faithfully.

Nikon D700 with 80–400mm lens (at 400mm), ISO 100, 1/640sec at f/5.6, beanbag

have an all-weather covering or are made from a water-repellent material. Thick, foam padded pouches offer the best protection. Exped, Lowepro, Tamrac and Zing are among the leading manufacturers of lens pouches.

Wraps

Lens wraps are normally made from a neoprene-type fabric and are designed to stretch tightly around optics to give them added protection from knocks – useful during transportation. While they may not offer the same level of protection as a foam-padded lens pouch, they are lightweight and don't consume much space. As a result, they are particularly popular among travel photographers. They are available in a range of sizes, to suit different focal lengths.

Lens wraps. Novoflex is among the manufacturers that produce adjustable wraps that stretch tightly around lenses to offer them added protection from knocks and bumps.

EXTENSION TUBES

EXTENSION TUBES ARE HOLLOW RINGS THAT FIT BETWEEN THE CAMERA AND LENS, DESIGNED TO ALLOW THE LENS TO FOCUS CLOSER. BY DOING SO, THEY EFFECTIVELY INCREASE THE LENS'S MAXIMUM MAGNIFICATION, MAKING THEM AN IDEAL ACCESSORY FOR CLOSE-UP PHOTOGRAPHY.

Extension tubes, or rings, are a cheap alternative to buying a dedicated macro lens (see page 110) and are capable of excellent results. Unlike a close-up dioptre/filter, they do not degrade image quality, as they have no elements in their construction. They are made in a variety of lengths – typically 12mm, 25mm and 36mm – and can be used singly or in combination to produce different levels of magnification. They work by extending the distance between the camera's sensor and lens, which shortens the lens's normal minimum focusing distance. The resulting reproduction ratio can be approximated by dividing the amount of extension by the focal length of the lens – although this will depend on the close focusing abilities of the lens to begin with. For example, combining 25mm of extension with a 50mm lens will create a 1:2 reproduction ratio – half life-size – whilst the same level of extension with a 100mm lens will result in a 1:4 reproduction. In order to achieve a 1:1 life-size reproduction, the amount of extension needs to equal the focal length. This is impractical with longer focal lengths, so if you wish to achieve high levels of magnification, it is best to opt for a short focal length, under 70mm. It's worth noting, though, that at high levels of extension, the camera-to-subject working distance can be quite short, which can prove a problem when photographing timid wildlife.

Being lightweight and compact, they are a convenient macro accessory. However, they do reduce the amount of light entering the lens. Your camera's TTL metering will automatically compensate for this, but shutter speeds will be lengthened for any given ISO. Also, they can disable some of the camera's automatic functions, for example autofocusing and some metering options – so check compatibility before you buy. Canon and Nikon are among the manufacturers of extension tubes, along with third-party brands like Kenko, and they offer an affordable introduction to the fascinating world of close-up photography.

∧ **Foxglove.** Extension tubes are also useful for reducing the minimum focusing distance of longer telephoto lenses. This is helpful in situations where you want to shoot relatively near subjects, like flowers, but are using a telephoto to flatten perspective in order to help isolate your subject from its surroundings.

Nikon D300 with 80–400mm lens (at 400mm), ISO 200, 1/80sec at f/8, Nikon PK-13 extension tube, tripod

∧ **Extension tubes.** Kenko is among the brands that make extension tubes. It produces a set of three rings – 12mm, 20mm and 36mm – which can be used singly or in combination. The latest versions boast upgraded circuitry in order to be compatible with the latest DSLRs.

LENS TIP

When shooting at high levels of magnification, even the smallest movement will be exaggerated. This can often result in camera shake or soft images. Therefore, whenever practical, utilize the stability of a tripod when shooting close-ups.

Bellows

Camera bellows work using a similar principle to extension tubes – extending the distance between the lens and sensor in order to allow the attached lens to focus closer. However, despite their old-fashioned accordion-style design, bellows are more sophisticated and can be employed to achieve a variety of reproduction ratios over a greater range.

Bellows are one of the most effective and precise accessories available to close-up photographers. The pleated, expandable bellows provides a flexible dark enclosure between the lens and sensor. This allows the lens to be moved in order to vary the level of magnification with great precision. The image quality of the attached lens is unaffected as there are no glass elements within its design. On the rear plate of the accordion-style design is a camera mount, with a lens mount on the front plate.

Most modern bellows are mounted on a mechanical rail to aid positioning and focusing. By extending the bellows, magnification is increased. However – similar to when using rings – more light is lost at higher levels of extension and, combined with their bulky, weighty design, bellows

are generally better suited to studio work than outdoor photography. It is also worth reiterating that, at high levels of magnification, depth of field and light is more limited and accurate focusing is essential.

Bellows are capable of magnifying a subject beyond the realms of a dedicated macro lens, and can even be coupled with a microscope lens. However, they are a specialist close-up attachment, and are not cheap as a result. German manufacturer Novoflex is one of the leading brands of automatic bellows, compatible with the latest DSLRs.

∧ **Novoflex bellows.** The bulky design of bellows make them less practical for work in the field, but they are capable of magnifying a subject beyond the capabilities of a macro lens. They are an effective and precise close-up attachment and ideal for studio work.

REVERSING RINGS

REVERSING RINGS ALLOW YOU TO MOUNT THE LENS BACK-TO-FRONT, ENABLING IT TO FOCUS MUCH NEARER TO THE SUBJECT. A HIGH LEVEL OF MAGNIFICATION CAN BE ACHIEVED BY DOING SO, BUT WITH QUALITY MACRO LENSES GROWING MORE AFFORDABLE THIS IS NOW PROVING A LESS POPULAR METHOD TO MAGNIFY A SUBJECT.

Reversing rings are an inexpensive close-up accessory. The adapter is designed with a rear lens mount one side, and a male filter thread the other, in order for the lens to attach to the camera back-to-front. They are available in a variety of mounts and threads, and you will need to buy one which is compatible with your camera and that matches the filter thread of the lens you intend using.

Reversing a lens in this way doesn't affect image quality and creates a close-focusing lens capable of excellent results at high reproduction ratios – depending on the lens used. It is best to reverse short, prime optics, as you can encounter problems with focusing and image sharpness if using zooms. Vignetting (see page 69) can occur when reversing very short focal lengths, so I would suggest 50mm to be the ideal for reversing.

⌃ **Spider silhouette.** Reversing rings allow photographers to shoot at high magnifications without compromising image quality. Although subject-to-camera working distances are close, they can prove an inexpensive close-up accessory.

Nikon D300 with 50mm lens and reversing ring, ISO 100, 1/400sec at f/7.1, tripod

While these adapters will appeal to photographers on a budget, they have one major drawback. Automatic metering and focusing is disabled when using cheaper rings and some lenses will also need another adapter to keep the diaphragm open – so check compatibility before buying. However, specialists like Novoflex produce reversing rings that retain the camera's normal functions. While they tend to be quite costly, they enable excellent image quality at magnifications as high as twice life-size.

Tele-converters

Tele-converters are optical components – not an actual lens. Placed between camera and lens, they magnify the focal length by the strength of the converter. They are typically made in 2x and 1.4x strengths and are a handy addition to any camera bag – increasing the versatility and range of your system.

Tele-converters – or 'extenders', as they are also known – are useful in a wide variety of situations. The increased focal length they create allows photographers to shoot subjects from further away – particularly useful when photographing timid wildlife, or at a sporting event when a closer approach isn't possible. They are small, light and reasonably priced, so their appeal to DSLR photographers is obvious.

A number of brands boast converters within their range, but it is recommended that photographers couple optics and converters of the same brand to maximize image quality – for example, a Canon lens with either its own Extender EF 1.4x II or Extender EF 2x II. I always carry a converter in my camera

∧ **Distant lighthouse.** Personally, I nearly always carry extenders with me, as they are a convenient way of increasing the flexibility of my system. In this instance, I attached a 1.4x converter to allow me to record this silhouetted lighthouse, larger in the frame.

Nikon D300 with 100–300mm lens (at 300mm) and 1.4x converter, ISO 200, eight seconds at f/11, tripod

backpack, as you never know when you might require extra magnification. Using one isn't without drawbacks, though. Firstly, by placing elements between the lens and camera, inevitably converters degrade image quality. Often the effect is quite negligible, but it is still advisable to buy the best quality converter you can afford. Secondly, converters absorb light. Attaching a 1.4x extender will incur a one-stop loss in light, while using a 2x converter will result in a two-stop loss. So, in practice, attaching a 1.4x extender to a telephoto lens boasting a maximum aperture of f/5.6 would effectively make f/8 the widest aperture available to you. Your camera's TTL metering will compensate for the loss of light, but shutter speeds will be lengthened for a given ISO. Despite this, they remain a good investment and are capable of excellent results.

LENS TIP
Due to their design, some lenses are incompatible with tele-converters. Check compatibility before purchasing and, if possible, try before you buy.

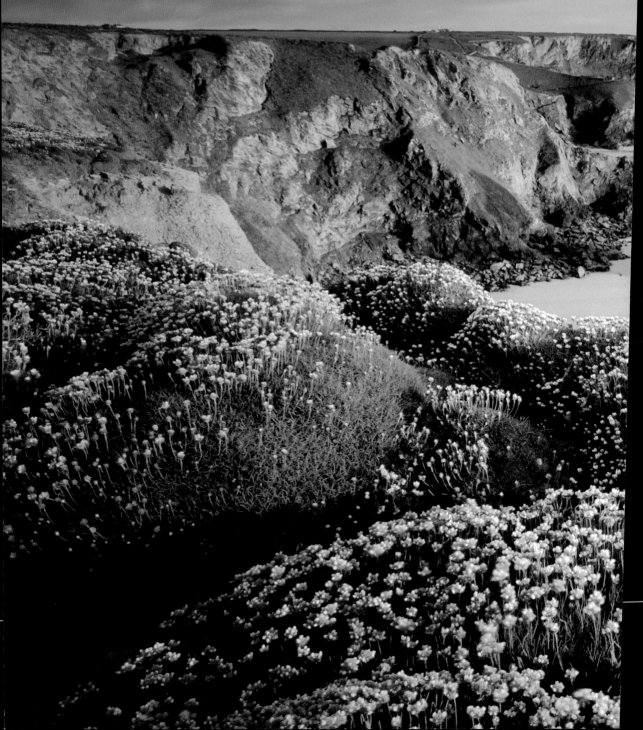

8 FILTERS

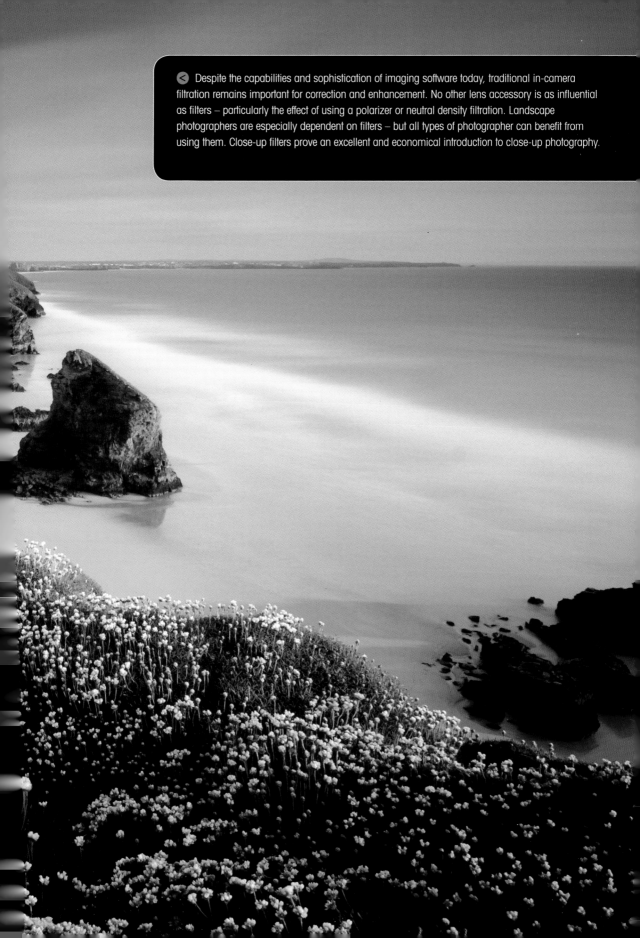

Despite the capabilities and sophistication of imaging software today, traditional in-camera filtration remains important for correction and enhancement. No other lens accessory is as influential as filters – particularly the effect of using a polarizer or neutral density filtration. Landscape photographers are especially dependent on filters – but all types of photographer can benefit from using them. Close-up filters prove an excellent and economical introduction to close-up photography.

FILTERS

Even in this digital age, filters remain an essential lens accessory. While it is true that some filters can be successfully mimicked post capture — and also that a camera's white balance facility has greatly negated the need for warming-up and cooling-down filters in order to correct or alter the light's colour temperature — several other filter types continue to play an integral role. For example, polarizing filters (page 130), neutral density (page 132) and graduated filters (page 132) cannot be mimicked in photo editing software and, for landscape photographers in particular, remain vital tools of the trade.

Sunset. Filters remain the most widely used lens accessory. For many photographers, they are essential corrective and creative tools. Personally, I only apply filtration to enhance a scene – not to alter it or create an artificial result. In this instance, I combined a polarizing filter with a graduated ND filter in order to capture the natural warmth of this vivid sunset.

Nikon D300 with 12–24mm lens (at 14mm), ISO 100, eight seconds at f/22, tripod

Also, close-up filters (page 134), which screw onto the front of the lens and act like a magnifier, are a good, inexpensive alternative to buying a specific macro lens. The next few pages are dedicated to filtration systems and how filters can be utilized in order to get the best results from your lens system.

Slot-in or screw-in filters?

Filters are available in two types – screw- or slot-in. Screw-in or circular filters attach directly to the front of the lens via its dedicated filter thread. Slot-in filters are rectangular or square pieces of glass – or optical resin – which are positioned via a filter holder attached to the front of

the lens, again via the filter thread. Both types are useful, depending on the filter type and situation. Therefore, many photographers employ a hybrid system of both circular and slot-in filters.

Screw-in filters

The majority of interchangeable lenses are designed with a filter thread at the front of the lens to allow the attachment of filters. The only exceptions tend to be large diameter lenses and extreme wideangle and fisheyes (page 108). Specialist optics like this are often designed with a gelatin filter holder at the rear of the lens instead.

The filter thread size will vary depending on the model, focal length and speed of the lens. 52mm, 58mm, 67mm and 77mm are all popular sizes, but it is important to check lens diameter before buying a screw-in filter – they need to match in order to be compatible. Circular filters are easy to use and are often of a high quality, but using them is not without drawbacks. If you own several lenses, it is highly unlikely they will all share the same filter thread size, resulting in a compatibility

LENS TIP

Don't worry if you are unsure of a lens's filter size – it is normally printed on the lens barrel and also on the inside of the lens cap.

UV AND SKYLIGHT – FILTERS FOR PROTECTION

Skylight and UV filters are circular, screw-in filters. They appear transparent, but are designed to absorb the image degrading effects of ultraviolet (UV) light. This type of light is virtually invisible to our eyes, but it can reduce contrast – characterized as slight haze in distant landscapes. However, skylight and UV filters are often employed in a different role to the one intended. Being clear, with no filter factor, and relatively inexpensive, many photographers utilize them to simply protect the front element of their lenses – a job they are well suited to. They will protect against dust, dirt, sand, moisture, greasy fingerprints and scratches – all of which are potentially damaging to the optics and can degrade picture quality. It is much safer to clean a filter on a regular basis, than the delicate multi-coated front element of a costly lens; and it's much cheaper to replace a scratched or damaged filter than a lens. Leaving a skylight/UV filter permanently screwed onto lenses is common practice among photographers. However, if you intend attaching another filter – or holder – remove the skylight/UV filter first – otherwise, the added depth of the filter's mount will enhance the risk of vignetting at short focal lengths.

< UV and skylight filters are designed to absorb UV light, but are more regularly employed to protect the delicate front element of valuable lenses.

Slot-in filters

A filter system is designed to accept square or rectangular slot-in filters. The holder normally boasts two or three slots (some can even be customized) making it possible to combine creative and corrective filters together without increasing the risk of vignetting – a problem that would grow increasingly likely if you sandwiched two or three circular filters together. The filter holder attaches to the front of the lens via an adapter ring. Adapter rings are relatively inexpensive and can be bought in a variety of sizes to fit different diameter lenses. Therefore, the major advantage of using a slot-in system is that the holder – and all compatible slot-in filters – will fit any lens in your camera bag that you have the relevant adapter ring for. The holder can be quickly removed from the adapter ring and switched to another lens if necessary, making it a convenient and practical system.

Regular users of NDs and grads will find a slot-in system the most cost-effective, versatile way to apply in-camera filtration. A variety of systems is available by brands like Lee, Cokin and Kood. They are available in progressive sizes – 67mm, 84/85mm and 100mm – designed to cater for different budgets and needs. Opt for the largest system you can justify, as the smaller systems are only suitable for small diameter lenses and the risk of vignetting is greatly increased when using wide focal lengths.

> **Slot-in system.**
With the aid of adapter rings, a filter holder can be attached to a variety of different diameter lenses – making it a versatile and widely compatible system. The Lee 100mm filter system is an excellent long-term investment for landscape photographers and regular filter users.

problem. You could invest in a set of circular filters for each diameter lens, but this would prove both costly and add unnecessary weight to your camera bag. Alternatively, you can buy dedicated step-up and step-down rings, which adapt a filter to a lens when they have differing diameters. However, in reality it is better to buy just the essential circular filters – like polarizing, UV/Skylight and possibly close-up – and invest in the versatility of a slot-in system instead.

POLARIZING FILTERS

POLARIZERS ARE DESIGNED TO REDUCE GLARE AND REFLECTIONS,
ENHANCING COLOUR SATURATION AS A RESULT — EFFECTS IMPOSSIBLE TO
REPLICATE POST CAPTURE. NO OTHER FILTER TYPE WILL HAVE A GREATER
IMPACT ON YOUR PHOTOGRAPHY. THIS IS A MUST-HAVE LENS ACCESSORY
FOR OUTDOOR PHOTOGRAPHERS.

How does a polarizer work?

Light is transmitted in waves, the wavelengths of which determine the way we perceive colour. They travel in all possible planes through 360 degrees. When they strike a surface, a percentage of wavelengths are reflected, while others are absorbed. It is these that define the colour of the surface. For example, a blue-coloured object will reflect blue wavelengths of light, while absorbing others. It is for this reason that foliage is green, as it absorbs all wavelengths of light other than those forming the green part of the visible spectrum. Polarized light is different. It is the result of wavelengths being reflected or scattered and only travels in one direction. It is these wavelengths that cause glare and reflections, reducing the intensity of a surface's colour. It is most obvious in light reflected from non-metallic surfaces, like water and in light from blue sky at 90 degrees to the sun.

A polarizer is designed to restore contrast and colour saturation by blocking polarized light from entering the lens and reaching the image sensor. It is constructed from a thin foil of polarizing material, sandwiched between two circular pieces of optical glass. Unlike other filters, the front of its mount can be rotated. Doing so alters the angle of polarization, changing the amount of polarized light that can pass through the filter. The direction that wavelengths of polarized light travel in is inconsistent, but the point of optimal contrast can quickly be determined by rotating the filter in its mount while looking through the camera's viewfinder. As you do so, you will see reflections come and go and the intensity of colours strengthen and fade. However, some surfaces remain unaffected by the polarizing effect – for example, metallic objects, like polished steel and chrome plate, do not reflect polarized light patterns.

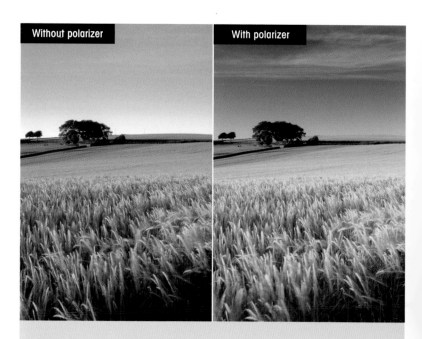

Without polarizer

With polarizer

∧ **Barley field**. Polarizers are renowned for their ability to saturate the colour of clear skies, but they also cut through the glare reflecting from foliage. A polarizer can make a dramatic difference to an image, giving it added vibrancy and life. These comparison images help illustrate the importance and role of a polarizing filter.

Nikon D700 with 12–24mm lens (at 14mm), ISO 100, two seconds at f/20, polarizer, tripod

Using a polarizer

Polarizers are normally screw-in filters. Two types are available – linear and circular. DSLR photographers need to buy the circular type, as the design of linear polarizers can affect the accuracy of modern TTL metering systems. They are available in a variety of filter thread fits, to suit the diameter of the lens you wish to combine it with.

Polarizers are best known for their ability to saturate the colour of clear, blue skies. The strength of the effect will vary depending on the angle of

the camera in relation to the sun. The optimum angle is around 90 degrees to the sun – the area where there is most polarized light. Therefore, to achieve the most pronounced effect, position the camera at right angles to the sun – known as 'Brewster's angle'. While a polarizer can have a dramatic effect on the colour intensity of images boasting blue sky, it has little or no effect on hazy, cloudy skies.

Many photographers invest in a polarizer simply for the filter's ability to intensify blue sky. However, the filter has many other uses. It reduces glare reflecting from foliage, making it useful when photographing countryside, woodland, gardens and close-ups of flowers. A polarizer can also be employed to weaken or even eliminate the reflections on the water's surface – ideal if you wish to photograph a subject underneath the water, like fish or coral in a rock pool. Equally, you may wish to attach a polarizer to diminish distracting reflections from glass if photographing modern buildings or urban landscapes.

> **Over-polarization**. The effect and vibrancy of saturated blue skies can be very seductive. However, it is possible to over-polarize skies, making them look artificially dark. It is important to remember that the most flattering effect isn't necessarily achieved at full polarization – always use your discretion.

Nikon D300 with 24–85mm lens (at 40mm), ISO 200, 1/80sec at f/11, polarizer

LENS TIP

A polarizer has a filter factor (page 135) of 4x – equivalent to two stops of light. Therefore, it can also be employed as a makeshift ND filter (page 132).

> **Oxeye daisies.** A vibrant blue, polarized sky can make a perfect backdrop for flowers, buildings and people.

Samsung GX10 with 18–50mm lens (at 50mm), ISO 200, 1/180sec at f/11, handheld

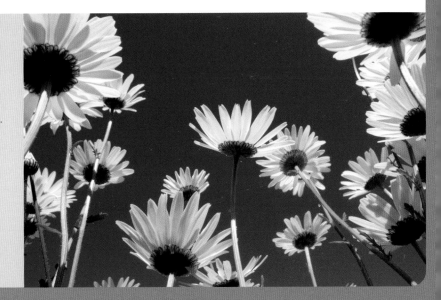

NEUTRAL DENSITY (ND) FILTERS

NEUTRAL DENSITY FILTERS ARE ONE OF THE MOST USEFUL FORMS OF IN-CAMERA FILTRATION AVAILABLE – PARTICULARLY FOR LANDSCAPE PHOTOGRAPHY. THEY HAVE A NEUTRAL GREY COATING, DESIGNED TO ABSORB THE LIGHT ENTERING THE CAMERA LENS. TWO TYPES ARE AVAILABLE – SOLID AND GRADUATED. A SOLID ND FILTER IS INTENDED TO ARTIFICIALLY LENGTHEN EXPOSURE TIME, TO EITHER EMPHASIZE OR BLUR MOVEMENT, OR TO ALLOW THE SELECTION OF A LARGER APERTURE WHEN THERE IS TOO MUCH LIGHT. GRADUATED ND FILTERS ARE HALF COATED, HALF CLEAR WITH A TRANSITIONAL ZONE WHERE THEY MEET. THEY ARE DESIGNED TO CORRECT THE DIFFERENCE IN BRIGHTNESS BETWEEN THE LAND AND BRIGHTER SKY, IN ORDER FOR PHOTOGRAPHERS TO ACHIEVE A CORRECT EXPOSURE OVERALL IN-CAMERA.

Solid

The ND coating is designed to absorb all the colours in the visible spectrum in equal quantities. As a result, the filter only alters the brightness of light, not its colour. ND filters are available in both screw-in and slot-in types and produced in a range of densities. The filter strength is printed on the filter or mount – the darker grey they are, the more light they will absorb. A density of 0.1 represents a light loss of one third of a stop. The most popular strengths are 0.3 (one stop), 0.6 (two stops) and 0.9 (three stops), but versions up to ten stops are available from some filter brands. The majority of photographers should find that a two-stop ND filter is adequate in most situations where you wish to artificially lengthen shutter time. For instance, it will lengthen an exposure of ¼sec, to one second, or allow the selection of an f-stop two stops wider; a significant shift, which has the potential to vastly alter the appearance of the final image. Deliberately emphasizing movement can prove a powerful creative tool. Solid ND filters are most popular for lengthening exposure time in order to blur the movement of running water, like a waterfall or waves. An exposure of one second or longer will blur the water, giving it a misty, ethereal look and producing atmospheric results. ND filters can also be used to creatively blur the movement of a number of other subjects, including cloud, people, foliage, crops, vehicles and wildlife.

Although ND filtration is designed to alter exposure time, presuming that you are using your DSLR's TTL metering system, you don't need to worry about making manual adjustments to exposure – the camera will adjust automatically.

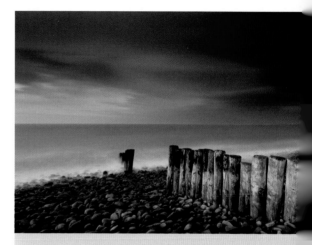

∧ Weathered groynes. Many landscape photographers, attach a solid ND filter in order to artificially slow the resulting shutter speed. In this instance, it allowed me to blur the movement of the incoming tide and the stormy cloud – creating a more atmospheric, moody result.

Nikon D300 with 12–24mm lens (at 12mm), ISO 100, 30 seconds at f/22, 0.9ND, 0.6ND grad, polarizer, tripod

Graduated

ND grads are an essential corrective tool for landscape photographers. They are usually a slot-in type filter and absorb light in a similar way to solid ND filters. However,

when using an ND grad, it is possible to block light from only a portion of the image-space, instead of all of it. This is suited to scenic photography, where the sky is typically brighter than the land below. This contrast in light will often exceed the camera's dynamic range, creating an exposure problem. For example, if you meter to correctly expose the sky, the foreground will be too dark, while if you expose for the land, the sky will be overexposed and devoid of detail. While you could take two differently exposed images and later merge them in Photoshop, most photographers prefer to balance this contrast in light in-camera – using graduated ND filtration to achieve a correctly exposed image overall. Careful positioning of the filter is important. Being half coated, half clear, slide the filter down into the filter holder until the transitional zone is in alignment with the horizon. By doing so, you will only filter the sky,

not the landscape. However, push the filter down too far into the holder and you will inadvertently darken the foreground too.

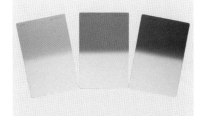

∧ **ND grad set.** Like ND filters, grads are available in a variety of densities to suit different lighting conditions. If you regularly shoot landscapes, it is worthwhile investing in a set of one-stop, two-stop and three-stop graduated ND filters.

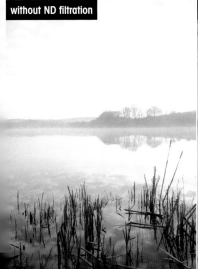

without ND filtration

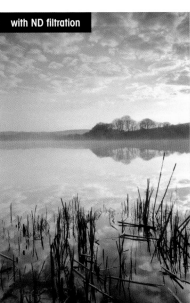

with ND filtration

< **Balancing the light.** When shooting scenic images, the foreground will normally be darker than the sky. The most popular method to lower the level of contrast – and achieve a correct exposure in-camera – is to employ graduated ND filtration. ND grads are essential corrective tools – their effect is clearly illustrated by these two images taken with and without filtration.

Nikon D300 with 12–24mm lens (at 12mm), ISO 100, 1/2sec at f/16, polarizer, 0.9ND grad, tripod

CLOSE-UP FILTERS

DESPITE THE WIDE APPEAL OF CLOSE-UP PHOTOGRAPHY, THE COST OF BUYING A DEDICATED MACRO LENS (PAGE 110) CAN DETER PHOTOGRAPHERS FROM SHOOTING CLOSE-UPS. HOWEVER, YOU DON'T NEED TO INVEST HEAVILY IN A NEW LENS TO SHOOT THE FASCINATING MINIATURE WORLD AROUND US – YOU CAN SIMPLY ADAPT ONE OF YOUR EXISTING LENSES BY ATTACHING A CLOSE-UP FILTER. SUPPLEMENTARY CLOSE-UP FILTERS ARE, IN FACT, DIOPTRES THAT SCREW ONTO THE FRONT OF THE LENS AND ACT LIKE A MAGNIFIER. WHILE THEY DO NOT OFFER THE SAME IMAGE QUALITY AS A MACRO LENS, THEY ARE COMPACT, LIGHTWEIGHT AND EASY TO USE. THEY ARE ALSO INEXPENSIVE – MAKING THEM IDEALLY SUITED TO PHOTOGRAPHERS NEW TO CLOSE-UP PHOTOGRAPHY AND FOR THOSE ON A BUDGET.

Getting closer

Basically, a close-up dioptre works by shifting the camera's plane of focus in order to reduce its minimum focusing distance. The lenses are convex meniscus – thicker in the middle than at the edges – and are similar to the optics found in glasses for long-sighted people. They do not affect normal camera functions, like TTL metering, or restrict the ambient light entering the lens. Normally, the filters are of a single-element construction and, typically, are produced in a range of four strengths; +1, +2, +3 and +4. The higher the number, the nearer it is possible for the lens to focus, resulting in

> **Close-up filter**. Although inexpensive, close-up filters are an excellent introduction to the world of macro photography. They are available in a range of filter threads and strengths and can be purchased individually or in a set.

FILTER FACTOR

Many filter types reduce the amount of light passing through the lens and reaching the image sensor. This is known as the 'filter factor' – a measurement indicating the degree of light that is absorbed. The higher the 'filter factor' the greater the light loss. TTL metering systems measure the actual light entering the lens, so it will automatically compensate for the filter's factor. However, it is still advisable to be aware of the affect the filters you are using are having on exposure. The 'filter factor' should be stated either on the filter, its mount or packaging. The table opposite lists the amount of light that the most popular filter types absorb.

a higher level of magnification. They can be combined to achieve a higher level of magnification, but image quality begins to noticeably deteriorate if you couple more than two filters together. They can be prone to spherical and chromatic aberration (page 59), but image quality can be maximized by selecting a mid-range f-stop of f/8 or f/11 and by using them in combination with a prime focal length. Most major filter brands boast screw-in type close-up filters within their range and if you don't presently own a macro lens, they are a useful addition to any photographer's camera bag.

FILTER FACTORS

FILTER	FILTER FACTOR	EXPOSURE INCREASE
Polarizer	4x	2 stops
ND 0.1	1.3x	$\frac{1}{3}$ stop
ND 0.3	2x	1 stop
ND 0.6	4x	2 stops
ND 0.9	8x	3 stops
ND grads	1x	None
Skylight/UV	1x	None
Close-up	1x	None

◁ Red hot poker. You don't necessarily need a costly macro lens to shoot frame-filling close-ups – a close-up filter is an inexpensive alternative.

Nikon D200 with 50mm lens and +4 close-up dioptre, ISO 200, 1/100sec at f/13, tripod

▽ Dragonfly. Close-up filters are available in a variety of filter thread diameters and simply screw onto the front of the lens. They do not reduce the amount of light entering the lens, so shutter speed remains unaltered, and are ideal in situations where you need to shoot handheld.

Nikon D300 with 50mm lens and +4 close-up dioptre, ISO 200, 1/200sec at f/8, handheld

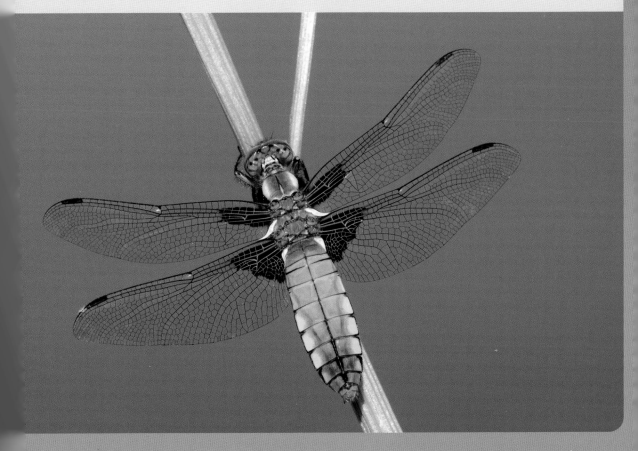

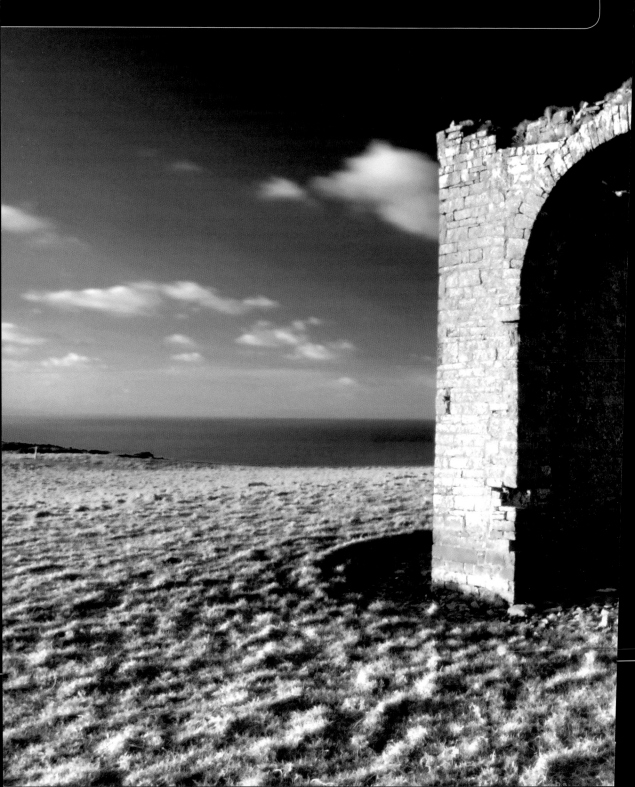

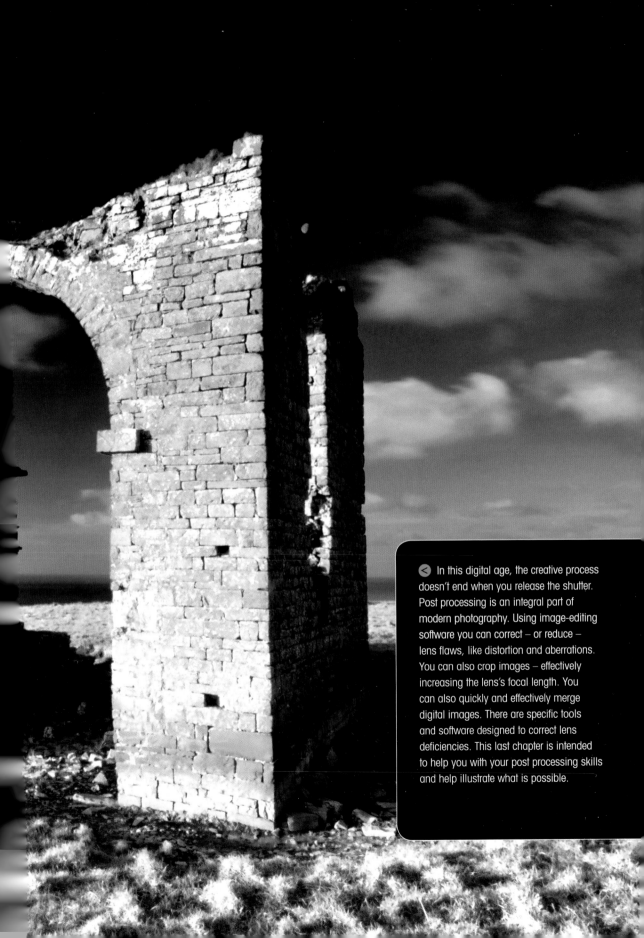

In this digital age, the creative process doesn't end when you release the shutter. Post processing is an integral part of modern photography. Using image-editing software you can correct – or reduce – lens flaws, like distortion and aberrations. You can also crop images – effectively increasing the lens's focal length. You can also quickly and effectively merge digital images. There are specific tools and software designed to correct lens deficiencies. This last chapter is intended to help you with your post processing skills and help illustrate what is possible.

LENS WORK IN THE DIGITAL DARKROOM

THE LOOK, FEEL AND QUALITY OF OUR PHOTOGRAPHS ARE GREATLY DICTATED BY OUR CHOICE OF LENS TYPE, FOCAL LENGTH, APERTURE AND ANY LENS ACCESSORY WE DECIDE TO ATTACH. HOWEVER, THIS ISN'T TO SAY THAT, ONCE WE HAVE RELEASED THE SHUTTER, IT IS THE END OF THE PROCESS. PHOTOGRAPHERS HAVE BEEN TWEAKING, CORRECTING AND IMPROVING THEIR IMAGES, POST CAPTURE, SINCE THE ADVENT OF PHOTOGRAPHY – POST PROCESSING ISN'T A NEW PHENOMENON. THIS CHAPTER AIMS TO HELP YOU CORRECT COMMON LENS PROBLEMS USING SOFTWARE.

Postproduction

Today, using sophisticated imaging software, postproduction is easier and more accessible than ever before. While some photographers embrace and enjoy this facet of photography, many don't. Personally, I would rather spend more time actually taking pictures, than sat in front of a computer. However, some degree of post processing is important if you wish to realize your photo's potential – and essential if your shoot in Raw.

Post processing, or postproduction, shouldn't be confused with image manipulation. Manipulation is the application of techniques that alter a photograph to create an artificial result – effects that would be impossible to achieve in-camera. In contrast, post processing is intended to enhance or correct the original. Like many photographers, I'm a traditionalist at heart. I rarely do more to my images than simply tidy them up, adjust contrast – using a tool like Curves or Levels – and add a small degree of saturation to enhance the image's

> **Software.** Although Photoshop is considered the industry standard, there are a vast array of other packages available, including software made by Apple, Corel and Phase One. All are very capable – personal preference and budget will dictate what you use.

colour and impact. However, post processing is a skill, with entire books dedicated to getting the most from your digital files. This chapter isn't, in any way, designed to replace such publications – there simply isn't room in this guide to go into the detail necessary. Instead, the next few pages concentrate on just a small area of post processing – lens correction.

In previous chapters, we have looked at some of the common problems that can occur when using interchangeable lenses – for example, aberrations, vignetting and perspective distortion. While it is always best to try to correct lens problems in-camera, this isn't always possible or practical – or you may simply have not noticed the problem until after you took the picture. Thankfully, using software, such problems can either be corrected or, at the very least, reduced.

Most DSLRs are bundled with good editing software designed for use with that particular model. However, there are also a huge number of independent programs available to enhance and correct your images. Photoshop is the industry standard so, for that reason, I have used this software for the brief tutorials included in this chapter. There are

> **Post processing.** Post processing is an important part of photography. It allows photographers to enhance their images or correct problems incurred at the time of capture – including lens-related problems.

RAW V JPEG

When capturing images, the two most common file types are JPEG and Raw. JPEGs (Joint Photographic Experts Group) are a lossy file type, so some data is discarded during compression. The pre-selected shooting parameters, like white balance and sharpness, are applied to the image in-camera. Therefore, after the file is transferred from the camera's buffer to the memory card, the photograph is ready to print or use immediately after download. This makes JPEGs ideal for when a photographer needs to produce the end result quickly and with the minimum of fuss. However, they are far less flexible and it is trickier to correct or alter images during processing. In other words, if you make a technical error at the time of capture, you are less likely to be able to salvage the photo. DSLRs allow you to take JPEGs in different quality settings and sizes.

For optimum image and print quality, it is best to shoot in the JPEG Fine, set to its largest resolution. This is the perfect format for beginners, who are still learning their craft and don't want to spend more time than necessary processing files on a computer.

Raw is a lossless file type – using a reversible algorithm – and is often considered to be the digital equivalent to a film negative. Unlike JPEGs or TIFFs, the shooting parameters are not applied to the image at the time of capture, but are kept in an external parameter set – accessed whenever the Raw file is viewed. Put simply, the image is unprocessed data. Once downloaded, a Raw file has to be processed – using compatible conversion software. It is at this stage that you can fine tune the image and adjust the shooting parameters – like contrast and white balance, or correct for lens problems like chromatic aberration. Once processing is complete, Raw images have to be saved as a different file type – typically JPEG or TIFF. The original Raw file remains unaltered.

Raw is a flexible file type, which maximizes image quality. As a result, it is the preferred format for enthusiasts and photographers who wish to get the most from their digital files.

a number of different Photoshop packages available. Photoshop Creative Suite (CS) is now in its fourth version. It is unrivalled, but pricey. In reality, Elements – a stripped-down version – is more than adequate for most photographers.

Hopefully, you will be able to easily replicate the lens work detailed in this chapter. However, photographers using older or newer versions of Photoshop might find they have to find slightly alternative ways, due to the different tools available to them.

The intention of this chapter is to continue to help you to achieve the best results possible from the lenses in your system.

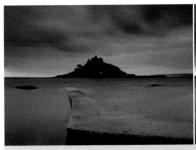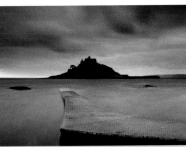

(A) Raw shooting. Shooting in Raw is advisable for enthusiast photographers looking to maximize image quality. Essentially, Raw files are unprocessed data, so require more time spent on them than a corresponding JPEG. However, they are a far more flexible and forgiving file type and during processing you can subtly enhance and correct the image in order to maximize its potential. For example, image 1 is an unprocessed file, straight from the camera. Image 2 is the same frame, but with a few simple tweaks using Levels and Hue/Saturation.

Nikon D300 with 18–70mm lens (at 25mm), ISO 100, 30 seconds at f/18, polarizer, ND, tripod

CROPPING

'CROPPING' IS A TERM WHICH REFERS TO THE SELECTIVE REMOVAL OF THE OUTER PARTS OF AN IMAGE IN ORDER TO IMPROVE COMPOSITION, ACCENTUATE THE SUBJECT, OR TO CHANGE THE ASPECT RATIO. WITH A DIGITAL IMAGE, THIS IS QUICKLY AND EASILY ACHIEVED USING A DEDICATED 'CROP TOOL' IN IMAGE-EDITING SOFTWARE LIKE PHOTOSHOP.

Cropping is a useful and important compositional tool which can vastly improve a photograph's look and balance. This is one of the most basic editing procedures, and is a very acceptable form of post processing – photographers have been cropping their images in order to improve them since the advent of photography. Cropping allows you to remove unwanted or distracting elements from the periphery of the frame or to change the aspect ratio. Cropping a standard-sized image into panoramic format is particularly popular.

Cropping is also a popular method of enlarging a subject. Doing so effectively makes the subject appear like it was captured using a longer focal length. As a result, cropping can, to some extent, compensate in situations when you didn't have a suitably long lens at the time of capture. However, when you crop an image – regardless of the reason – it is important to remember that you are also removing pixels and, therefore, reducing the image's resolution. It is for this reason that, whilst cropping is an important and useful tool, you should only do so when it is necessary or genuinely beneficial.

With quality of digital sensors being so high today, there is an argument that the advantages of using a shorter focal length – and then cropping the image accordingly – can potentially produce a better result than using a longer focal length in the first instance. For example, the risk of camera shake is reduced using shorter, lighter lenses and a shorter focal length produces

a larger depth of field. Also, many optics perform best towards the centre of the lens than at the edges, where vignetting and distortion can be a problem – cropping alleviates these problems. However, cropping an image to effectively enlarge a subject will also highlight imperfections or exaggerate poor focusing and, in practice, it is best to only crop an image for the sake of improving composition.

Cropping step by step

While we might strive to get everything right in-camera, even the best photographers will find that – when reviewing their images – a percentage of their shots will benefit from a degree of cropping for one reason or another. Cropping gives photographers a second chance to get the image right. Cropping is a very intuitive process that relies on many of the compositional rules and skills outlined in earlier chapters. Don't be too aggressive when cropping and always keep an unaltered copy of the original image, just in case you later change you mind or wish to crop the image in a different way.

1. First, open the image you wish to crop in Photoshop. Click on the Crop Tool in the toolbox or press C – the keyboard shortcut for the crop tool. The cursor changes to the crop icon.

2. In the options bar you can enter the exact width, height and resolution for the final cropped image. To the far left of the options bar, you can select from several preset options. However, most photographers decide to crop their images manually.

> 3. Click on the image and drag the cursor to make your initial, rough selection. When you let go, the crop marquee will appear and the area to be discarded is shaded grey. The shield makes it easier to visualize how the cropping will affect the final image.

< 4. At the corners and sides of the selection marquee are 'handles'. When you move the cursor over a handle it changes to a double pointing arrow to indicate that you can resize the crop border. Utilize these to adjust and fine tune your selection. If you drag a corner handle, you can adjust the width and height at the same time.

LENS TIP

When using the crop tool, if you move the cursor to just outside one of the corner handles, it will change to a double pointing curved arrow. When this is active, you can rotate the selection marquee. This allows you to simultaneously crop and straighten a crooked image.

^ 5. When you are happy with your selection, crop the image by pressing Enter/Return or simply double click. If you change your mind after you've cropped the image, click Edit>Undo Crop. Cropping can radically alter the look of the original.

CORRECTING CHROMATIC ABERRATION

CHROMATIC ABERRATION (PAGE 59) IS A COMMON LENS FLAW, RESULTING IN COLOUR FRINGING AND LOSS OF SHARPNESS. IT IS CAUSED WHEN A LENS FAILS TO FOCUS ALL THE COLOURS AT THE SAME POINT. AS A RESULT, COLOUR 'FRINGES' OCCUR ALONG BOUNDARIES THAT SEPARATE DARK AND LIGHT PARTS OF THE IMAGE. THESE BRIGHTLY COLOURED HALOS ARE TYPICALLY PURPLE OR GREEN AND, WHILE THEY MAY NOT ALWAYS BE IMMEDIATELY OBVIOUS, THEY GROW MORE NOTICEABLE THE LARGER THE IMAGE IS REPRODUCED. THANKFULLY, BY USING SOFTWARE – LIKE PHOTOSHOP – IT IS POSSIBLE TO REDUCE THE VISIBILITY OF CHROMATIC ABERRATIONS.

Chromatic aberration occurs due to photographic lenses having a different refractive index for different wavelengths of light. Since the focal length of a lens is dependent on the refractive index, different wavelengths of light will be focused at different positions. Therefore, technically speaking, there are two forms of chromatic aberration – longitudinal (or axial) and lateral.

Longitudinal is the problem of different wavelengths of light failing to focus on the same plane. Its occurrence is most likely when the aperture is wide open, so to minimize the problem, select a smaller f-stop. Lateral chromatic aberration is the result of different wavelengths of light being shifted laterally across the image plane, due to changes in image magnification in peripheral areas of the lens. Lateral colour fringes are a fairly common problem when using budget optics.

Typically, special glass – with a low refractive index – is employed to correct for chromatic aberration. However, it is normally only professional-quality optics that are able to eliminate the problem. The majority of photographers cannot justify the cost of buying the highest-quality lenses, so simply have to live with the problem. In reality, chromatic aberration – while undesirable – will not be noticeable enough to be a significant problem and, with the help of software, the effect can be greatly reduced anyway.

If you shoot Raw, it is best to correct chromatic aberrations during conversion. Using Photoshop, there is a range of ways to alleviate the problem. The most sophisticated are too long and complex to include here. Instead, this brief tutorial shows you how to reduce colour fringing quickly and easily, yet still effectively.

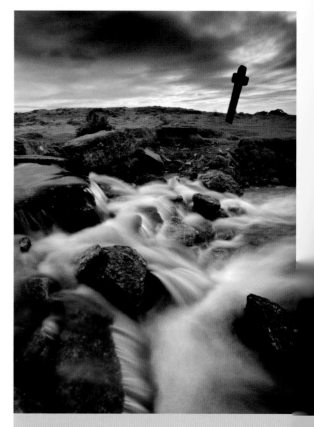

< ∧ This image, of an old granite cross on Dartmoor, looks fine when viewed small. However, when viewed beyond 100 per cent, brightly coloured fringing is evident along the edges of the cross.

⌄ A quick, and normally reliable, method to remove colour fringing is using the Hue/Saturation control. Using the Zoom Tool, zoom into the part of the image affected by colour fringing and then click Image> Adjustments> Hue/Saturation.

> In the Edit drop down box, select the colour closest to the type of colour fringing. In this instance, I selected Cyan. Using the Eyedropper Tool, click on any point in the picture that needs to be fixed for chromatic aberration. Now, reduce the Saturation and Lightness sliders until the colour of the fringing fades.

> The effects of the colour fringing will either be eliminated, or vastly reduced. This is a quick and easy method, which suits most affected files. However, this technique isn't recommended if there are similar tones (to the colour of the fringing) within the image – as these areas will also be affected by your Hue/Saturation adjustment.

USING THE LENS CORRECTION FILTER

The Lens Correction Filter is an extremely useful Photoshop tool that can be used to fix common lens problems. Its preview displays a customizable grid that can be activated and reactivated to help guide you while making adjustments. Several of the adjustment types can be found in Raw converters such as Adobe Camera Raw and Lightroom.

Among the filter's controls are settings to reduce the problem of colour fringing. Click Filter>Distort> Lens Correction to open the dialogue box. Using the Zoom Tool, zoom in on the image preview to get a closer view of the fringing as you make the correction. Under the Chromatic Aberration control are two sliders. Fix Red/Cyan Fringe slider will compensate for red/cyan colour fringing, by adjusting the size of the red channel relative to the green channel. Fix Blue/Yellow Fringe alters the size of the blue channel relative to the green channel. The sliders are intuitive controls – gradually move them until you are satisfied that you have reduced the visibility of the fringing. Click OK to apply the correction.

CORRECTING VIGNETTING

VIGNETTING IS A FAIRLY COMMON LENS-RELATED PROBLEM, OCCURRING WHEN LIGHT IS OBSTRUCTED FROM REACHING THE EDGES OF THE FRAME. THE RESULT IS DARKENING AT THE PERIPHERY OF THE PICTURE, PARTICULARLY THE CORNERS. THE EFFECT OF VIGNETTING CAN VARY GREATLY IN ITS EXTREMITY — FROM SUBTLE DARKENING TO DEFINED BLACK CORNERS. VIGNETTING IS RARELY DESIRABLE AND PHOTOGRAPHERS WILL NORMALLY WANT TO CORRECT IMAGES SUFFERING FROM THE EFFECT.

Vignetting is normally considered to be a filter-related problem. When two or more filters are combined, or a filter holder attached, vignetting grows increasingly likely — particularly when using super-wideangles. This is because, due to their wide angle of view, the attachment obstructs the optical path at the edges of the frame. However, many short focal lengths exhibit some degree of vignetting — or light falloff at the corners of the image — at large apertures (small f-numbers). While subtle vignetting can help draw you eye towards the centre of the frame — and therefore be utilized aesthetically — normally it is undesirable.

Although not the perfect solution, severe vignetting — black, defined corners caused by an attachment — is best removed by cropping the image accordingly. Alternatively, if vignetting is only affecting areas devoid of detail and of constant tone — sky, water or snow, for example — you can often remove it using the Clone or Healing Brush Tool from the Photoshop toolbox. However, gradual vignetting caused by lens light falloff — such as the cos4 law of illumination, which obliges wideangle lenses to spread their light more thinly at the edges than in the centre — requires a more sophisticated approach.

There is a variety of Photoshop plug-ins, and standalone software packages, designed to correct vignetting and, using Photoshop, there are highly accurate techniques to eliminate the problem. However, determining the correction values for a given lens, at different f-stops, is too complex and long to include in this guide. Thankfully, there is a much simpler and quicker method to correct vignetting — using Photoshop's Lens correction filter.

V The result of vignetting is obvious in this image. The sky around the tree avenue progressively darkens, caused by the use of a large aperture in combination with super-wideangle lens.

> Open the image in Photoshop and click Filter>Distort>Lens correction. This will open the Lens correction screen. To the right are the filter's options, including the Vignette controls.

< Under the Vignette heading are two sliders – Amount and Midpoint. Drag the Amount slider to the right (lighter) to reduce darkening. Adjust the Midpoint slider to alter the midpoint (depth of the fade) to suit the image being correcting.

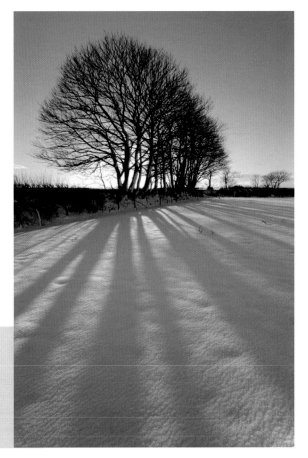

> Click OK to apply the correction. While the Lens correction filter might be relatively basic, with limited controls, it is possible to remove vignetting intuitively – just by eye – quickly and easily.

PERSPECTIVE CORRECTION

CONVERGING VERTICALS (PAGE 68) ARE A COMMON HEADACHE WHEN USING WIDEANGLE LENSES. THIS TYPE OF PERSPECTIVE DISTORTION IS PARTICULARLY NOTICEABLE WHEN PHOTOGRAPHING A SUBJECT WITH PARALLEL LINES — A BUILDING, FOR EXAMPLE. ITS SIDES CAN APPEAR TO LEAN, CREATING AN UNNATURAL-LOOKING RESULT THAT HAS THE POTENTIAL TO RUIN THE PICTURE. PERSPECTIVE DISTORTION CAN BE CORRECTED AT THE TIME OF CAPTURE BY KEEPING THE CAMERA PARALLEL TO THE SUBJECT — TYPICALLY, THIS MEANS MOVING BACK AND USING A LONGER FOCAL LENGTH — OR BY USING A DEDICATED PERSPECTIVE CONTROL LENS (PAGE 114). OFTEN, NEITHER OPTION IS PRACTICAL OR POSSIBLE — INSTEAD PERSPECTIVE DISTORTION CAN BE CORRECTED DURING POST PROCESSING.

Transforming perspective

Photographers usually want rectangular or square subjects to look correct in their images. However, if your camera is not perfectly parallel to the subject, they will be distorted. The answer is to use a tilt and shift lens, but they are pricey and aimed at professional architectural photographers. For photographers who only occasionally shoot buildings – but want similarly professional-looking results – photo editing software is the best, most economical solution.

There are a variety of ways to correct converging verticals post capture. Dedicated software and plug-ins are available online and there are a couple of different methods using Photoshop – depending on the version you own. The lens correction filter (page 143) is one option, but for this tutorial we will utilize the Transform tool.

> ▽ This image was taken using a wide focal length of 12mm. The old, derelict building appears to be leaning slightly, which in this instance is distracting.

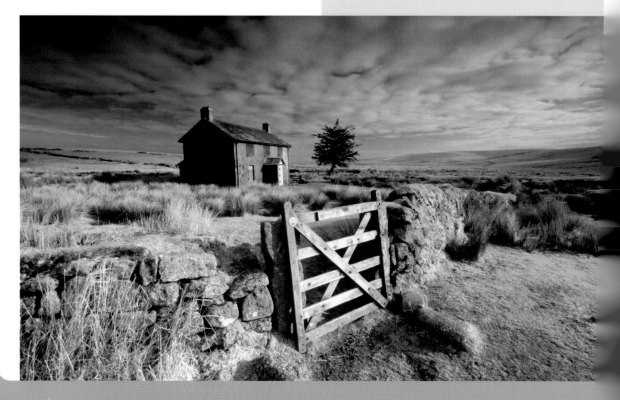

< With the file opened in Photoshop, select all of the image by clicking Select>All. When correcting converging angles, a grid is a useful aid. This can be overlaid by clicking View>Show>Grid.

< Now, click Edit>Transform>Perspective. Eight small squares will appear around the image edges. Click and drag the corner squares in the opposite direction to the way the verticals are tilting. In this instance, I clicked on the top left square and dragged it inward until the sides of the building appeared parallel.

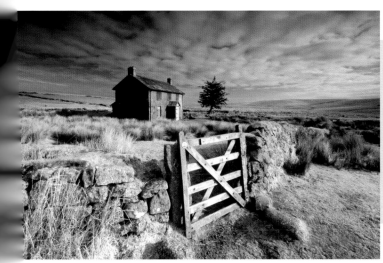

< Fine tune your adjustment and, when you are happy with the degree of correction, click Return/Enter or double click on the image. After you have stretched and squeezed the image, there may not be enough picture left on one side, or top or bottom. Therefore, you may also need to crop (page 140) the result – as I had to in this instance – before saving.

PANORAMICS AND COMPOSITE IMAGES

IMAGE STITCHING, AND MOSAICKING, IS THE PROCESS OF COMBINING TWO OR MORE IMAGES TOGETHER USING EDITING SOFTWARE. STITCHING IS A WAY TO EXTEND A LENS'S FIELD OF VIEW, BUT THERE ARE OTHER ADVANTAGES ALSO — FOR EXAMPLE, DEPTH OF FIELD AND RESOLUTION ARE EFFECTIVELY INCREASED. THE MOST COMMON TYPE OF COMPOSITE IMAGES PHOTOGRAPHERS TEND TO CREATE IS PANORAMICS. THIS POPULAR 'LETTERBOX' ASPECT RATIO PARTICULARLY SUITES LANDSCAPE IMAGES. HOWEVER, STITCHING IS A USEFUL TECHNIQUE TO BE FAMILIAR WITH, REGARDLESS OF WHAT YOU SHOOT. THE RESULTS CAN BE STUNNING, BOASTING REMARKABLE DETAIL.

Creating any type of composite images relies on the photographer doing a number of things at the time of capture. To ensure an accurate stitch, successive images need to be taken with a consistent overlap of between 10 and 30 per cent. Your digital SLR should be kept level throughout the shooting sequence and, ideally, should be rotated around the nodal point of the lens. Focal length, white balance and exposure need to remain constant with each of the source images – this is crucial to remember.

While the process of precisely aligning images together, in order to create a perfect composite, might sound fiddly and time consuming, sophisticated imaging software makes stitching relatively quick and easy. There is a wide variety of dedicated programs available – like Autostitch, Hugin, Ptgui, Panorama Tools, PanaVue, Photostitch and CleVR. Not all software is costly and some stitching programs are available to download for free online. However, for the sake of this tutorial, we will continue to use Photoshop – as this is the most commonly accessible software.

Photoshop includes a tool called 'Photomerge' – and also 'Auto-Blend' in newer versions. While this might not be the most advanced method to merge images – boasting fairly basic, limited controls – it is ideally suited to photographers who haven't attempted stitching before and, using Photomerge, you can quickly create seamless panoramas.

1. To start creating your panorama, select Photomerge by clicking File>Automate>Photomerge in Photoshop. This will open a dialogue box.

2. Click the Browse button and locate and select the files you wish to stitch together. Click the Open button to add images to the source files section of the dialogue box. Click OK to open the Photomerge dialogue box.

△ 3. To change the view of the images use the Move View tool or change the scale and the position of the whole composition with the Navigator. Images can be dragged to and from the lightbox to the work area with the Select Image tool.

△ 4. With the Snap to Image box checked, Photomerge will attempt to match similar details of different images when they are dragged over each other. Once your composite is complete, click OK.

PHOTOMERGE CONTROLS

The Perspective option, in Photomerge, utilizes the first image you place into the layout as the base to which the perspective of subsequent pictures added is adjusted to match. So, images placed into the composition later will be adjusted to fit the perspective of your base picture.

The Cylindrical Mapping option adjusts a perspective-corrected image so that it is more rectangular in shape. The Advanced Blending option will try to smooth out uneven exposure or tonal differences between stitched pictures. The effects of Cylindrical Mapping as well as Advanced Blending can be viewed by clicking the Preview button. The final composite image is produced by clicking the OK button.

LENS TIP

Potentially, any lens can be utilized to create an image sequence to stitch, although problems with accurate alignment are more likely with wideangles. A perspective control lens (page 114) is best, helping to prevent parallax error with foreground subjects. Also, the final composite photo will retain the rectilinear perspective of the original lens.

▽ 5. Often you will need to crop (page 140) the resulting composite image to remove image overlap. Also, adjust contrast if required – using Levels or Curves. Finally, name and save your new image.

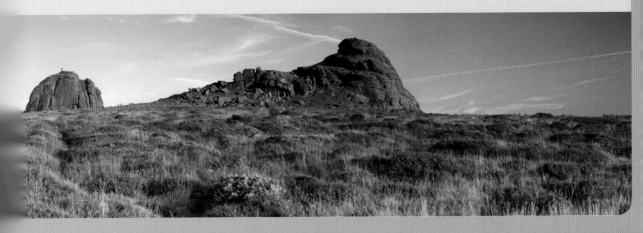

SPECIALIST LENS CORRECTION SOFTWARE

ADOBE, APPLE, BIBBLE, CORAL, GOOGLE, PHASE ONE AND STUDIOLINE ARE AMONG THE PRODUCERS OF EXCELLENT IMAGE EDITING SOFTWARE. HOWEVER, THE PACKAGES THEY PROVIDE ARE INTENDED FOR GENERAL POST PROCESSING AND RAW CONVERSION. WHILE THEY ARE DESIGNED WITH THE TOOLS TO CORRECT LENS PROBLEMS, THIS ISN'T THEIR SOLE PURPOSE. HOWEVER, THERE ARE A NUMBER OF DEDICATED PACKAGES, AND PLUG-INS, READILY AVAILABLE THAT ARE INTENDED PURELY FOR LENS CORRECTION.

Available software

While the majority of photographers will find their normal image-editing package is more than capable of correcting lens-related flaws affecting image quality, others require greater control and precision. There is no shortage of options, with a variety of dedicated programs available to buy and download. Below are a couple of the most popular software packages available. They are designed to enhance a photographer's level of control when correcting common lens deficiencies – like distortions, aberration and light falloff. While this is by no means an exhaustive list, it should provide you with an introduction to the type of software available aimed specifically at lens correction.

Acolens

Produced by German developer Nurizon, Acolens is software designed to correct lens deficiencies. It is a tool aimed at correcting such problems as distortions, vignetting and lack of focus towards the periphery of the frame. Image correction is optimized using a highly precise lens calibration method. The software's pre-installed lens profile library is based on the calibration of a range of popular lens models. Profiles of new optics can be downloaded for free. Photographers can also calibrate their lenses individually if they wish. The software is designed not to interfere with the photographer's artistic autonomy. Instead, Acolens optimizes images based purely on objective criteria. Therefore, should a certain effect be intended – for example, creative use of distortion – their correction can be excluded by simply switching off the relevant function. The software is intended to save photographers time, while being easy to use. It supports all relevant image formats and a complete correction only takes a couple of minutes – depending on your computer system.

PLUG-INS

A plug-in is a computer program that integrates into another, adding new features and increasing functionality. The most abundant type for graphics is Photoshop compatible plug-ins for image editing. Plug-ins are almost always developed by a third party. This is because the purpose of the plug-in is to add functionality that is not inherent in the original software.

There is a variety of plug-ins available, designed specifically to correct common lens deficiencies. They range in capability and usefulness. Some are available to download for free, while others you will need to purchase.

The PTLens is one of the most highly regarded lens correction downloads. This is a lens and camera-specific piece of software – based on Panorama Tools – that is available as either a Photoshop plug-in, or as a standalone version. It is designed to correct lens pincushion and barrel distortion, vignetting, chromatic aberration and perspective. A free trial version is available – after which you need to purchase a licence, which is inexpensive.

Whenever downloading software from the internet, be sure you can trust the website before commencing.

DxO Optics Pro

DxO Optics Pro is highly regarded for correcting the optical imperfections of cameras and lenses. Based on unique DxO optics correction modules – created through advanced analysis of camera and lens combinations – the software automatically performs sophisticated optical corrections to affected images. The software considers camera settings and focal lengths when calculating its adjustments. Even extreme and highly complex distortions – for example, fisheye – can be corrected, along with typical lens problems, like barrel and pincushion distortion, vignetting, colour fringing and lens softness.

⌃ Correction software.
DxO Optics Pro is a highly sophisticated piece of software which takes into account a number of technical factors before performing the requested corrections.

⌃ Distortion. The sophisticated controls of programs like DxO and Acolens allows photographers to remedy lens problems that couldn't be corrected at the time of capture. I used DxO Optics Pro to remove the subject distortion present in this image of a rusty old telephone box – created by shooting from a low angle with a short focal lens.

Nikon D300 with 10–24mm lens (at 12mm), ISO 200, 1/300sec at f/8, polarizer, handheld

GLOSSARY

Aberration
An imperfection in the image caused by the optics of a lens.

Angle of view
The area of a scene that a lens takes in, measured in degrees.

Aperture
The opening in a camera lens through which light passes to expose the image sensor. The relative size of the aperture is denoted by f-numbers.

Autofocus (AF)
A through-the-lens focusing system allowing accurate focus without the user manually focusing the lens.

Camera shake
Movement of the camera during exposure that, particularly at slow shutter speeds, can lead to blurred images. Often caused by an unsteady hold or support.

CCD (charged-coupled device)
One of the most common types of image sensor incorporated in digital cameras.

Centreweighted metering
A way of determining the exposure of a photograph, placing emphasis on the lightmeter reading from the centre of the frame.

CMOS (complementary oxide semi-conductor)
A microchip consisting of a grid of millions of light-sensitive cells – the more sensors, the greater the number of pixels and the higher the resolution of the final image.

Colour temperature
The colour of a light source expressed in degrees Kelvin (K).

Compression
The process by which digital files are reduced in size.

Contrast
The range between the highlight and shadow areas of an image, or a marked difference in illumination between colours or adjacent areas.

Depth of field (DOF)
The amount of an image that appears acceptably sharp. This is controlled by the aperture – the smaller the aperture, the greater the depth of field.

Distortion
Typically, when straight lines are not rendered perfectly straight in a photograph. Barrel and pincushion distortion are examples of types of lens distorion.

Dynamic range
The ability of the camera's sensor to capture a full range of shadows and highlights.

Elements
The individual pieces of glass that form the overall optical construction of a lens.

Evaluative metering
A metering system whereby light reflected from several subject areas is calculated based on algorithms.

Exposure
The amount of light allowed to strike and expose the image sensor, controlled by aperture, shutter speed and ISO sensitivity. Also the act of taking a photograph, as in 'making an exposure'.

Exposure compensation
A control that allows intentional over- or underexposure.

Filter
A piece of coloured, or coated, glass or plastic placed in front of the lens for creative or corrective use.

Fisheye
A type of lens with an extremely wide angle of view, typically 180 degrees.

Focal length
The distance, usually in millimetres, from the optical centre point of a lens element to its focal point, which signifies its power.

F-stop/number
Number assigned to a particular lens aperture. Wide apertures are denoted by small numbers such as f/2.8 and small apertures by large numbers such as f/22.

Highlights
The brightest areas of an image.

Histogram
A graph used to represent the distribution of tones in an image.

Image stabilization
This technology helps steady the image projected on the sensor to compensate for high-frequency vibration – for example, hand shake.

ISO (International Standards Organization)
The sensitivity of the image sensor measured in terms equivalent to the ISO rating of a film.

JPEG (Joint Photographic Experts Group)
A popular image file type, compressed to reduce file size.

LCD (liquid crystal display)
The flat screen on the back of a digital camera that allows the user to playback and review digital images and shooting information.

Lens
The eye of the camera. The lens projects the image it sees onto the camera's imaging sensor. The size of the lens is measured and indicated as focal length.

Macro
A term used to describe close-up photography and the close-focusing ability of a lens.

Manual focus
This is when focusing is achieved through manual rotation of the lens's focusing ring.

Metering
Using a camera or handheld lightmeter to determine the amount of light coming from a scene and calculate the required exposure.

Metering pattern
The system used by the camera to calculate the exposure.

Megapixel
One million pixels equals one megapixel.

Monochrome
Image comprising only grey tones, from black to white.

Multiplication factor
The amount the focal length of a lens will be magnified when attached to a camera with a cropped-type sensor – smaller than 35mm.

Noise
Coloured image interference caused by stray electrical signals.

Overexposure
A condition when too much light reaches the sensor. Detail is lost in the highlights.

Perspective
In context of visual perception, it is the way in which objects appear to the eye depending on their spatial attributes, or their dimensions and the position of the eye relative to the objects.

Pixel
Abbreviation of 'picture element'. Pixels are the smallest bits of information that combine to form a digital image.

Post processing
The use of software to make adjustments to a digital file on a computer.

Prime
A fixed focal length – a lens which isn't a zoom.

Raw
A versatile and widely used digital file format where the shooting parameters are attached to the file, not applied.

Resolution
The number of pixels used to either capture an image or display it, usually expressed in ppi. The higher the resolution, the finer the detail.

Saturation
The intensity of the colours in an image.

Shadow areas
The darkest areas of the exposure.

Shutter
The mechanism that controls the amount of light reaching the sensor by opening and closing when the shutter release is activated.

Shutter speed
The shutter speed determines the duration of exposure.

SLR (single lens reflex)
A camera type that allows the user to view the scene through the lens, using a reflex mirror.

Spotmetering
A metering system that places importance on the intensity of light reflected by a very small percentage of the frame.

Standard lens
A focal length similar to the vision of the human eye – typically 50mm is considered a standard lens.

Telephoto lens
A lens with a large focal length and a narrow angle of view.

TIFF (Tagged-Image File Format)
A universal file format supported by virtually all image-editing applications. TIFFS are uncompressed digital files.

TTL (through-the-lens) metering
A metering system built into the camera that measures light passing through the lens at the time of shooting.

Underexposure
A condition in which too little light reaches the sensor. There is too much detail lost in the shadow areas of the exposure.

Viewfinder
An optical system used for composing and sometimes focusing the subject.

Vignetting
Darkening of the corners of an image, due to an obstruction – usually caused by a filter(s) or hood.

White balance
A function that allows the correct colour balance to be recorded for any given lighting situation.

Wideangle lens
A lens with a short focal length.

Zoom
A lens which has a focal length which can be adjusted to any length within its focal range.

USEFUL WEBSITES

Photographers

Ross Hoddinott www.rosshoddinott.co.uk

Lenses

Four-thirds www.four-thirds.org
Canon www.canon.com
Cosina www.cosina.co.jp
Leica http://us.leica-camera.com
Nikon www.nikon.com
Olympus www.olympus.com
Pentax www.pentaximaging.com
Samyang www.syopt.co.kr
Schneider Kreuznach www.schneider-kreuznach.com
Sigma www.sigma-photo.com
Sony www.sony.com
Tamron www.tamron.com
Tokina www.tokinalens.com
Zeiss www.zeiss.com

Lens accessories and supports

Benbo www.patersonphotographic.com
Bogen www.bogenimaging.co.uk
Cokin www.cokin.com
Intro 2020 www.intro2020.co.uk
Joby Gorrillapod www.joby.com
Lee Filters www.leefilters.com
Lens Baby www.lensbaby.com
Lowepro www.lowepro.com
Gitzo www.gitzo.com
Manfrotto www.manfrotto.com
Novoflex www.novoflex.com
Wimberley www.tripodhead.com

Hides

Wildlife Watching Supplies
www.wildlifewatchingsupplies.co.uk

Photography workshops

Dawn 2 Dusk www.dawn2duskphotography.com

Software

Adobe www.adobe.com
Apple www.apple.com/aperture
Bibble www.bibblelabs.com
Corel www.corel.com
DxO www.dxo.com
Phase One www.phaseone.com
PTLens www.epaperpress.com/ptlens
Nurizon www.nurizon-software.com

Useful reading

Digital Photography Review www.dpreview.com
Digital SLR photography www.digitalslrphoto.com
Ephotozine www.ephotozine.com

ABOUT THE AUTHOR

Ross Hoddinott is an award-winning, professional outdoor photographer and writer. Based in the southwest of England, Ross is one of the country's leading natural history and landscape photographers. His intimate, striking imagery is widely published and he will be familiar to readers of many photographic and wildlife publications, including *Outdoor Photography*, *Digital SLR Photography* and *BBC Wildlife*.

Lenses for DSLRs is Ross's sixth photography book. Previous titles include, *The Digital Exposure Handbook* and *Digital Macro Photography*. Like any photographer – amateur, enthusiast or professional – Ross is passionate about photography and enjoys sharing his knowledge and experience with others. Find out more about Ross and his work at www.rosshoddinott.co.uk.

ACKNOWLEDGEMENTS

Although it is my name on the cover, this title wouldn't have been possible without the hard work of everyone at Photographers' Institute Press. Thank you to Gerrie Purcell, Jonathan Bailey, Ali Walper, Virginia Brehaut and James Beattie. However, the biggest thank you goes to Ailsa McWhinnie – my editor for this project – whose help and experience has been invaluable. Thank you also to Bogen Imaging, Canon, Cokin, Hoya, Intro2020, Lensbaby, Lee Filters, Lowepro, Nikon, Novoflex, Olympus, Samyang, Sigma, Sony, Tamron and Wildlife Watching Supplies for their help and for supplying product images, and to photographers Thomas Collier, Ollie Blayney and Daniel Lezano for allowing me to use a couple of their fantastic images in this book. As always, the biggest thank you is reserved for my wonderful family. Their love, support and encouragement is unfailing. I have amazing parents, who have always supported and encouraged me. Thanks mum, dad and also to my wonderful big sis, Michelle. I am a very lucky man to be sharing my life with the most fantastic woman – my beautiful wife Felicity. She is not only my best friend, but also the most wonderful mum to our beautiful daughters, Evie and Maya. The very last thank you goes to my special little girls – I love you both so much.

INDEX

AMMONITE PRESS

AE Publications Ltd, 166 High Street, Lewes, East Sussex BN7 1XU, United Kingdom
Tel: +44 (0)1273 488006 Fax: +44 (0)1273 472418 Website: www.ammonitepress.com

Contact us for a complete catalogue, or visit our website. Orders by credit card are accepted.